19

Supreme Instants: The Photography of

EDWARD WESTON

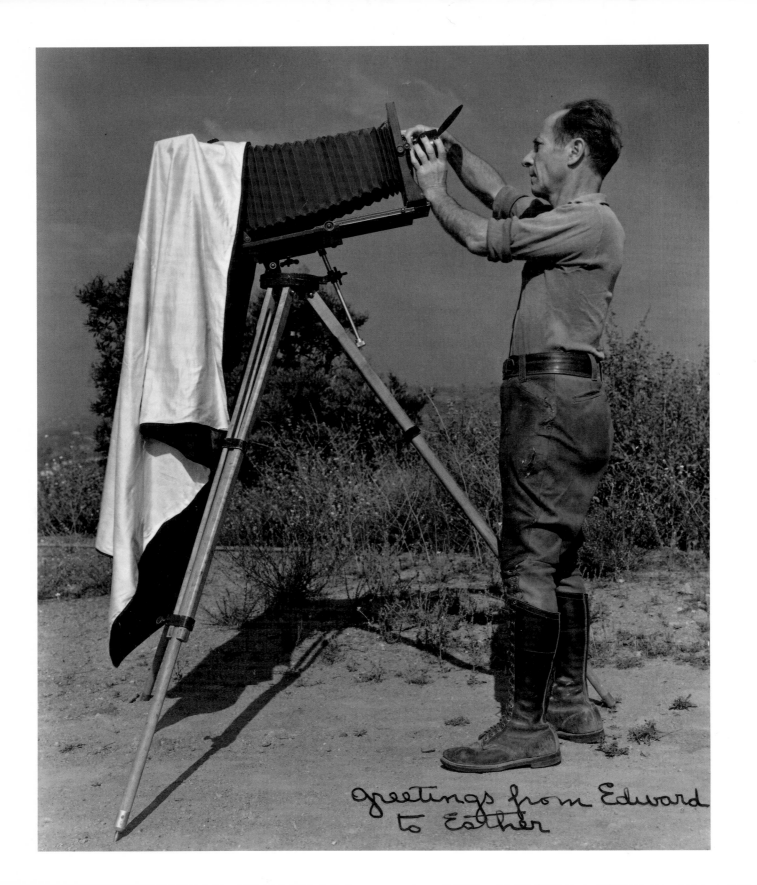

greetings from Edward to Esther

Supreme Instants: The Photography of

EDWARD WESTON

BY BEAUMONT NEWHALL

A New York Graphic Society Book

Little, Brown and Company · Boston

Published in association with the Center for Creative Photography, University of Arizona

This book and exhibition were made possible by a grant from the BankAmerica Foundation.

Frontispiece:
Photographer unknown: Edward Weston with his 8 x 10 camera, 1930s
Inscribed to Esther Tuthill Compton

Text
Copyright © 1986
by Beaumont Newhall

Photographs by Edward Weston
Copyright © 1981
by Arizona Board of Regents
All Rights Reserved

First edition

The photographs reproduced in this book
are in the Edward Weston Archive
of the Center for Creative Photography, University of Arizona, in Tucson, Arizona.

Library of Congress Cataloging in Publication Data on page 192

New York Graphic Society books
are published by Little, Brown and Company (Inc.)
Published simultaneously in Canada by Little, Brown and Company (Canada) Limited

Printed in Switzerland

CONTENTS

PREFACE

Edward Weston was a great American artist who early in his life chose photography as his medium and for half a century pursued it with diligence and passion. His life is an absorbing chronicle of dedication to the creative potential of photography.

It is not the purpose of this essay to retell the story of his life, which has been written so admirably by Nancy Newhall and by Ben Maddow. Rather, it is my intention to examine Weston's stylistic development as an artist and his understanding of photography as a process independent of, yet closely related to, other picture-making media.

This essay could not have been written without the privilege of having known Weston during the last two decades of his life. He shared with Nancy Newhall and me his personal archive of photographs, correspondence, and publications containing contributions both literary and photographic. I am specially indebted to Weston's *Daybooks* covering the years 1923 to 1934. These so vividly describe his attitude toward his life and his work that I have quoted from them as freely as if they were notes taken at personal meetings.

I express my thanks to Edward Weston's sons, Brett, Chandler, Neil, and Cole; to his former wife Charis Wilson; to his friends Willard Van Dyke and Ansel Adams. Amy Conger, my co-editor in the selection of articles for *The Edward Weston Omnibus* and compiler of an excellent catalogue raisonné of Weston's photographs from his start until 1927, provided much important information for which I am grateful.

Special thanks to the Center for Creative Photography of the University of Arizona, which was selected by the Edward Weston estate to be the custodian of the photographer's extensive archive. I am grateful to the Center's director, James L. Enyeart, for inviting me to co-curate with him the Edward Weston centennial exhibition. In the preparation of this essay I have been greatly helped by the following members of the Center's staff: Stuart Alexander, Lawrence Fong, Marguerite McGillivray, Roger Myers, Dianne Nilsen, Terence Pitts, Nancy Solomon, and Amy Stark.

For her perceptive criticism and encouragement I thank Christi Newhall.

BEAUMONT NEWHALL

ACKNOWLEDGMENTS

This book and the centennial exhibition of photographs by Edward Weston (1885–1958) could not have been realized without the support and encouragement of the BankAmerica Foundation. Since its founding in 1968, BankAmerica Foundation has made major contributions to the quality and spirit of American culture through such projects as this. In addition, the Bank of America Corporation has made significant contributions through its own collection and exhibition programs.

We are indebted to Beaumont Newhall, preeminent historian, museum director, and MacArthur Fellow, for new insights into Weston's photography. As guest curator of the exhibition and author of this book, Newhall has brought to both a sense of intimacy and an understanding that stems from his many years of working directly with the artist. It is appropriate that this tribute to Weston's photography should be enhanced by a scholar such as Newhall, who offers the perspectives of advocate, critic, and contemporary.

The following museums will participate in a major national tour of the exhibition, which will travel for a period of three years. They are listed in the order of the exhibition's appearance: San Francisco Museum of Modern Art; Seattle Art Museum; Museum of Photographic Arts, San Diego; Metropolitan Museum of Art, New York City; National Museum of American Art, Washington, D.C.; Amon Carter Museum, Fort Worth; Los Angeles County Museum of Art; High Museum of Art, Atlanta; Mary and Leigh Block Gallery at Northwestern University, Evanston; Denver Art Museum; Museum of New Mexico, Santa Fe; Cincinnati Art Museum; and the Center for Creative Photography, Tucson. We are grateful to these participating museums who have made it possible to share Weston's photography with the widest possible audience.

We are especially indebted to the heirs of Edward Weston for placing the Edward Weston Archive at the Center for Creative Photography. Their interest and support of the Center have made the centennial project possible and ensured that the work of this great American artist will be fully appreciated and studied.

JAMES L. ENYEART
Director
Center for Creative Photography

Success in photography, portraiture especially, is dependent on being able to grasp those supreme instants which pass with the ticking of a clock, never to be duplicated – so light, balance – expression must be seen – felt as it were – in a flash, the mechanics and technique being so perfected in one as to be absolutely automatic.

EDWARD WESTON[1]

SUPREME INSTANTS
The Photography of Edward Weston

I

Edward Henry Weston was born on March 24, 1886, in Highland Park, Illinois, a suburb of Chicago. He died on January 1, 1958, at his home in Carmel, California.

His father, Edward Burbank Weston, was a physician by profession and an expert archer by avocation. As a boy, Edward was restless and lonely, with few companions, no special interests, and a marked dislike for school. In the summer of 1902 father Weston sent his sixteen-year-old son, who was vacationing on a farm in Michigan, an inexpensive Kodak box camera – a Bulls-Eye No. 2 for taking 3 ½ x 3 ½-inch negatives on roll film. With the camera, Dr. Weston sent a letter with detailed instructions on how to operate it. Like most box cameras of the time, the Bulls-Eye was fitted with a waist-level viewfinder that enabled the user to see a miniature replica of the camera image formed by a very small lens fitted into the corner of the box, with a mirror below it set at 45 degrees to reflect the image upward. Dr. Weston described this viewfinder as "the mirror." He wrote: "See what you are going to take in the mirror. You can only take 12 pictures so don't waste any on things of no interest. You'll find enough for the 12. After you are ready, and see your picture in the Kodak, all you have to do is press, or move, the lever sideways.... See if you can snap any birds – even chickens. But you must be close to them."[1]

Edward acknowledged his father's gift in a letter dated August 20:

Dear Papa,

Received camera in good shape. It's a dandy. Is it the same one? I think I can work it all right. Took a snap at the chickens. I think it's a good one as I was right near them – they were coming towards me. It makes me feel bad to think of the fine snaps I could have taken if I had had the Kodak the other day. I was within 6 ft. of two swallows perched on a

wire fence. It would have made the prettiest imaginable picture. I was only a little distance from a wood dove, and could nearly have touched another little bird. I suppose I'll have plenty of chances and I'm going to wait for good subjects.

Tomorrow I intend to take the house when the sun is right. I would like to take a view of part of the farm but wouldn't it be rather small. I can see a fine picture in the mirror from the ridge – looking down. What do you suggest. May [Edward's sister] is coming Monday. Aunt Em left today. We are going to help Mazie all we can even if Aunt Em is gone.

I'm so glad to be able to use the camera, I wish I had had it at the "conference" meet.

Must close and meet Aunt Guss at train.

Your Loving Son

Ed.[2]

I quote this letter in full because it is so remarkably prophetic. At the very outset of his interest in photography, Weston unconsciously expressed the basis of what was to become his philosophy: to see the final picture in the camera before making the exposure.

On his return to Chicago, Edward discovered within weeks that while the Bulls-Eye might be all right for "snaps at chickens," it was not satisfactory for more serious photography. So he saved every penny he could until he had eleven dollars, with which he purchased a secondhand 5 x 7-inch camera with a ground glass and a tripod. He later recollected in his daybook: "Then what joy! I needed no friends now – I was always alone with my love – School was neglected – I played 'hookey' whenever possible – Zero weather found me wandering through snow-drifts – seeking the elusive patterns in black and white – which covered the ground – or sunsets over the prairie wastes – Sundays my camera and I would take long car-rides into the country around Chicago – always alone, and nights were spent feverishly developing my plates in some makeshift dark-room – and then the first print I made from my first 5 x 7 negative – a snow scene – the tightening – choking sensation in my throat – the blinding tears in my eyes when I realized that a 'picture' had really been conceived – and how I danced for joy into my father's office with this initial effort: I can see every line of the composition yet – and it was not half-bad – I can only wish I had kept the print at least for memory's sake – and not destroyed it with many others in some moment of dissatisfaction. Months of happiness followed – interest was sustained – yes – without many lapses – is with me yet."[3]

It is indeed unfortunate, as Weston pointed out, that not one of his very first photographs, taken with such fervor and excitement in 1902, exists. The earliest in the Edward Weston Archive is a landscape entitled

Spring that he later dated as having been taken in 1903. He submitted it to the magazine *Camera and Darkroom,* where it was published in the April 1906 issue. The editor wrote: "The composition is highly satisfactory and the treatment shows that the maker is possessed of considerable artistic taste as well as technical ability. . . . We hope to see more of Mr. Weston's work." The other existing photographs from this period are far more original views of Lake Michigan (Plate 1) and Chicago in the snow. Their direct simplicity is a forecast of much later work.

In 1906, Edward went to California to vacation and visit his sister May in Tropico (now Glendale). He liked the area, and planned to stay there. After a short period of working with a survey party and on the railroad, he decided to earn his living as a photographer. His transition from amateur to professional was swift. His first plan was to work as an itinerant, soliciting portrait sittings as he went from door to door with a post-card camera. But when he fell in love with Flora May Chandler, he realized that the income of an itinerant photographer would hardly support a family, so he enrolled in the Illinois College of Photography in Effing-ham to train as a professional portraitist. He completed the required courses in six months at this trade school. On his return to California he found employment as a printer and cameraman in two Los Angeles studios.

He married Flora in 1909. Four sons were born to them: Chandler (1910), Brett (1911), Neil (1914), and Cole (1919). His first studio, which he built in 1911, was a rustic shack in Tropico, set within a garden. The sky-lit studio was 11 x 14 feet. The camera was of the bellows type on a large stand. He used glass plates at this time, and his favorite lens was the Wollensak Verito, a soft-focus design for portraiture in particular. An inter-viewer described how he made a sitting:

"Weston has a way of taking photographs for customers that seems to stamp him as a genius at once. Coming into the four-by-six reception-room of the shack studio, the customer prepares his features and neck-tie in the arrangement that he fancies he wishes to be in the reproduction.

"He is engaged in conversation by Weston; and before the visitor is aware, he is sitting in the skylit room in a big chair, answering Weston's questions as to his likes and dislikes. He talks carelessly and entirely at ease, waiting, as he believes, for Weston to finish preparing the big camera, around which he hovers.

"When the sitter has begun to get nervous again, thinking that it is time to arrange his necktie and features once more, Weston quietly asks him to move his chair over a bit, into the ray of sunlight. He is not quite satisfied with the first six plates he has taken. Then the visitor realizes that, instead of hovering over the camera, Weston has been caressing it and coaxing from it the highest form of picture art."[4]

Weston was already a successful commercial portraitist in 1915, when this interview took place. His

work was widely exhibited and published in photographic magazines in America and abroad. He was invited as guest of honor by the Photographer's Association of America, a professional organization, to demonstrate his portrait technique at their national convention in Cleveland in July 1916.

This early success was won by hard work. He described the business side of portraiture in a lively, little-known article titled "Shall I Turn Professional?" published in *American Photography* magazine for November 1912. It is in the form of a dialog between himself as a beginner in professional photography and an amateur who has won a sufficient reputation in photography to encourage him to consider making a career of his hobby, without knowing what is required of a "pro." Weston's first advice to the amateur is to get a job in some studio, even if you have to work as an apprentice:

"I don't care how many years experience you may have had, what 'School of Photography' you may have attended (I had a short course in one and have never been sorry); go into a studio before you aspire to own one, and learn how to turn out work in quantities and in a uniform systematic manner. . . .

"As an amateur you have been used to turning out prints in small batches. . . . Now stop and ask yourself, Could I turn out from one to five hundred prints a day, and have them all uniform in tone, quality, and depth? And how about your negatives? Heretofore you have paused breathlessly over one little 4 x 5 plate in a little tray, tinkered and coaxed it along, and, after all, had to reduce or intensify it. How about 50 or 60 plates? . . .

"If I can make you stop and reason with yourself before you take up a profession requiring as much all-around ability as any I can think of, I shall be satisfied. . . .

"All during your amateur career you have chosen your subjects. They are usually beautiful, or else those making strong studies of character. Now, as a professional, you must expect the beautiful, the strong, to be an exception, not the rule. In comes Mrs. Moneybags with a waist measure of forty-four and a height of five feet even. She doesn't expect you to show her up that way, however! She is willing to pay the price if you can deliver the goods. Can you so pose and light her face as to bring out all that's good in it and subdue all that's gross and unrefined? Another sitter comes in, this time tall, lean, and awkward. She believes in herself, however, for didn't James tell her she was surpassing fair just last evening as they sat in the dimly lighted front parlor? It's 'up to you' to get a good order and retain her friendship, and James anxiously awaits the chance to tell her how poor the proofs are, how little they resemble her own sweet self. Woe unto you if you turn the toplight on and make those cheekbones like an Indian's and those eyes two black caverns, or silhouette her bony figure against the background! . . .

"Photography to the amateur is recreation, to the professional it is work, and hard work too, no matter how pleasureable it may be."[5]

Despite his rigorous training as a professional, Edward soon adopted a highly personal portrait style. He specialized in what he called "high key portraiture," using only the upper portions of the gray scale. He was an expert in photographing children, both in his studio and out-of-doors. His studio itself and his lighting methods were personal. He wrote about them in the September 1917 issue of *Photo-Miniature* magazine: "I work in a room in which the light comes from three directions: from two French doors and one long, low, horizontal window – all clear glass. . . . I have a room full of corners – bright corners, dark corners, alcoves! An endless change takes place daily as the sun shifts from one window to another.

"But stop now! All those harnessed to the bugbear of a diffused 45 degrees north light! Tradition enervates you; read no further! Dare you to walk alone, and unafraid, of criticism or your pocketbook? . . . The portrait photographer of the future must be an artist; if not a genius, at least talented."[6]

Weston's advice at this early period in his career on the choice of a lens is surprising considering the soft focus of his own work at this time, but prophetic in view of his future insistence that every area of a photograph *must* be as sharply defined as possible. "Think you to buy a semi-achromatic lens and in so doing become an artist? Amongst abominations a picture made by the tyro with a soft-focus lens ranks high. Better by far an honest, clean cut record photograph than a nondescript abortion."[7]

Edward did not shy away from the hard, and often exasperating, work of making a living for his wife, his four sons, and himself by portraiture. But he deeply regretted that the long hours in the studio, the darkroom, and at the retouching desk left him but little time and energy for what he called his "personal work," by which he meant his production as a creative artist with the camera.

Back in 1902, when Weston so enthusiastically took up the camera, "pictorial photography" was at its height. The term was used to define photographs taken with artistic intent, rather than as mere records. It was an international movement that began in Europe in 1891, when the Club of Amateur Photographers in Vienna, to the amazement of the photographic world, held an exhibition of photographs selected by a jury, not of photographers, but of painters and sculptors. They chose 600 prints from 4,000 entries. In London the following year a group of British photographers, both amateur and professional, formed "The Linked Ring," a society for the sole purpose of promoting art photography. They organized annual exhibitions that they chose

to call "photographic salons" to indicate their artistic character. The first was held in London in 1893; soon salons sprang up in both Europe and America. Weston recollected that he was greatly impressed by the salon held in 1903 by the Art Institute of Chicago.

In their effort to gain for photography its recognition as a fine art, the pictorialists began to imitate painting, etching, and other graphic arts. They avoided sharp focus by the use of specially designed lenses that gave a softness of definition. They preferred mat-surfaced printing papers, such as platinotype, to glossy-surfaced gelatin-silver paper. Many pictorialists favored the gum-bichromate printing process, by which water-color pigment of any desired tint was made light sensitive by the addition of gum arabic and potassium bichromate. Drawing paper was coated with this mixture. When dry, it was exposed to sunlight beneath a glass negative. Development was simply brushing the exposed pigment with water. Other ways of manipulating the photographic image were popular. The paintings and drawings that most frequently served the pictorialists as models were those of the impressionists, James McNeill Whistler, and especially Japanese printmakers.

The most important pictorialist group in America, if not in the world, was formed by Alfred Stieglitz and his friends in New York in 1902. To indicate its artistic character, Stieglitz named it "The Photo-Secession." The name was derived from the custom in Germany and Austria, where Stieglitz spent his student days, to name avant-garde artistic groups "secessions" to indicate the members' break from academicism. The purpose of the society, Stieglitz wrote, was "to hold together those Americans devoted to pictorial photography in their endeavor to compel its recognition, not as the handmaiden of art, but as a distinctive medium of individual expression."[8] Beyond Stieglitz himself, the most influential members were Gertrude Käsebier, Clarence H. White, and Edward Steichen (or Eduard J. Steichen, as he then signed his name). Their work and that of other pictorialists was brilliantly reproduced in *Camera Work*, the beautiful quarterly edited and published by Stieglitz. Weston knew this periodical as well as the many other photographic magazines that were published. He was greatly impressed by the quality of the illustrations. Indeed, in his article "A One-Man Studio" he asked: "Where, oh where would we who believe in pictorial photography be, if 'twere not for such magazines as *American Photography*? Not all of us are blessed with the opportunity of seeing salons, and we must derive our inspirations from the splendid halftone illustrations of works by the masters of our art published monthly in leading photographic periodicals."[9]

Around 1912, Weston began sending "personal work" to the salons with marked success. His greatest coup of this period was that five of his photographs were accepted by the London Salon of 1914. He was

greatly pleased when the secretary of the Salon praised them in an article in the *British Journal of Photography* as the best in the exhibition. Three years later Weston was elected a member of the London Salon. This was a distinct honor, since the total membership was only thirty-seven, and of these only six were American.

The prints that he submitted to these exhibitions were figure studies highly original in concept, posing, and, in particular, lighting. The models were, for the most part, chosen from his growing circle of friends, many of whom were highly influential to him. Around 1912 he met Margrethe Mather, already an accomplished photographer, who became his business partner and model. Nancy Newhall wrote in her notes on Weston's life a description of Margrethe that appears to be based on Edward's recollections:

"One day there burst into his studio a little woman and a huge man, come expressly to tell him what his work meant to them. The huge man was in the movies, later a gag man for Charles Chaplin. The woman was Margrethe Mather, at first sight no more interesting than a wren. If you looked again, you saw she was exquisite. Then you could not take your eyes from her; behind your eyes she moved, haunting, elusive, delicate. Where she came from, how she lived, Edward, though he loved her many years, never really knew. . . . Margrethe was an esthete, nothing less than the perfect would do – the perfect moment, the air, light, scent and shape of flowers. . . . Edward tried to pin her down, keep her close to him; took her as pupil, made her his assistant in studio and in darkroom – anything, everything. . . . She brought him a world he did not know and made it visible and tangible – the world of art, music, literature."[10]

Edward became knowledgeable about modern art largely, I believe, through reproductions of paintings and sculptures in such avant-garde magazines as *The Little Review* and such books as *Cubism and Post-Impressionism* by Arthur Jerome Eddy (1914), which he praised as "amazingly fine." He was also a friend of J. Nilsen Laurvik, director of the San Francisco Museum of Art, and corresponded with the art critic Sadakichi Hartmann. The Panama-Pacific International Exposition in San Francisco in 1915, where his photographs were on display, included many pieces of avant-garde painting and sculpture, as well as a large futurist show. By 1920, Edward was making highly unusual photographs, obviously inspired by modern paintings, of friends posed in sunlit attics in which dormer windows cut into sloping roofs, forming compositions resembling to a degree abstract paintings (Plate 8). His friend the photographer Imogen Cunningham wrote him a letter about one of the attic photographs: "If it doesn't make old near sighted Stieglitz sit up and look around at someone beside the seven constellations, I don't know what could. It has Paul Strand's eccentric efforts, so far as I have seen them, put entirely to shame, because it is more than eccentric. It has all the cubisticly inclined photographers laid low."[11]

Edward's response to this effusive compliment is not known to me. But certainly by this time he greatly admired Alfred Stieglitz; he treasured all his life the July 1921 issue of *Photo-Miniature* magazine containing a review by John A. Tennant, the editor and publisher, of the Stieglitz exhibition held in February at the Anderson Galleries in New York. Tennant described the Stieglitz prints as having "the subject itself in its own substance of personality, as revealed by the natural play of light and shade about it, without disguise or attempt at interpretation, simply set forth with perfect technique. . . . They offered no hint of the photographer or his mannerisms, showed no effort at interpretation or artificiality of effect, there were no tricks of lens or lighting. I cannot describe them better or more completely than as plain, straightforward photographs. . . ."[12]

In this same year, the avant-garde magazine *The Dial* featured a review of this exhibition. The essay, by Paul Rosenfeld, so impressed Edward that, when asked by the Southern California Camera Club to lecture, he read them this excerpt: "The photographs of Stieglitz affirm life not only because they declare the wonder and significance of myriad objects never before felt to be lovely. They affirm it because they declare each of them the majesty of the moment, the augustness of the here, the now."[13]

Edward commented: "I know in which pictures I have felt this 'Majesty of the Moment' most keenly – those pictures in which, when the fleeting instant was before me and recognized, I was breathless with anxiety and excitement lest I fail to seize and record it for all time."[14]

In addition to his lengthy discussion of the Rosenfeld article on Stieglitz, Edward spoke with equal enthusiasm of his conversations with J. Nilsen Laurvik, his art critic friend. Laurvik had praised the attic series, saying, "Your photographs (this as he looked them over) are more stimulating, more imaginative, more refreshing, than most of the work in that show in the other room of the San Francisco Art Association."[15]

To those of us who have long considered Weston's landscapes of the later years of his career to be among his finest productions, his closing remarks to the Southern California Camera Club may seem very strange: "I must conclude – after all – that my ideals of pure photography – unaided by the hand – are much more difficult to live up to – in the case of landscape workers – for the obvious reason that nature unadulterated and unimproved by man – is simply chaos. . . . The etcher or painter have all the best of it in this, with their power of selection and elimination. . . . The conclusion from all this must be that photography is much better suited to subjects amenable to arrangement or subjects already co-ordinated by man. Pictures of the tremendous industries of our day – pictures drawn from out the whirl of our seething maelstrom of commercialism – and of course – portraiture."[16]

This dislike of the natural scene is reflected in Weston's choice of subjects for the dozens – if not hundreds – of prints that he submitted to domestic and international salons in the early years of his career (Plates 2 to 7). Practically all of them were portraits or figure studies.

In 1922, Edward's sister May and her husband invited him to visit them in Middletown, Ohio. While there he made his first industrial photographs, of the huge smokestacks of Armco – the steel plant of the American Rolling Mill Company (Plates 10 and 11). These photographs are a complete departure from his earlier work, not only in subject matter, but in their stark, uncompromising realism.

From Ohio, Edward went on to New York City. There he met Gertrude Käsebier and Clarence H. White, both former members of the Photo-Secession; the painter and photographer Charles Sheeler, whose work he greatly admired; Nickolas Muray, whose photographs he did not like; and John Tennant, the editor of *Photo-Miniature*. He visited the museums and saw paintings by the impressionists, but was surprised not to see contemporary paintings by Picasso and Matisse or sculptures by Brancusi.

But it was Alfred Stieglitz who made the greatest impression on him – one that was to remain with him all his life.

Toward the end of his visit he wrote Stieglitz: "I am only staying on in the hope of meeting you – perhaps if I tell you *fortunately* I have a room at $4.50 a week – you will understand me without further elaboration – You are the one person in this whole country (and photographically this surely means the world) with whom I wish to contact at this important time of my life. . . ."[17]

The meeting with Stieglitz meant so much to Edward that he described it in several manuscripts and drafts in his daybooks. The following excerpt is from what is apparently the first version – a long letter to Johan Hagemeyer headed "on train" – written during his return to Glendale. I have retained his original punctuation.

"Brilliantly – convincingly – he spoke with all the idealism and fervor of a visionary – enforcing his statements by an ever repeated 'You see – you see.' His attitude towards life presented no revolutionary premise to distress me – though it was all fascinating conversation – but my work he irrefutably laid open to attack –

"And am I happy! I saw print after print go into the discard – prints I loved – yet I am happy! for I have gained a new foothold – a new strength – a new vision – I knew when I went there something would happen to me – I was already changing – yes changed – I had lugged these pictures of mine around New York

and been showered with praise – all the time knowing them to be part of my past – indeed not hardly enthusiastic enough to put on an exhibit. I seemed to sense just what Stieglitz would say about each print – So instead of destroying or disillusioning me he has given me more confidence and sureness – and finer aesthetic understanding of my medium – Stieglitz is absolutely uncompromising in his idealism – and that I feel has been my weakness – Quick as a flash he pounced upon the mother's hands in 'Mother & Daughter' (Tina), on irrelevant detail in the pillows of 'Ramiel in his Attic' – bad texture in the neck 'Sybil' – and the unrelated background of 'Japanese fencing mask' – 'Why did you not consider this pipe in 'Pipe and Stacks' – it's just as important as those stacks – nothing must be unconsidered – there must be a complete release' – And all this to one who has believed in and been praised for his rendering of textures! On the other hand I feel that I was well received by Stieglitz – it was obvious that he was interested and the praise he interjected was sufficient to please me – for I know his reputation as an egoist and his rightfully intolerant attitude towards most photographic salons – 'You *feel* – I can see that – you have the beginning – will you go on – I do not know! You are going in your own direction but it is good – go ahead.' Stieglitz has not changed me – only intensified me – Technically I was tending more and more to sharpness – any indefinite wavering line or portion distressing me greatly – so when I found he used an anastigmat lens of 13 in. focus on 8 x 10 plate – stopped down to f.45 or more – that he used a head rest! to enable him to give exposures of 3 or 4 minutes I rejoiced in the possibilities of entirely new experimentation."[18]

II

In 1923, Edward Weston moved to Mexico with his eldest son, Chandler, aged thirteen, and Tina Modotti.

There were several reasons for this move: he disliked the physical and cultural environment of Glendale, he was estranged from his wife, Flora, and his portrait business was not doing well. He was impressed by what he learned of artistic activity in Mexico City and was pleased that several of the photographs he had lent for exhibition at the Academia de Bellas Artes had been sold. He hoped that he could manage to make a living as a professional portraitist and have time for creative photography. In addition, the move was prompted by the urge for expatriation he shared with so many American writers and artists of his generation. As Nancy Newhall explained in her introduction to *The Daybooks of Edward Weston*, he "easily accepted the

post World War I cynicism about America and democracy which led many of the most gifted writers and painters to consider themselves the 'Lost Generation' and go abroad to live."[19]

He chose as his partner in this venture Tina Modotti, an Italian-born budding actress who had played bit roles in Hollywood films. She was his model, was much interested in photography, became his pupil, and produced some fine photographs.

Edward, Tina, and Chandler sailed from Los Angeles aboard the S.S. *Colima* on July 29, 1923, and arrived in the port of Mazatlán a week later. There Edward made his first Mexican photographs. He noted in his daybook on August 6: "I was tempted in Mazatlán to 'go tourist' with my camera, making 'snaps' of street scenes. . . . But yesterday I made the first negatives other than matter-of-fact records – negatives with intention. A quite marvelous cloud form tempted me – a sunlit cloud which rose from the bay to become a towering white column."[20] Edward did not print the "great white cloud" negative until two months later. He was disappointed that the film had somehow deteriorated. "I have spent hours and many plates trying to improve its technical quality in the negative. Despite this loss in quality, it will be one of my finest and most significant photographs."[21] The print that he finally made of the cloud is highly dramatic – and marks a new departure in his choice of subject matter. Hardly a year had passed since he told the members of the Southern California Camera Club that "nature unadulterated and unimproved by man – is simply chaos."[22]

During the last two weeks of October 1923, an Edward Weston exhibition was held at the Aztec Land Gallery in Mexico City. Although Edward's photographs were hardly known in Mexico, the show was a success: he sold – to his surprise and delight – eight prints, and he estimated that between 800 and 1,000 people saw the show, the greatest attendance the proprietor of the gallery had ever recorded. But Edward was not happy: "Viewing my work day after day on the walls has depressed me greatly, for I know how few of them are in any degree satisfying to me, how little of what is within me has been released."[23]

Among the visitors was Diego Rivera, then the most popular Mexican artist. "Nothing has pleased me more than Rivera's enthusiasm," Edward noted. "Not voluble emotion, but a quiet, keen enjoyment, pausing long before several of my prints, the ones which I know are my best. Looking at the sand in one of my beach nudes, a torso of Margrethe [Mather], he said, 'This is what some of us "moderns" were trying to do when we sprinkled real sand on our paintings or stuck on pieces of lace or paper or other bits of realism.'"[24]

Edward was greatly impressed with Rivera's wife, Guadalupe. He described her as "tall, proud of bearing, almost haughty; her walk was like a panther's, her complexion almost green, with eyes to match –

grey-green, dark circled, eyes and skin such as I have never seen but on some Mexican señoritas."[25] He photographed her out-of-doors in brilliant sunlight in a bold close-up of her head alone against the sky while she was talking – or perhaps I should say shouting (Plate 15). It is a completely unposed portrait, taken spontaneously in the fraction of a second. Edward was gratified that the proofs pleased Lupe and Diego. He made other out-of-door portraits with a handheld Graflex camera. The most successful was of his friend the Mexican senator Manuel Hernández Galván (Plate 16). It was taken on a picnic while Galván was target shooting – not for sport, but for reasons of personal security. Indeed, the entire picnic party was armed, because the rebellion against the government led by the revolutionist Adolfo de la Huerta had not been quelled. "We went prepared for emergencies," Edward wrote in his journal on February 3, 1924:

"Three automatics and a rifle, much ammunition. Precautions proved not mere unnecessary readiness against fanciful possibilities. For, arriving at the Convent, we found it barricaded and awaiting an expected raid. Two days before the de la Hueristas had attacked and taken away some thirty horses. Now, on the roof behind sandbags, soldiers leaned on their rifles.

"The wilderness around held a grim portentousness. The sky was leaden. The wind whistled through a sea of pines. 'Wear this,' said Galván significantly, handing me a Colt automatic."[26]

In this atmosphere of suspense Edward made the memorable portrait of his friend: "I wanted to catch Galván's expression while shooting. We stopped by an old wall, the trigger to his Colt fell and I released my shutter. Thirty paces away a peso dropped to the ground – 'un recuerdo' – a keepsake, said Galván, handing it to Tina."[27]

"Es un retrato de Mexico" – it is a portrait of Mexico, Diego Rivera said of it. A poster was made of it, and when Edward sent a print to the great Film und Foto exhibit in Stuttgart in 1929, it was hailed as the top photograph of the entire show.

Edward was shocked, but not surprised, to learn in 1926 that his friend had been shot dead by a political opponent.

Edward Weston's impeccable photographic technique was based upon his early training as a professional photographer. Throughout his career it remained almost unchanged.

He used two types of cameras in Mexico: a large 8 x 10-inch view or stand camera, and a smaller, handheld Graflex for 3¼ x 4¼-inch sheet film. The large camera he used for subjects that were relatively

stationary, such as landscapes, still lifes, architecture, and carefully posed portraits. This classic camera, almost unaltered in design throughout photography's history, consists of a leather accordion-like bellows attached at one end to a lens board that can be racked back and forth on the horizontal bed and at the other end to a frame for a ground glass or a plate holder. In use, the camera was firmly fastened to a tripod. By throwing a light-tight cloth over the back of the camera and his head and shoulders, the photographer could see on the ground glass an upside-down exact image of what would be recorded by the film at the moment of exposure. After the picture was carefully composed, the ground glass was replaced by a plate holder and the exposure made. The 8 x 10-inch camera was bulky and awkward to handle. And it was heavy. For field work Edward carried a tripod, the camera in its case, and film holders in another case – a load of sixty pounds.

Edward's second camera – with which he took the portraits of Lupe Rivera and Galván – was a Graflex. This camera, which first came on the market in 1902, gave Edward dynamic picture-making possibilities. It was a single-lens reflex that could be handheld or fastened to a tripod. It accepted glass plates or sheet film in various sizes; the one Edward took to Mexico was for 3 ¼ x 4 ¼-inch negatives. It was in the form of a box, with a lens on one end and the sensitized plate at the opposite end. On top of the box was a piece of ground glass. Within the box was a mirror pivoted so that it was normally at 45 degrees to the axis of the lens. Thus, the image formed by the lens was reflected upward to the ground glass, which was shielded by a collapsible hood so that the image could be seen in its full size and full detail. When a lever was pressed, the mirror instantly swung to a horizontal position directly beneath the ground glass, and the shutter was released, exposing the film. Throughout his career, Edward insisted on seeing on the ground glass the exact image, and this capability was given him by both the view camera and the Graflex. He summed up his approach to the photographic process in a concise statement to a visitor in 1924: "I told him that my photographs were entirely free from premeditation, that what I was to do was never presented to me until seen on the ground-glass, and that the final print was usually an unchanged, untrimmed reproduction of what I had felt at the time of exposure."[28]

The Graflex had a further advantage over the view camera. Magazines were available in which twelve or eighteen sheets of film, each enclosed in a metal sheath, could be loaded. After each exposure, the photographer pulled a rod, and a fresh sheet of film was brought to the front of the pack. Exposures could be made in rapid succession. Thus, Edward made three dozen negatives of Tina Modotti within twenty minutes.

It has always seemed to me remarkable that Edward Weston recorded his failures as well as his successes in his personal journal. He and Tina were delighted with the facial expressions he had recorded in this sitting.

But they were bitterly disappointed that the negatives were underexposed. Edward asked himself in his day-book, "Why should I of all persons fail in exposure?" and explained:

"I had figured to a nicety, 1/10 sec., *f*/11, Panchro film, Graflex, knowing though that I was on the borderland of underexposure. I had placed Tina in a light calculated not to destroy expression in her eyes, and then to augment it cast reflected light down from above with an aluminum screen – an unusual procedure for me – to be using light accessories. But the sun moves in its orbit, and I, working in a state of oblivion, did not note that my reflector no longer reflected! I feel the weakness of my excuse, my intellect should not have been overwhelmed by my emotions, at least not in my work!

"With a stand camera, my hand on the bulb, watching my subject, there is a coordination between my hand and brain; I *feel* my exposure and almost unconsciously compensate for any change of light. But looking into a Graflex hood with the shutter set at an automatic exposure, a fixed speed, is for me quite different. I dislike to figure out time, and find my exposures more accurate when only *felt*."[29]

At this period of his career Edward preferred platinum or palladium paper for printing. These papers, then commercially available, relied upon the light sensitivity of iron salts to reduce platinum or palladium salts to their respective metals. The resulting platinotypes or palladiotypes have a textured surface and a long tonal scale. Their light sensitivity was so low that prints could be made only by putting the paper directly in contact with the negative and exposing it to sunlight or a Cooper-Hewitt lamp. Edward had no such artificial light, and so was dependent on clear, sunny weather for printing.

There was a further disadvantage to the use of platinum or palladium papers. The prints were limited in size to that of the negative. To make 8 x 10-inch prints from his 3 ¼ x 4 ¼-inch Graflex negatives, Edward had first to make enlarged positive transparencies with his view camera and from them, internegatives. This was a tedious and lengthy task. He noted in his daybook on October 7, 1924: "I am utterly exhausted tonight after a whole day in the darkroom, making eight contact negatives from the enlarged positives."[30]

It must be remembered that Edward depended upon his earnings as a professional portraitist for his livelihood and that of his son Chandler and his lover, Tina. Time for his "personal work" – that is, creative photography – was limited. He feared that he might lose a sitter if he left the studio. And so he began to photograph figurines, dolls, painted gourds, and other folk art objects that he avidly collected in the street markets. These *juguetes* (toys) delighted him, and he made many arrangements of them. He wrote in his daybook in 1924: "These still lifes, strange to say, are the first I have ever done; and feeling quite sure they number among my best things, I would comment on how little subject matter counts."[31]

The dichotomy between subject and form, or realism and abstraction, became of deep concern to Edward during the Mexican period.

Among the first photographs Edward made in Mexico were a few in which he pointed the camera upward. The unusual angle interfered with the recognition of the subject matter, and this apparently bothered Edward. One showed a huge circus tent (Plate 17) and another the stairwell, railings, and glass skylight of a public building. He called these in his daybook "pleasant and beautiful abstractions, intellectual juggleries which present no profound problems. But in the several new heads of Lupe, Galván, and Tina, I have caught fractions of seconds of emotional intensity which a worker in no other medium could have done as well. I shall let no chance pass to record interesting abstractions, but I feel definite in my belief that the approach to photography is through realism – and its most difficult approach."[32]

By "realism" Edward never, in all his voluminous writings, meant mere record-making, nor objective documentation. He stated a simple credo in his daybook on March 10, 1924: "The camera should be used for a recording of *life*, for rendering the very substance and quintessence of the *thing itself*, whether it be polished steel or palpitating flesh."[33]

But in fact he demanded much more. One of his most striking photographs of 1924 is of a palm tree (Plate 13). He described this picture as "just the trunk of a palm towering up into the sky; not even a real one – a palm on a piece of paper, a reproduction of nature: I wonder why it should affect one emotionally – and I wonder what prompted me to record it. Many photographs might have been done of this palm, and they would be just a photograph of a palm – Yet this picture *is* but a photograph of a palm, plus something – something – and I cannot quite say what that something is – and who is there to tell me?"[34]

Shortly after Christmas 1924, Edward and his son Chandler returned to Los Angeles, leaving Tina in Mexico. In his daybook Edward records that he longed to see his boys. He found his old studio in Glendale, which he had left in the charge of his business partner, Margrethe Mather, in a sad state of disrepair. Hardly had he arrived than he planned to go back to Mexico. He wrote Tina, "I have sold two lenses and am bending every effort towards acquiring money for the return."[35] That did not occur, however, until August, when he and his son Brett arrived in Mexico on the S.S. *Oaxaca*. Reflecting on the eight months he spent mostly in San Francisco, Edward wrote: "Prolific I have not been these past months in the States. I have seldom been aroused or had opportunity to work, yet from each brief period with my camera, some sensitive recording

has been achieved."[36] The photographs he listed are now recognized as masterpieces: the nude torso of his son Neil, square-rigged ships in Alameda, and portraits of his friend Johan Hagemeyer as an invalid.

On his return to Mexico in 1925, he set himself a challenge: to photograph the most commonplace of objects, a toilet bowl, in such a way that the beauty of its form, which Edward somewhat extravagantly compared to the *Victory of Samothrace*, could be appreciated. He gave a detailed account of the problems of photographing the *excusado*. The importance to the photographer of the accuracy of his camera is well brought out by Edward's description of his first exposures (October 28, 1925): "I am not absolutely happy with the toilet photograph. My original conception on the ground glass allowed more space on the left side, hardly a quarter inch more, but enough to now distress me in the lack of it. Not my fault either, excepting I should have allowed for the play of holder in the camera back. I finally trimmed the right side to balance and though I admit a satisfying compromise, yet I am unhappy, for what I saw on the ground glass, I have not, – the bowl had more space around it. I spent hours yesterday contemplating the print, trying to say it would do, but I am too stubborn and refuse to say. This morning I am no wiser which may mean that I should do it over."[37] He made another exposure, this time with the camera at floor level, and with a lens of shorter focal length, which produced a bolder, more sculptural rendering of the base of the toilet (Plate 25). "The opening circle to the receptacle does not enter into the composition, hence to nice people it may be more acceptable, less suggestive. . . . But I have one sorrow, all due to my haste, carelessness, stupidity. . . . The wooden cover shows at the top, only a quarter inch, but distracting enough. Of course I noted this on my ground glass, but thought I must make the best of it; such a simple act as unscrewing the cover did not occur to me. . . . Now shall I retouch the cover away – difficult to do – being black, or go to the effort and expense of doing my 'sitting' over? I dislike to touch a pencil to this beautiful negative. . . . To take off the toilet's cover, either by unscrewing or retouching, would make it less a toilet, and I should want it more a toilet rather than less. Photography is realism! – why make excuses?"[38]

Twelve days later, Edward made what he described as "my finest series of nudes."[39] The model was his friend Anita Brenner. Of the fifteen negatives he made, those showing only her buttocks and back are so sculptural as to defy recognition of the photograph as of a woman (Plate 27). Edward was greatly pleased that his friends, including Diego Rivera and Jean Charlot, also liked them. He especially noted that "most of the series are entirely impersonal, lacking in any human interest which might call attention to a living palpitating body."[40] These words may appear contradictory to Edward's statement of a year earlier that his interest lay in the "recording of *life*, . . . the *thing itself*, whether it be polished steel or palpitating flesh."[41]

Edward recognized this apparent confutation, and noted: "Not that I am prepared to say this is a finer use of photography than the rendering of realism . . . but one must satisfy all desires and at present my tendency seems entirely toward the abstract."[42]

By 1926 he could write: "I can now express either reality, or the abstract, with greater facility than heretofore."[43] This confidence, it seems to me, enabled him to create his strong, personal style, based on the union of the "real" and the "abstract."

III

Edward Weston's last months in Mexico were disillusioning and disappointing. He was offered a contract to make photographs to illustrate a book, *Idols Behind Altars*, that his friend Anita Brenner was writing. The assignment involved much travel to little-known areas of Mexico, and he was looking forward to the experience. He wrote Miriam Lerner on May 22, 1926, "I am awaiting a proposition which will take me all over Mexico, photographing the indigenous crafts, frescoes of the Spanish-Indian fusion, etc. . . ."[44] He went on to name the cities and states within a 300-mile radius of Mexico City that he and Brett and Tina would visit: Michoacan, Guadalajara, Tehuantepec, Orizaba, Oaxaca, Guanajuato, Veracruz. For making 400 photographs he would be paid 3,000 pesos (then equivalent to $1,500) and allowed half-fare on the railroad. He realized that he would make no profit, but felt that the opportunity would be "rich and unforgettable."[45] He was bitterly disappointed. The railroads were extremely inefficient, with irregular schedules, frequent breakdowns, even derailments. The accommodations in the country hotels were far from comfortable, and on numerous occasions were infested with fleas. But beyond discomfort was fear. "Another revolution is more than possible," he wrote Miriam in August. "July 31 the government orders all Catholic churches closed for services. Nothing less than an explosion can result, Catholicism is by far too strong for such drastic steps. I wish that I were through with this work and in the states before more trouble. But here we are!"[46] On November 13, 1926, Edward and Brett left Mexico. Volume One of his daybooks closes with bitter words: "This time, Mexico, it must be adios forever. And you, Tina? I feel it must be farewell forever too."[47]

It is sad to recount that Edward, looking back in 1932 to his Mexican period, considered it a failure: "I can blame three things . . . immaturity, psychic distress, and economic pressure. The latter condition

kept me waiting in the studio for work which seldom came. It turned me to photograph toys, – juguetes, which have their place, still live; but I should have had more chance to go out."[48]

The first "personal" photographs that Edward recorded in his daybook on his return to California were of nudes and shells. However different these subjects, he found that both gave him the opportunity to record simplified form. A friend, the dancer Bertha Wardell, posed for him nude. The shells he discovered in the collection of a new friend, Henrietta Shore, a painter. "I am stimulated to work with the nude body, because of the infinite combinations of lines which are presented with every move. And now after seeing the shells of Henrietta Shore, a new field has been presented," he wrote on April 1, 1927.[49]

Some of the shells he photographed singly, others he grouped or placed one within another. Usually, the background was simply a dark tone (Plates 26 and 28). The exposures were extremely long – up to 4½ hours – due to the need to extend the bellows so that at close distance the image would be in focus.

Edward sent a group of these shell photographs to Tina Modotti in Mexico. Her reactions to them amazed him to such an extent that he quoted from them at length in his daybook: "My God, Edward, your last photography surely took my breath away! I feel speechless in front of them. What purity of vision. When I opened the package I couldn't look at them very long, they stirred up all my innermost feelings so that I felt a physical pain. . . . They are mystical and erotic."[50] Diego Rivera on looking at them asked, "Is Edward sick at present? . . . These photographs are biological, beside the aesthetic emotion they disturb me physically – see, my forehead is sweating."[51] José Clemente Orozco, the painter, thought they made one think of the sexual act.

Tina, in her letter of June 26, noted: "I hope you take it for granted that in spite of using the words disturbing – erotic, etc. – I am *crazy* about your latest creations – they have been an inspiration and a joy and I thank you for them."[52]

Edward was overwhelmed by this reaction and denied in his daybook that he had any thought, let alone intention, of recording erotic symbolism.[53] Yet he observed, of a nude photograph, "I saw the repeated curve of thigh and calf, – the shin bone, knee and thigh lines forming shapes not unlike great sea shells."[54] Undaunted by the comments of his Mexican friends, he extended his close-ups to include vegetables, which he photographed larger than life. He was particularly attracted to green peppers because of their ever-varied and decisive convolutions (Plate 34). Through his camera he saw the humble peppers as "sculpture, carved obsidian,"[55] and compared his photographs of them to the sculpture of Constantin Brancusi, which he knew from the four examples in the collection of his friend Walter Arensberg. A pepper photograph he made on August 2, 1930, he considered "a classic, completely satisfying, – a pepper – but more than a pepper: abstract, in

that it is completely outside subject matter. It has no psychological attributes, no human emotions are aroused: this new pepper takes one beyond the world we know in the conscious mind."[56] A few days later, Edward noted that he found one recent pepper to be "so dynamic it becomes terrific with implied esoteric force."[57] And, of yet another pepper, he wrote: "It has a mystic significance."[58]

Beside peppers, Edward photographed many other varieties of common vegetables he found in local markets. He not only recorded the outer forms of lettuce and cabbage (Plate 29) and radish, but the inner structures as well. Among his strongest of the vegetable series are extreme close-ups of halved onions (Plate 31), cabbages, and artichokes. Each was unique, for he cut off a slice with each exposure.

Throughout the daybooks Edward sought an explanation of what he could only call the *plus* of photography. As he said of his palm tree photograph, it "*is* but a photograph of a palm, plus something – something – and I cannot quite say what that something is – and who is there to tell me?"[59]

That "something" was, of course, the indefinable spiritual drive that he found manifest also in his nudes and shells.

In 1931 the M. H. de Young Memorial Museum in San Francisco held a large Weston exhibition. It was reviewed by Ansel Adams, who only recently had abandoned his plan to become a concert pianist and was now starting his career as a photographer. At this time he hardly knew Weston, beyond a casual meeting in 1928 at a supper hosted by Albert Bender, a philanthropist, collector, and friend of many artists in the San Francisco area. Edward recollected years later that he was not as much impressed by Ansel's photographs as by his piano playing. He told Nancy Newhall in 1950: "The thought that in this young musician, with such a future before him, we'd have one of the greatest photographers we've ever had, never so much as crossed my mind."[60]

A hundred and fifty prints were hung at the de Young museum, and it is likely that this group of Edward's work was the largest that Ansel had seen. He did not understand all of the photographs, particularly the close-up "abstractions." His review, which appeared in *The Fortnightly*, December 18, 1931, began with a dogmatic statement: "In a strict sense photography can never be *abstract*, for the camera is not capable of synthetic integration. This basic limitation is indeed a fortunate one, in that it strengthens the incontrovertible realism of the lens. Photographic conceptions must be unencumbered by connotations – philosophical, personal, or suggestive of propaganda in any form."[61] Ansel's chief criticism seems to be that Weston "often makes his subjects *more* than they really are in the severe photographic sense."

Edward replied to this criticism in a letter to Ansel, dated January 28, 1932, in which he pointed out

that, in his opinion, "Nature has all the 'abstract' (simplified) forms Brancusi or any other artist can imagine."[62] Edward's most important statement – and to me the most surprising – is a declaration of the *unreality* of photography, or as he put it, "the willful distortion of fact," as opposed to Ansel's somewhat naïve belief in "the incontrovertible realism of the lens."

Edward pointed out that "photography is not at all seeing in the sense that the eyes see. Our vision, a binocular one, is in a continuous state of flux, while the camera captures and fixes forever (unless the damn prints fade!) a single, isolated condition of the moment. Besides, we use lenses of various focal length to purposely exaggerate actual seeing, and we often 'overcorrect' colour for the same reason. In printing we carry on our willful distortion of fact by using contrasty papers which give results quite different from the scene or object as it was in nature."[63]

In 1928, Edward and Brett visited a friend who lived in Big Bear Lake, California, in the mountains west of the Mojave Desert. Their friend drove them to a formation of rocks that Edward found amazing: "Stark-naked they rose from the desert, barren except for wisps of dry brush: belched from the earth's bowels by some mighty explosion, they massed together in violent confusion, in magnificent contiguity. Pyramids, cubes, rectangles, cylinders, spheres – verticals, obliques, curves – simple elemental forms, complex convolutions, opposed zigzags, at once chaotic and ordered, an outstanding sight!"[64] Upon developing the negatives he made there, he found them "the most important I have ever done. They have all the forms I felt and revealed in shells and vegetables plus greater strength and vitality. So writing I do not mean to belittle my former period, – it led to this."[65]

Edward's move to Carmel in the beginning of 1929 was of the utmost importance to his future photographic work, because the magnificent natural environment of the Pacific coast inspired him to spend more time out-of-doors with his camera. At first the immensity of the landscape overwhelmed him. "My desert rocks were much easier to work with, and quite as amazing, or more so. They were physically approachable, I could walk to their very base, touch them. At Big Sur, one dealt with matter from hundreds of feet to many miles distant."[66] Apparently he made no photographs of this coastal landscape, for he observed: "The way will come in time to see this marriage of ocean and rock"[67] – a prediction brilliantly realized in his later years.

But now he preferred his photograph of a nude "which in contrast makes the cliffs pale: the latter visually tremendous as seen in reality, – the former transformed by my way of seeing and understanding into something greater."[68] But only three weeks later he discovered Point Lobos, a peninsula of 354 acres jutting

into the Pacific about three miles south of Carmel. It is truly a sanctuary of wildlife and happily is protected as a preserve by the state of California. Nothing can be removed from the area. If a tree falls, it is left where it fell. Wildflowers cannot be picked; the whole ecology is uncontrolled, uncultivated. There are species of trees hundreds of years old, not to be found elsewhere – particularly the Monterey Cypresses, which appear to grow out of the very rock, and lovely stonecrop that springs forth in profusion from crevices in the cliffs.

Edward's reaction to this unique and extraordinary environment was to explore its natural beauty through his camera. From his daybook: "*March 21, 1929*: Point Lobos! I saw it with different eyes yesterday than those of nearly fifteen years ago, And I worked! . . . I did not attempt the rocks, nor any general vista: I did do the cypress! . . . [Plate 93] No one has done them – to my knowledge – as I have, and will. Details, fragments of the trunk, the roots, – dazzling records, technically superb, intensely visioned."[69]

Later Edward did photograph the seaworn, eroded rocks of Point Lobos, and they are some of his finest prints (Plates 91, 98, and 99). In their rich and varied convoluted forms they bear out Edward's repeated observation that nature contains all the "abstract" qualities that a sculptor or painter can imagine.

Then he began to focus on distant views. He infuriated his friends when he photographed a brilliant shell that he had placed in the foreground of a seagirt rocky landscape of Point Lobos (Plate 90). They felt that such "arranging" was artificial. His close friend Ramiel McGehee said, "It is not a Weston."[70] But Edward was, as usual, ahead of his critics. He wrote in his daybook on October 14, 1931, that the photograph in dispute, which he titled *Shell & Rock – Arrangement*, was "a viewpoint which combines my close-up period with distance, a way I have been seeing lately."[71] He further noted: "My own response in making it was one of emotion from contrasting scale, – the tiny shell in a vast expanse, yet the shell dominating."[72]

By 1930, Edward had won international recognition. Not only was he invited to show some of his prints at the prestigious *Film und Foto* exhibition organized in Stuttgart in 1929 by the Deutsche Werkbund, a leading German art society, but he was asked to contribute a foreword to the catalog and to select prints from other West Coast photographers for the exhibit. His first New York exhibition, at the Delphic Studios in 1930, was a success. Edward was especially pleased that Charles Sheeler, the painter and photographer he had met on his 1922 New York visit, took the trouble to write him a congratulatory letter. He copied an excerpt of it in his daybook: "'It must always be encouraging to those who insist that photography should stay within the bounds of the medium to witness such an outstanding demonstration as you have given that the medium is adequate.'"[73]

For many of his one-man exhibitions Edward wrote statements that were printed in the catalog or as labels for the wall of the gallery. What he wrote in 1930 for the exhibition at the Museum of Fine Arts, Houston, seems to me to brilliantly summarize his way of "seeing plus":

"Clouds, torsos, shells, peppers, trees, rocks, smokestacks, are but interdependent, interrelated parts of a whole – which is life. Light rhythms, felt in no matter what, become symbols of the whole. The creative force in man recognizes and records – with the medium most suitable to him, the object of the moment – these rhythms, feeling the cause, the life within the outer form.

"Recording unfelt facts by acquired rule results in sterile inventory.

"To see the thing itself is essential; the quintessence revealed direct, without the fog of impressionism – the casual noting of transitory or superficial phase.

"This then: to photograph a rock, have it look like a rock, but be more than a rock. Significant representation – not interpretation.

"The photographs exhibited, with the exception of the portrait studies, are contact prints from direct 8 x 10 negatives, made with a rectilinear lens costing $5 – this mentioned due to previous remarks and questions. The portraits are enlarged from 3 ¼ x 4 ¼ Graflex negatives – the camera usually held in hands.

"I start with no preconceived idea – discovery excites me to focus – then rediscovery through the lens – final form of presentation seen on ground glass, the finished print previsioned, complete in every detail of texture, movement, proportion, before exposure.

"The shutter's release, which automatically and finally fixes my conception, allowing no after manipulation – the print, which is but a duplication of all that I saw and felt through my camera."[74]

IV

Edward Weston was a most hospitable man. If he liked you at first meeting, you became his friend at once. When Willard Van Dyke came as a young man in 1929 to study with him, Edward wrote in his daybook that his prospective pupil "knows enough to make me feel I have little to give him, who will go a long ways from present indications."[75]

Willard was greatly impressed with Edward's photographs and with his esthetic of "pure photography" based on the recognition of the limitations and possibilities of the medium. This approach Willard

saw as a healthy antidote to what his friend Ansel Adams called the "decadent theatrics" of those photographers who still subscribed to the "pictorial" tradition. As we have seen, Edward had abandoned that tradition in the early 1920s, when he gave up a soft-focus lens in favor of a sharp-cutting anastigmat, and chose to print on platinum paper rather than use such manual control processes as gum-bichromate or bromoil.

Definitely inspired by Weston, Willard founded an informal society for the promotion of "pure photography" in 1932. At the founding meeting, held in Willard's Oakland gallery, the following photographers were admitted as members: Ansel Adams, Imogen Cunningham, John Paul Edwards, Sonya Noskowiak, Henry Swift, Willard Van Dyke, and Edward Weston. There were no officers, no by-laws, no formalities; their purpose was to further the practice and appreciation of pure photography through exhibitions, lectures, and publications. They named the new society Group *f*/64. This somewhat esoteric title was derived from the optical term for one of the smallest openings of the iris diaphragm of a camera lens, which enables the image to be in sharp focus from the foreground to the distance. Thus it defined – but only to the photographically initiated – one of the tenets of pure photography: an insistence on overall sharpness of focus and the rendering of the most minute detail in the negative.

Group *f*/64 was invited to hold its first exhibition in the M. H. de Young Memorial Museum, one of the finest art museums in San Francisco.

In addition to exhibiting their work, the group contributed articles to the photographic press that were highly critical of pictorial photography and that led to a spate of letters to the editor. Most of these articles were written by Ansel and Willard.

Edward noted in his daybook that many of his friends were surprised that he should have joined Group *f*/64, "having gone my own way for years. But I see it as purely educational. We are all friends, free from politics; and I have no desire to be the founder of a cult!"[76]

Group *f*/64 was short-lived. The members disbanded in 1935, when Willard moved to New York City to begin his distinguished career as a documentary filmmaker. Yet the name has survived for over fifty years to define that kind of pure photography so widely practiced today.

The year 1932 was somewhat mixed for Edward. It opened with his highly successful second New York exhibition at the Delphic Studios. But by March he denied any further interest in the very subject matter shown at that exhibition. He wrote in his daybook, "I am about through with the trees and rocks of Point

Lobos for the time, nor do the vegetables or still-life indoors excite me. . . . I feel like turning to portraits for a while."[77] This is surprising, for throughout the daybooks there is a constant lament about the demands made upon his time, strength, and patience by the portrait business on which he depended for a living.

The daybooks are not casual notes, scribbled down all in a rush. They are as carefully composed as though Edward planned to publish them. Many entries were rewritten several times, to judge from existing fragments of early drafts. They constitute a quite extraordinary dialog between Edward Weston the artist and his alter ego – Weston the practical man of the world.

He was a brilliant portraitist. He once estimated that he had taken over five thousand likenesses. What bothered him was not the camera work, but what the textbooks called "the after-treatment of the negative." As Weston described it in 1931:

Weston the Artist

When making a portrait, my approach is quite the same as when I am portraying a rock. I do not wish to impose my personality upon the sitter, but, keeping myself open to receive reactions from his own special ego, record this with nothing added: except, of course, when I am working professionally –

Weston the Professional

When money enters in, – then, for a price, I become a liar, – and a good one I can be whether with pencil or subtle lighting or viewpoint. I hate it all, but so do I support not only my family, but my own *work.*

Weston the Artist

The latter I will never, not if I starve, make to please others for their price.[78]

Edward forthrightly and courageously solved this dilemma by announcing that he would no longer retouch portraits. "I am revolutionizing my way of working in portraiture," he wrote in his daybook on December 8, 1932. "I have purchased a 4 x 5 Graflex and will start making contact prints, *unretouched*. . . . This is a daring step to make during a major economic crisis, but it *had to be done* ! . . . The 4 x 5 size is large enough, I hope, so that I will not be asked to enlarge; which means greater technical perfection; for no matter how well done, an enlargement does lose quality, cannot compare with a contact from the same negative. I do not dare to say 'no enlargements,' not yet; that will be the next step. But I will not sign, except duplicate prints from old negatives, any retouched order."[79]

Along with this new departure in portraiture, Edward now changed his way of printing. For years he had been using less expensive commercial gelatin-silver paper for proofs or study purposes. For portraits and prints for exhibition or his own portfolio he preferred either platinum or palladium papers. Because the gelatin-silver papers were coated with an emulsion containing light-sensitive silver salts, they had a smooth, often glossy surface, as contrasted to the textured "paper" quality of the platinotype. In 1930 he wrote that he now liked glossy paper "because the prints do not 'dry down,' losing shadow detail and flattening highlights. . . . No other surface is now to be thought of."[80] And in this year he hurriedly reprinted on gelatin-silver paper his entire New York one-man show of fifty prints. For the rest of his life, Edward Weston used no other type of printing paper.

Edward opened his daybook for 1934 with a backward glance over his accomplishments for the year just passed. "The personal result of my new way of working in portraiture has been that I have done the finest portraits of my life. For the first time in years, portraiture has meant more to me than just a job, has been a creative expression." And he concluded: "Portraits, nudes, and open landscape have been my expression this last year; only two or three 'close-ups' have been added to my portfolio. The landscapes, which I did in New Mexico please me, and have moved others, – even to the point of buying! I think they mark a definite step in advance, and indicate the next phase of my work."[81]

The New Mexican landscapes that so pleased Edward were made during a two-week trip with Sonya Noskowiak and Willard Van Dyke in 1933. Previously Edward had shown little interest in landscapes. His daybook entry for the few landscapes he made in Mexico in 1924 was almost apologetic: "Another landscape from San Cristobal now printed. It rings rather novel for me to be writing of my 'landscapes,' practically the first I have done since I began photography as a boy some twenty years ago."[82] We have seen that he was fairly overwhelmed in 1929 by the immensity of the Big Sur area of the Pacific coast and was not moved to photograph its majestic beauty. Now, in 1933, what he called "open landscapes" became subject matter that would preoccupy him for the rest of his career.

In 1934 a great change took place in Edward Weston's life when he met Charis Wilson, the twenty-year-old daughter of Harry Leon Wilson, novelist and scriptwriter for Hollywood films. She became Edward's model, his assistant, his editor, his lover, and eventually, his wife.

Edward was photographing nudes in his Carmel studio, and Charis volunteered to model for him. She was surprised that he did not direct her to take static poses. Instead he invited her to move around all she

wished. When he saw a picture on the ground glass of his Graflex, he would simply say, "Hold it!" and make the exposure. The prints were small in size (4 x 5 inches), intimate in feeling, and realistic in the rendering of flesh. They never showed the head and seldom the entire body, but portions only, in a somewhat abstract way. As a series, these photographs almost seem to be frames of a motion picture (Plates 39 to 42).

Edward, who moved to Santa Monica with Charis in 1935, took no more nudes in this short-lived style. As Charis has put it, in her book *Edward Weston: Nudes*, he did "no more 'bits' and 'pieces,' only whole people in real life."[83]

Among the strongest of the "whole people" nudes were the extraordinary series of Charis lying full-length sunbathing amid the sand dunes of Oceano (Plate 43). The setting is immense, for the dunes reach a height of 100 feet and their configuration constantly changes with the blowing of the sand by the wind.

Now Edward's vision became bolder, and he had complete confidence in his mastery of photography. What is yet more remarkable is that he returned in his maturity to the admiration of the *thing itself* that marked his style of the 1920s. His photographs were no longer "puzzle pictures." And the subject matter was now mostly landscapes, seascapes, cityscapes, buildings of all kinds. When people were portrayed, they were usually shown in their normal surroundings.

Edward applied for a John Simon Guggenheim Memorial Foundation Fellowship in 1936. His proposal read:

I wish to continue an epic series of photographs of the West begun about 1929; this will include a range from satires on advertising to ranch life, from beach kelp to mountains.[84]

The Guggenheim Foundation granted him a fellowship for a year beginning in April 1937, which was renewed for a second year in 1938. Although the stipend was only $2,000 per year, Edward and Charis were able to travel by automobile 35,000 miles throughout California. Edward made more than 1,500 negatives. They were all taken with the bulky and unwieldy 8 x 10-inch view camera, into which he loaded plate holders one by one, each containing two sheets of film. After every day of field work, the film holders – sometimes all twelve of them – had to be unloaded and then loaded with fresh film in a makeshift darkroom. Edward boasted that he could set up the tripod, fasten the camera securely to it, attach the lens to the camera, open the shutter, study the image on the ground glass, focus it, close the shutter, insert the plate holder, cock the shutter, set it to the appropriate aperture and speed, remove the slide from the plate holder, make the exposure, replace

the slide, and remove the plate holder in two minutes and twenty seconds. Today, with a high-quality roll-film camera, such as the Hasselblad, he could easily have made twenty-four successive exposures in that time. But to Edward, trained as he was in the use of the traditional "professional" equipment, there was nothing like the 8 x 10-inch "view box." When asked why he preferred such a large camera, he would reply that he liked its large, full-sized image – indeed he found it essential to his personal way of working. Over and over again he wrote that the final print was the image that he saw upon the ground glass.

The Guggenheim project gave Edward the opportunity to test his theory of mass production seeing: "I have always considered the rapidity of the camera's recording process an important asset since it means that the number of pictures a photographer can make is only limited by his ability to see. Quality, in quantity, is possible in photography to a degree unequalled in any other medium."[85]

To summarize the massive production of truly epic photographs done during two Guggenheim years is hardly possible. Among the most notable are the breathtaking views of Death Valley (Plate 76), the harsh scenes of the north coast of California (Plates 56 and 58), the snow scenes in Yosemite National Park (Plates 79 and 80), and, of course, Point Lobos.

When asked why he did not photograph people on this project, Edward replied: "I have actually done people in my own way. Wrecked automobiles and abandoned service stations on the desert, deserted cabins in the high Sierras, the ruins of Rhyolite, ghost lumber towns on the bleak north coast, a pair of high buttoned shoes in an abandoned soda works, the San Francisco embarcadero, the statue of a leering bellhop advertising a Los Angeles hotel – all these are pictures of people as well as life."[86]

Charis wrote an absorbing account of their travels that was published in 1940 by Duell, Sloan and Pearce in a book titled *California and the West*, with ninety-six excellent reproductions of a selection of Edward's 1,500 photographs.

V

My first contact with Edward Weston was in 1937, when I invited him to lend some of his photographs for the large, 800-print exhibition *Photography 1839–1937* that I was putting together for the Museum of Modern Art in New York. Although my position on the staff of the museum was librarian, I was asked by the director,

Alfred H. Barr, Jr., to organize this show and to write the accompanying catalog. Edward graciously and promptly sent four recent photographs of the sand dunes of Oceano, California.

The exhibition opened on March 17, 1937, and was a great success. The museum's president, A. Conger Goodyear, stated that the show "must be counted one of the most complete and satisfying exhibitions in the Museum's history."[87] It traveled to ten major museums throughout the country, including the M. H. de Young Memorial Museum in San Francisco, where Edward saw it. Some of us on the staff of the Museum of Modern Art dreamed of forming a Department of Photography as a permanent part of the museum's activities. I wrote Edward about this hope and he replied:

"I was tremendously interested in your news of the establishment of a photographic section. It is most fitting that the Museum of Modern Art should be the first to do this. If anything is contemporary it is photography; if anything is peculiarly American it is photography. Count on me to cooperate in any way I can. Of course American museums have presented 'salons' of photography for many years, but almost always photography with a very bad smell. And some museums have small collections which you probably know more about than I do. But so far as I am aware no museum, nor individual, has had any plan for acquiring a representative collection of photographs. Early work must already be difficult to acquire; later work, such as the Photo-Secession period must be equally hard to find; and soon the work of today will be scattered.

"But once it becomes known that the Museum of Modern Art has a plan, and a section of important work, I can well imagine that offers, donations and cooperation will flow in from unexpected sources.

"In time you should have a collection worthy of a pilgrimage to see, – the only one of its kind.

"One-man shows would seem important, group shows are never fair to the individual. Ten prints, or twenty, or even fifty cannot be representative.

"Your historical show had great value, and could be done on an even more comprehensive scale on the 100th anniversary.

"You set a fine pace with Photography 1839–1937. Let us have more. With all the hundreds of magaazines, annuals, collections of nudes, 'candids,' – nothing is published worth a second glance."[88]

In the summer of 1940, Nancy and I went to California on vacation. The first person we visited in San Francisco was Ansel Adams, whose acquaintance we had made when he was in New York a year earlier. It so happened that he and Edward Weston were both speakers at a photographers' meeting of some sort in San Francisco. Ansel had planned to drive Edward to his home in Carmel after the meeting and invited us to

come along. We were delighted. Although our stay was brief, the Westons and the Newhalls became friends almost at once. Nancy described the visit: "It was dark when we reached Carmel. . . . Charis, her long hair loose and shining, came out to greet us. . . . There were jubilations and embraces. Then we all went into that wide-roofed room and the firelight. Supper was a celebration. Afterward, Charis showed us the half-finished text of *California and the West*. Then Edward set up a simple easel, adjusted the light, put on a green eyeshade, and began showing us some of the photographs selected for the book. They were brilliant; the variety of Weston was astonishing. . . . When the prints went safely back in the cabinets, Charis opened the firewood hatch and called. Cats began to leap in, so fast they became a torrent, cats of all sizes, colors, and ages. . . . The Weston way of life, we learned, involved the minimum time and effort in the kitchen or at the dishpan. Breakfast was coffee; you could help yourself to fruit and bread and honey if you liked. Lunch was eaten in the hand – a hunk of cheese, a few dates, an avocado. Around four o'clock, when light goes bleak in the west, there was a cry for 'Coffee!' At nightfall, all hands dropped work and joyously collaborated to make supper a feast. I found this simplicity and freedom exhilarating. . . . We went to Point Lobos with Edward, and to see Lobos with Edward was to see Dante's *Inferno* and *Paradiso* simultaneously. The vast ocean, dangerous and serene, pale emerald and clear sapphire, sucking in and out of caves full of anemones; tidepools flickering with life or drying inward into crystals and filaments of salt; the cliffs starred with stonecrop; the living cypresses dark as thunder clouds, with the silver skeletons of the ancient dead gleaming among them – and in those days one could wander at will over Lobos. Then as the apocalyptic moments of the fog closed in and became cool twilight, back to the little house and coffee, firelight, the latest pages from the typewriter, and more prints."[89]

Photographing with Edward Weston was indeed an experience. I knew his work from his 1932 book, published by Merle Armitage, and from reproductions in photographic periodicals and annuals. I knew a bit about his photographic esthetic from his frequent articles in *Camera Craft* magazine. I also knew about "pure photography" and the doctrines of Group $f/64$. But I had never seen him at work.

At the time of our visit I was using a Voigtländer "Avus" camera for 9 x 12-centimeter or 3 ¼ x 4 ½-inch sheet film. It was basically a miniature view camera, with ground-glass focusing. I felt rather foolish accompanying Edward with my tiny camera as he clambered over the cliffs with his big 8 x 10-inch camera on its tripod. Whenever he found a promising view he would set up the camera, and those who were with him would step back quietly while he studied the ground glass. If the image pleased him, he would make an exposure. Then he would invite us to look at the ground glass. It was a lesson in seeing. I found it amazing that

what I saw through his camera was not at all what I had seen of the same subject through my own eyes. The more I worked alongside Edward, the more I began, quite unconsciously, to take photographs much too similar to his. So I decided not to photograph on Point Lobos, but to make a camera record of the Westons' little house on Wildcat Hill.

I was surprised and delighted when Edward offered me the use of his darkroom to develop my films. Although I was not familiar with his "A-B-C Pyro" developer, the negatives were entirely satisfactory. Edward was complimentary and suggested that I print them right away.

When I showed him my prints, he asked me, "Why didn't you dodge them?" This darkroom technique, by which the printing light is manually controlled, I thought to be a violation of the strict "no hands" doctrine of pure photography, and to be avoided. Edward, with a chuckle, took me into his darkroom and showed me how he dodged.

He had no enlarger, for at that time he made no enlargements, but only contact prints, that is, prints the same size as the negative. Above the workbench beside the sink, a bare light bulb hung from the ceiling. Edward turned off all the lights except the orange "safelight." He put my negative in a frame and laid a piece of glossy gelatin-silver printing paper on top of it, closed the back of the frame, and laid it, glass side up, beneath the hanging bulb. He turned this on, and after a few seconds he was shading the light with a cardboard disk on the end of a twisted wire handle. "We have to hold back the light here," he said, "because as you can see, the shadows are so light in the negative that they will print too dark." Then he picked up a square piece of cardboard and held it so that just a slit of light fell on the edge of the negative. "It's always a good idea to tone down the edges," he said, "so long as it's not overdone, to destroy the atmosphere of the place."

The resulting print was a great deal better than my "straight" print. Now there was detail in the shadows and the whole image seemed more brilliant. Edward explained that dodging was essential when the brilliance of the subject lay beyond the range of the printing paper.

It may seem that this printing technique contradicts his often-repeated dictum: "One must prevision and feel, BEFORE EXPOSURE, the finished print . . . when focusing upon the camera ground glass. . . . Development and printing become but a careful carrying on of the original conception."[90] If the quote is changed to read "development and printing *must* carry on the original conception," Edward's meaning becomes clearer.

This printing session with the master made it utterly clear to me that the doctrine of pure photography

was fallacious, and that there is as much skill of hand, indeed artistry, in making a truly fine photographic print as in making an etching, a lithograph, or even a painting. Edward's son Cole, who has printed hundreds of his father's negatives, has stated that almost half of them required dodging.

We agree with Ben Maddow's statement in his biography of Edward Weston: "If the doctrine of photographic purity was not already seen to be illusory, the practice of dodging proved it logically absurd."[91]

On April 14, 1941, Edward wrote us, "News – we will see you before many months," and explained that he and Charis would "criss-cross America" taking photographs for a new edition of Walt Whitman's *Leaves of Grass* that the Limited Editions Club was publishing.[92] Two weeks later he described the project more fully: "This I should tell you; there will be no attempt to 'illustrate,' no symbolism except perhaps in a very broad sense, no effort to recapture Whitman's day. The reproductions, only 54, will have no titles, no captions. This leaves me great freedom – I can use anything from an airplane to a longshoreman. I do believe, with Guggenheim experience, I can & will do the best work of my life. Of course I will never please everyone with my America – wouldn't try to."[93]

They traveled, as on the Guggenheim project, by automobile, camping out or staying with friends, but otherwise the trip was quite different. On their travels throughout California, Edward's photographs were mostly of spectacular landscapes, the natural scene, and the destruction wrought by the fierce tides of the north coast, the sun in Death Valley, and forest fires; now he concentrated on cityscapes, buildings of all sorts, industrial scenes, and many sensitive portraits of people in their customary environments. They covered the eastern seaboard, from Bangor, Maine, to Louisiana. By September, Edward had made 400 negatives. They were heading south from Delaware on December 7, 1941, when the Japanese bombed Pearl Harbor and the nation was plunged into war.

Edward wrote us from Athens, Georgia, "I am glad we were in N. Y. before the deluge. We will have to head west to defend our home."[94] They arrived in Carmel at the end of January, with seven hundred 8 x 10-inch negatives and "several dozens of 4 x 5's."[95]

The Japanese threat was alarming to those who lived on the Pacific coast. If Pearl Harbor was so vulnerable, what about defenseless California? As Edward wrote, "If we should get a few incendiary bombs along the coast, this shack along with everything I have ever done might go."[96] He and Charis volunteered for civilian defense work and joined the Airplane Warning Service, standing watch two hours a day, three times a week, from Yankee Point, a rocky promontory within walking distance of Wildcat Hill. These duties, plus

printing for the Limited Editions Club, left little opportunity for Edward to make photographs, and the few he took were on Wildcat Hill, for Point Lobos was closed, and the use of a large view camera along the coast was frowned upon in this period of war hysteria.

Photographic activities at the Museum of Modern Art were also affected by the outbreak of war. I had planned an Edward Weston retrospective exhibition at the museum when the war intervened. I joined the U.S. Army Air Force as a photographic intelligence officer and spent twenty-eight months in the European theater. Happily, Nancy Newhall was appointed Acting Curator. In 1943 she invited Edward's participation in the exhibition. He answered, "Count on me for full cooperation. One request, or demand, I must make – give me plenty of time. I would like a year to prepare."[97] In 1944, Nancy went to Carmel and began working with him, making a preliminary selection of prints from the 3,000 neatly filed away in his cabinets. Laboriously, and not without difficulty because of occasional opposing tastes, they reduced the selection to 267. The exhibition – the largest of Edward's work held during his lifetime, opened on February 12, 1946, and was greeted with acclaim. At the close of the New York showing, it was circulated to nine art museums across the country.

Edward came to New York to see the exhibition. Unfortunately he came alone. Charis had divorced him only a few months previously.

Quite unexpectedly, Edward took up color photography at this time. In August 1946, he received a letter from George L. Waters, Jr., of the Eastman Kodak Company:

Dear Mr. Weston:

I am wondering if you would like to make an 8 x 10 Kodachrome transparency for us of Point Lobos.

We desire to use a scenic picture of the Monterey Bay area in our color advertising. Realizing how intimately you are acquainted with the moods of the sea and sky at Carmel, I would like you to use your own artistic judgment in producing a really fine color picture of Point Lobos.[98]

Edward's reply no longer exists, but apparently he did not accept the offer, claiming that he knew nothing about color photography technique. He suggested Ansel Adams for the assignment. But George Waters wrote back:

I certainly appreciate your generous attitude and suggestion that Ansel Adams might be the man to undertake the Point Lobos picture. . . . Your modesty about doing a color picture is admirable and understood. The technical knowledge required to expose the film is a fairly minor factor which you can quickly determine by practical tests. The important thing is your knowledge of Point Lobos.

Under separate cover, two dozen 8 x 10 daylight Kodachrome Films go to you via airmail.[99]

In those days, Kodachrome dye-coupling emulsion was coated on sheet film as well as on 35mm roll film. Edward at once exposed all twenty-four sheets and sent them to Kodak's Hollywood laboratory for processing. He was delighted with the results and sent thirteen on to George Waters, who selected seven for purchase at $250 each. "I decided I like color," Edward commented.

Like so many master photographers of his generation, Edward did little work in color. Among his papers in the Center for Creative Photography is an undated note: "As a creative medium, black and white photography has, at the start, an advantage over color in that it is already a step removed from a factual rendition of the scene." But with the new experience of working with Kodachrome and, later, Ektachrome film, he came to realize that color itself has form, that it can be as far removed from "a factual rendition of the scene" as black-and-white. In his article "Color as Form" in the December 1953 *Modern Photography* magazine, he pointed out that "you find a few subjects that can be expressed in either color or black-and-white. But you find more that can be said only through one of them."[100] He spoke from experience, for in his search for an understanding of color he went back to rephotograph in color some of the very subjects he had recorded successfully in black-and-white, such as the *Cypress, Point Lobos* (see Plates 93 and 118).

In 1947, Willard Van Dyke made a motion picture of Edward Weston. Among the locations that they visited was Death Valley, where Edward had made some of his finest photographs on the Guggenheim trip. He deliberately took only color film with him. Many of his transparencies duplicated his earlier black-and-white work. But the finest were of utterly different subject matter, which depended on vivid local color for their effect. It was unfortunate that Weston came to appreciate color so late in his career, for the few color photographs that now exist hold great promise. "At just the moment I began to get somewhere, I had unfortunately, for several reasons, to quit. I feel I only scratched the surface. But those who say that color will eventually replace black-and-white are talking nonsense. The two do not compete with each other. They are different means to different ends."[101]

The principal reason that Edward "had to quit" was his state of health. He was suffering from Parkinson's disease, a chronic nervous disorder that affects a person's control of the muscles. With the unrelenting advance of the disease it became increasingly difficult for him to photograph. When he could no longer carry a view camera, his sons would help him. In spite of this physical handicap, Edward made some of his finest photographs of Point Lobos.

In the final years of his life he initiated a unique and quite extraordinary project: the printing of 1,000 negatives that he considered the best of his entire life's production. Since he could not make the prints himself, he entrusted that work to his son Brett. A friend, who chose to remain anonymous, put up a fund of $6,000 to cover production costs.

"When [the] project is done," Edward wrote Nancy on January 19, 1953, "there will, or should be, 5 or 6 prints each from 1000 negatives. I can already hear the cries of 'too many,' 'it can't be done,' and perhaps with some justification. But mass production in seeing has been part of my way of life. I shall wind up fulfilling that part of my way. I do regret that 'Parkinson's' prevents me from doing all the work or at least the printing myself. But Brett is doing a wonderful job. I am fortunate in having him."[102] He was indeed fortunate, for the official negative log records the printing of eight sets of 838 negatives – a total of 6,704 prints!

Edward Weston died quietly on New Year's Day, 1958. His four sons scattered his ashes on the Pacific from his favorite beach at Point Lobos. "I never tire of that wonder spot," Edward wrote in 1930, "nor could I ever forget it, no matter where I go from here."[103]

NOTES

Abbreviations

BN Beaumont Newhall

CCP Center for Creative Photography, University of Arizona

DBI *The Daybooks of Edward Weston, Vol I: Mexico*, ed. Nancy Newhall (Millerton, N.Y.: Aperture, 1973).

DBII *The Daybooks of Edward Weston, Vol. II: California*, ed. Nancy Newhall (Millerton, N.Y.: Aperture, 1973).

EW Edward Weston

EWP *Edward Weston on Photography,* ed. Peter C. Bunnell (Salt Lake City: Peregrine Smith, 1983).

MOMA The Museum of Modern Art, New York

NN Nancy Newhall

Epigraph. EW, "Random Notes on Photography." Manuscript of a lecture by EW to the Southern California Camera Club, Los Angeles, June 1922, p. 2. CCP.

I

1. Edward Burbank Weston to EW, August 18, 1902. CCP.
2. EW to Edward Burbank Weston, August 20, 1902. CCP.
3. Undated manuscript page from pre-1923 daybook. CCP. Reprinted, DBI, p. 3.
4. J. C. Thomas, "A David Grayson Kind of Man," *American Magazine* 80 (August 1915), pp. 55–56.
5. EW, "Shall I Turn Professional?" *American Photography* 6 (November 1912), pp. 620–624.
6. EW, "Unconventional Portraiture," *Photo-Miniature*, No. 165 (September 1917), pp. 254–256.
7. Ibid.
8. Alfred Stieglitz, "The Photo-Secession," *The Bausch & Lomb Lens Souvenir* (Rochester, N.Y.: Bausch & Lomb Optical Co., 1903), unpaged.
9. EW, "A One-Man Studio," *American Photography* 7 (March 1913), pp. 130–134.
10. NN, unpublished notes on EW. Newhall Collection.
11. Imogen Cunningham to EW, July 27, 1920. CCP.
12. John A. Tennant in *Photo-Miniature*, No. 188 (1921), pp. 138–139.
13. Paul Rosenfeld, "Stieglitz," *The Dial* 70 (April 1921), pp. 397–409.
14. EW, "Random Notes on Photography." Manuscript of a lecture by EW to the Southern California Camera Club, Los Angeles, June 1922, p. 1. CCP.
15. Ibid., p. 5.
16. Ibid., pp. 6–7.
17. EW to Alfred Stieglitz, November 1922. Beinecke Library, Yale University.
18. EW to Johan Hagemeyer. November 1922. CCP.

II

19. DBI, p. xviii.
20. DBI, p. 14.
21. DBI, p. 23.
22. EW, "Random Notes on Photography," p. 6.
23. DBI, p. 25.
24. DBI, p. 26.
25. Ibid.
26. DBI, pp. 46–47.
27. DBI, p. 47.
28. DBI, p. 49.
29. DBI, p. 95.
30. DBI, p. 96.
31. DBI, p. 94.
32. DBI, p. 55.
33. Ibid.

34. DBI, p. 91.

35. DBI, p. 114.

36. DBI, p. 129.

37. DBI, p. 134.

38. DBI, pp. 134–135.

39. DBI, p. 136.

40. Ibid.

41. DBI, p. 55.

42. DBI, p. 136.

43. DBI, p. 150.

III

44. EW to Miriam Lerner, May 22, 1926. Bancroft Library, University of California, Berkeley.

45. Ibid.

46. EW to Miriam Lerner, August 19, 1926. Bancroft Library, University of California, Berkeley.

47. DBI, p. 202.

48. DBII, p. 247.

49. DBII, p. 12.

50. DBII, p. 31.

51. Ibid.

52. Tina Modotti to EW, June 26, 1927. CCP.

53. DBII, p. 32.

54. DBII, p. 10.

55. DBII, p. 131.

56. DBII, p. 181.

57. DBII, p. 182.

58. DBII, p. 175.

59. DBI, p. 91.

60. Nancy Newhall, *Ansel Adams, the Eloquent Light* (Millerton, N.Y.: Aperture, 1980), p. 68.

61. Ansel Adams, "Photography," *The Fortnightly* 1 (December 18, 1931), pp. 21–22.

62. EW to Ansel Adams, January 28, 1932. CCP.

63. Ibid.

64. DBII, p. 57.

65. DBII, p. 58.

66. DBII, p. 111.

67. Ibid.

68. Ibid.

69. DBII, p. 114.

70. As quoted by EW in his letter to BN of January 1, 1944. MOMA.

71. DBII, p. 226.

72. Ibid.

73. DBII, p. 192.

74. Wall label, EW exhibition in Museum of Fine Arts, Houston, 1930. Quoted in EWP, p. 61.

IV

75. DBII, p. 136.

76. DBII, p. 265.

77. DBII, p. 248.

78. DBII, p. 242.

79. DBII, pp. 265–266.

80. DBII, pp. 149, 155.

81. DBII, pp. 279–280.

82. DBI, p. 89.

83. Charis Wilson, *Edward Weston: Nudes* (Millerton, N.Y.: Aperture 1977), p. 13.

84. "Plan for Work," a draft of EW's application for a John Simon Guggenheim Memorial Foundation Fellowship, 1936. CCP.

85. *U.S. Camera Annual 1940*, p. 37.

86. EW, "My Photographs of California," *Magazine of Art* 32 (January 1939), pp. 30–32.

V

87. *The Museum of Modern Art, New York: The History and the Collection* (New York: Harry N. Abrams, 1984), pp. 18–19.

88. EW to BN, March 1, 1938. MOMA.

89. NN manuscript notes on EW. Newhall Collection.

90. EW, "Statement, 1930," *Experimental Cinema* 1 (February 1931), pp. 13–15.

91. Ben Maddow, *Edward Weston: His Life and Photographs* (Millerton, N.Y.: Aperture, 1979), p. 255.

92. EW to BN and NN, April 14, 1941. MOMA.

93. EW to BN and NN, April 28, 1941. MOMA.

94. EW to BN, December 15, 1941. MOMA.

95. EW to NN, February 9, 1942. MOMA.

96. EW to BN and NN, June 5, 1942. MOMA.

97. EW to NN, April 8, 1943. MOMA.

98. George L. Waters, Jr., to EW, August 16, 1946. CCP.

99. Ibid., August 26, 1946, CCP.

100. EW, "Color as Form," *Modern Photography* 17 (December 1953), pp. 54–59.

101. Ibid.

102. EW to NN, January 19, 1953. MOMA.

103. DBII, p. 157.

PORTFOLIO

Unless otherwise noted, the photographs are gelatin-silver prints.

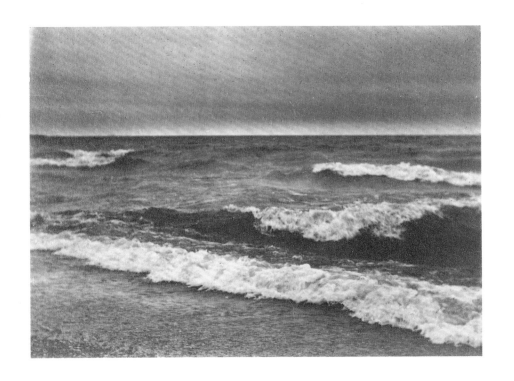

PLATE I
Lake Michigan, Chicago, 1904, platinum

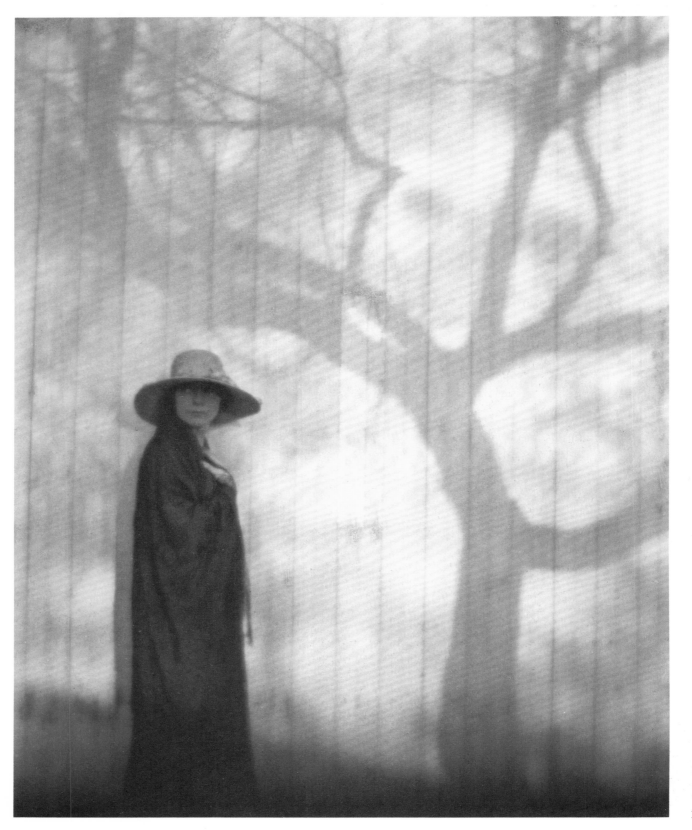

PLATE 2
Prologue to a Sad Spring,
1920, platinum

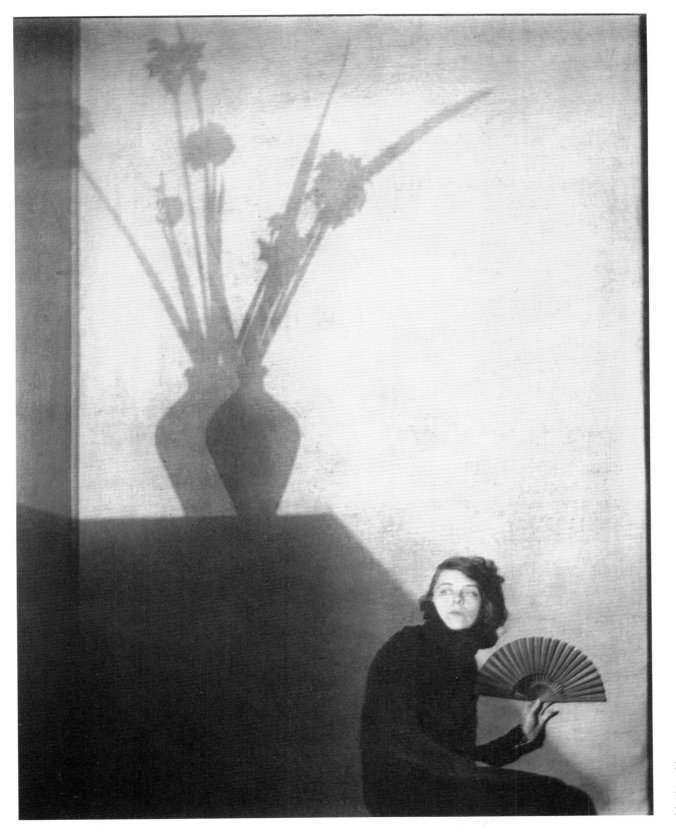

PLATE 3
Epilogue,
1919, platinum

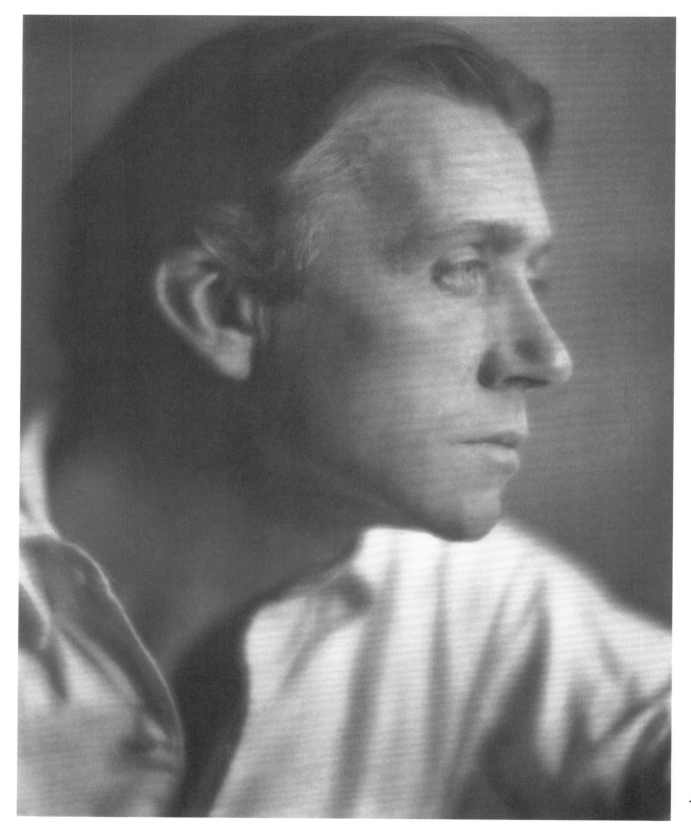

PLATE 4
Johan Hagemeyer,
1921, platinum

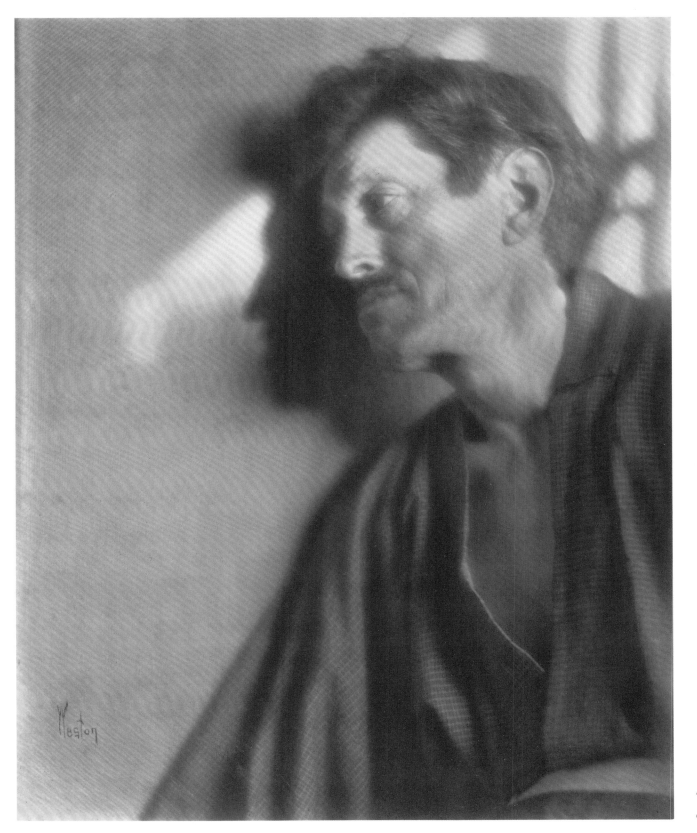

PLATE 5
Sadakichi Hartmann,
ca. 1920, platinum

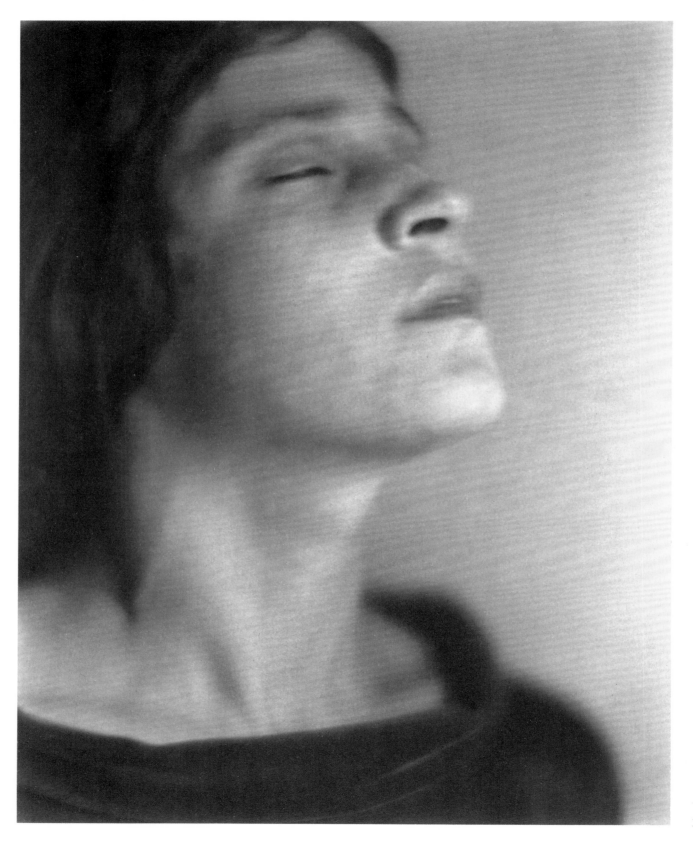

PLATE 6

Head of an Italian Girl,
1921, platinum

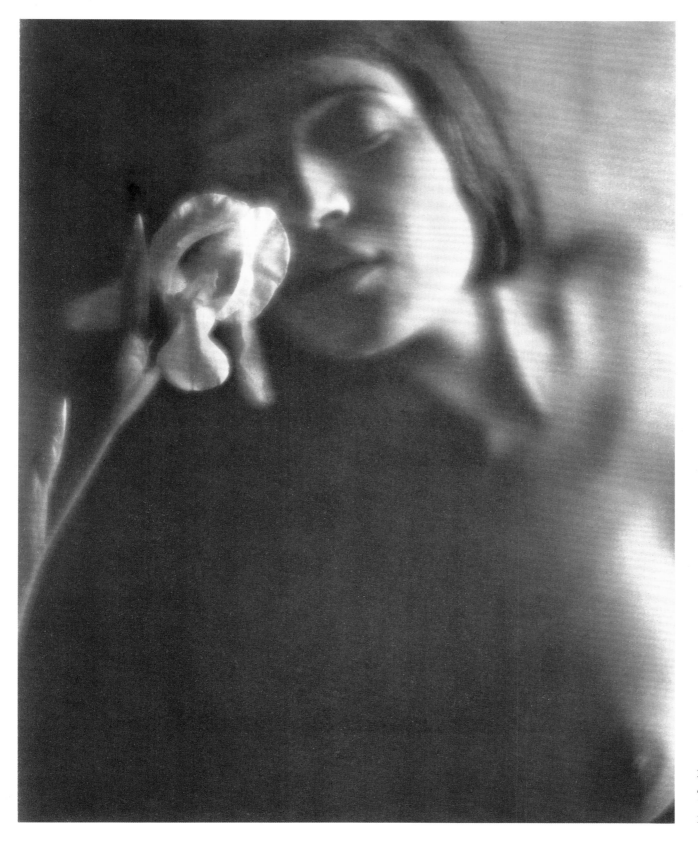

PLATE 7
The White Iris,
1921, platinum

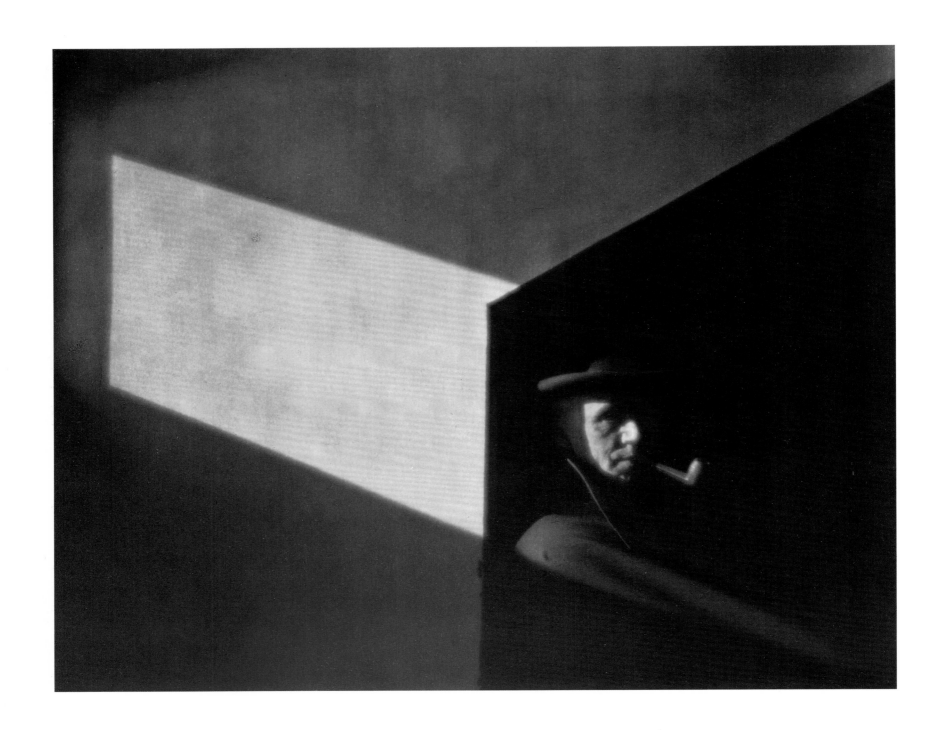

PLATE 8
Sunny Corner in an Attic, 1921, platinum

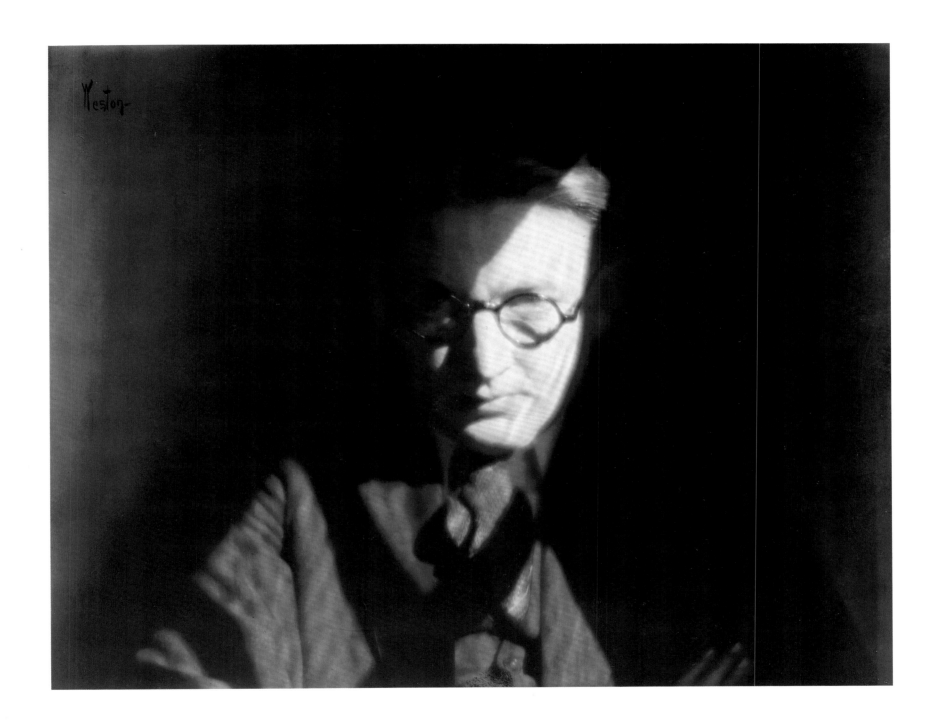

PLATE 9
Triangulation: George Hopkins, 1919

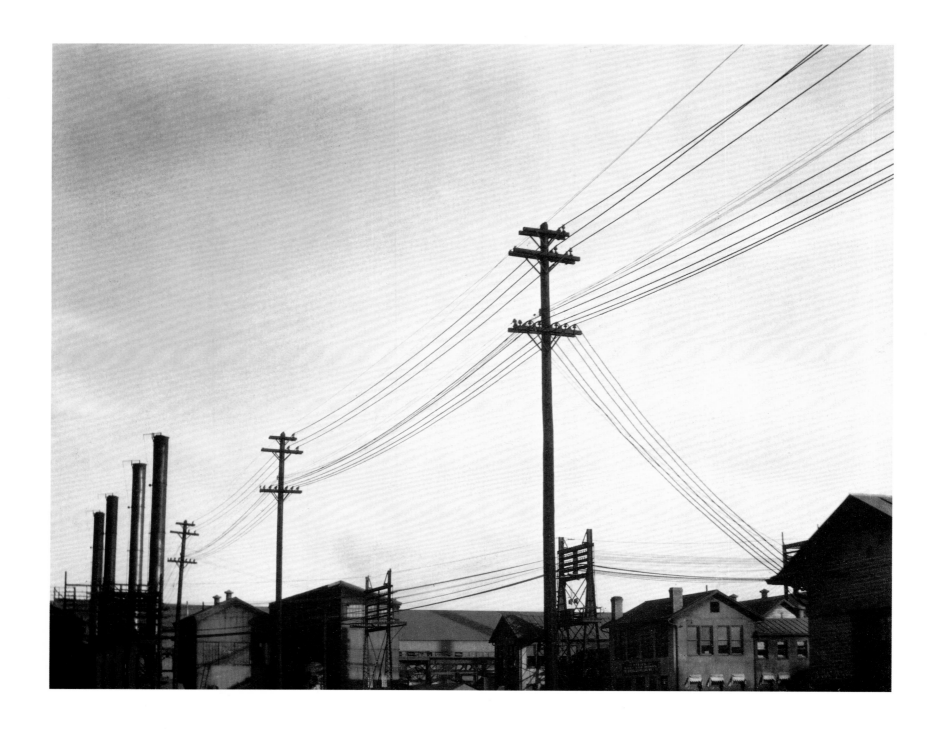

PLATE 10
Telephone Lines (Armco Steel), 1922, platinum

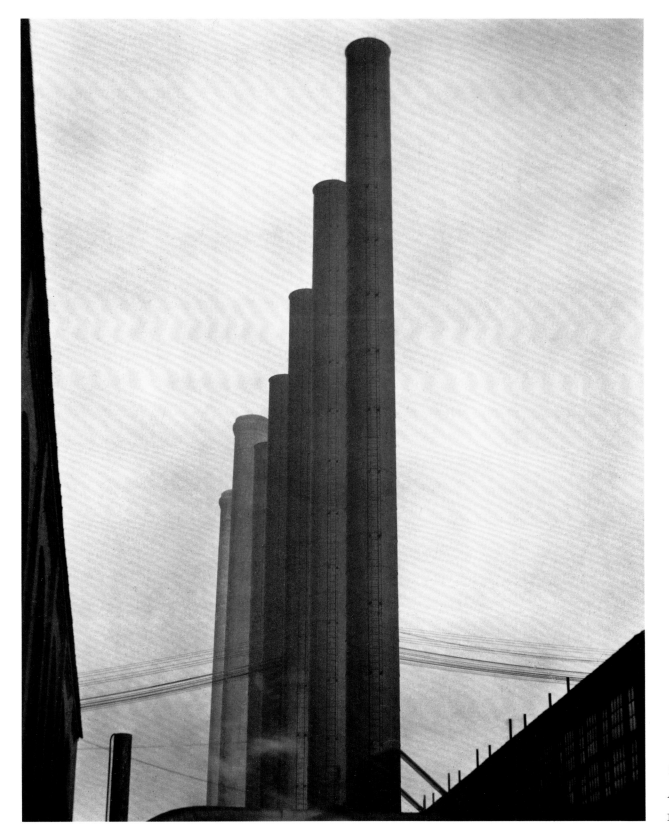

PLATE II
Armco Steel, Ohio,
1922, platinum

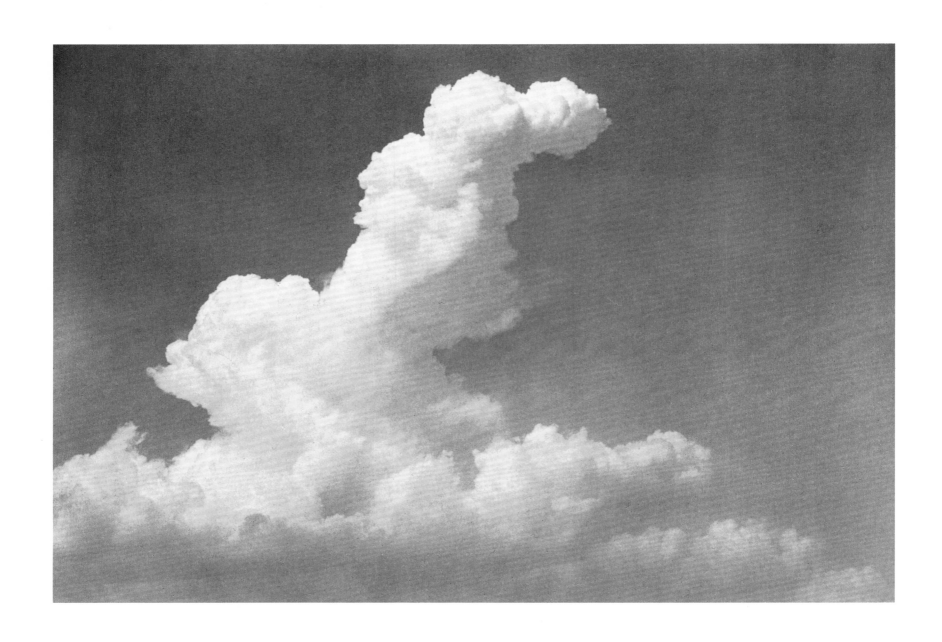

PLATE 12

Cloud Study, Mexico, 1924, platinum

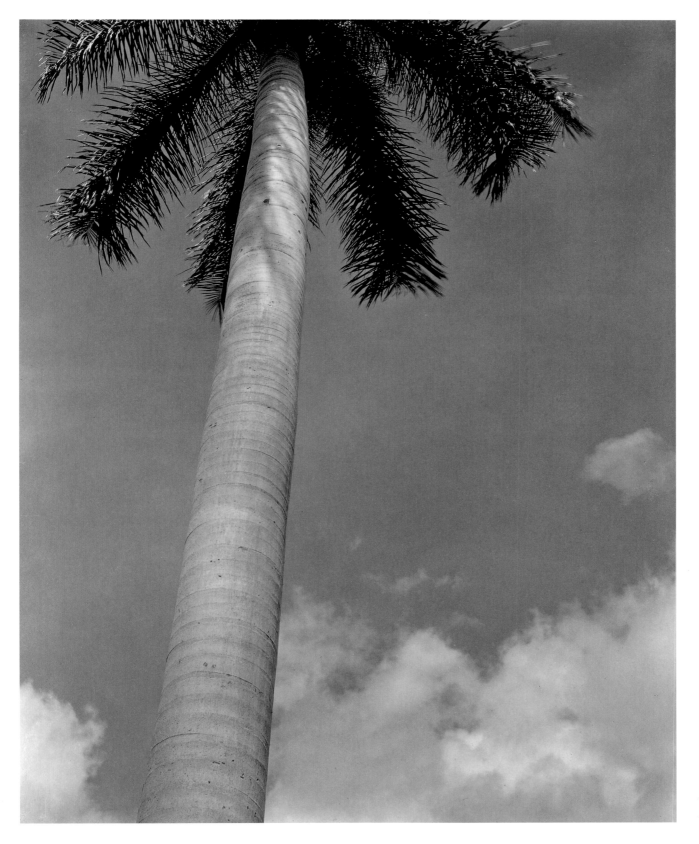

PLATE 14
Tina Modotti, ca. 1924

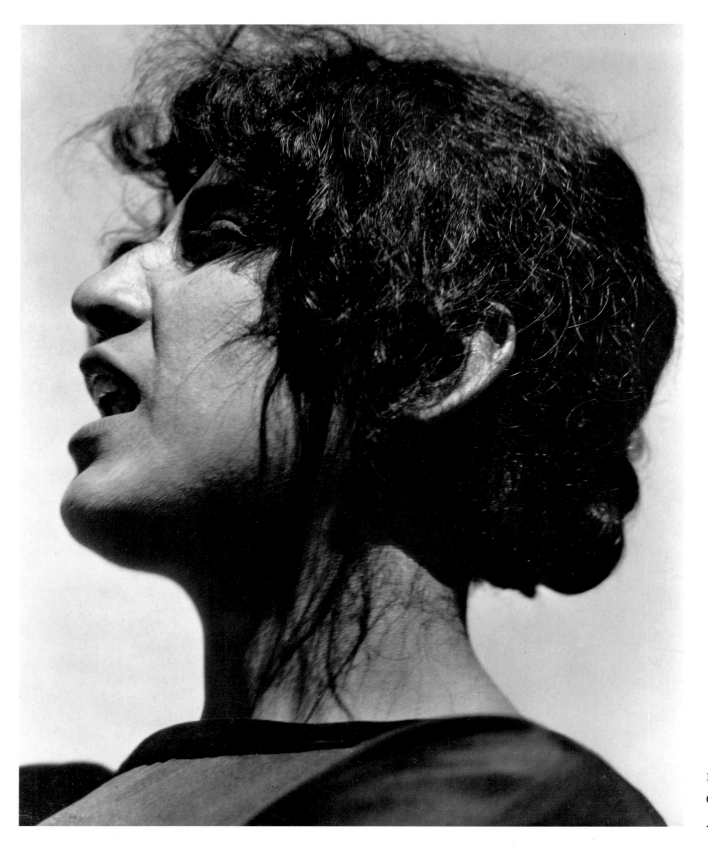

PLATE 15

*Guadalupe Marín de Rivera,
Mexico,* 1924

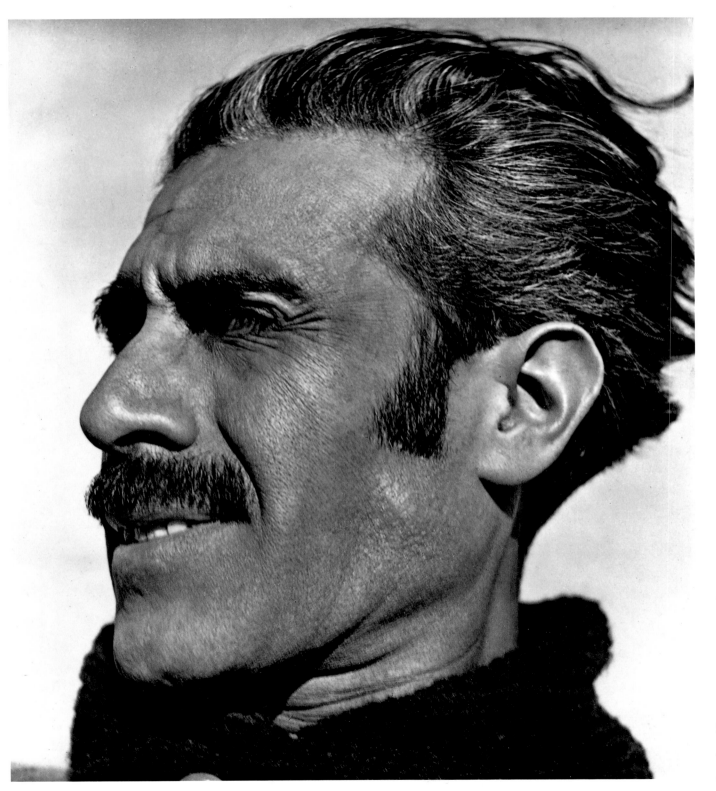

PLATE 16
Manuel Hernández Galván,
Mexico, 1924

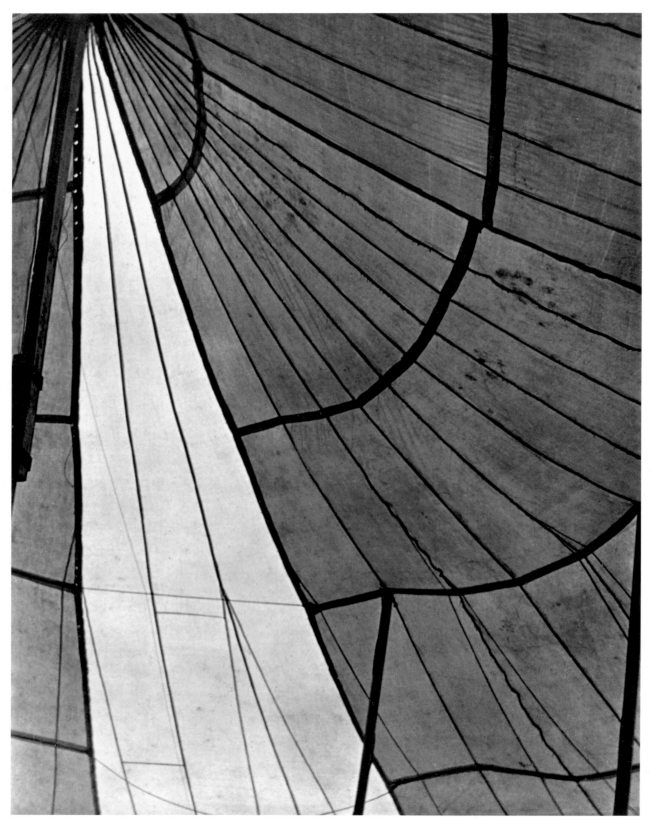

PLATE 17
Circus Tent, 1924

PLATE 18

Aqueduct, Los Remedios, 1924

PLATE 19

Desde la Azotea with Trees, 1924

PLATE 20

Casa de Vecindad, D.F., 1926

PLATE 21
Pulquería, Mexico City,
1926

PLATE 22

Pulquería, Mexico, 1926

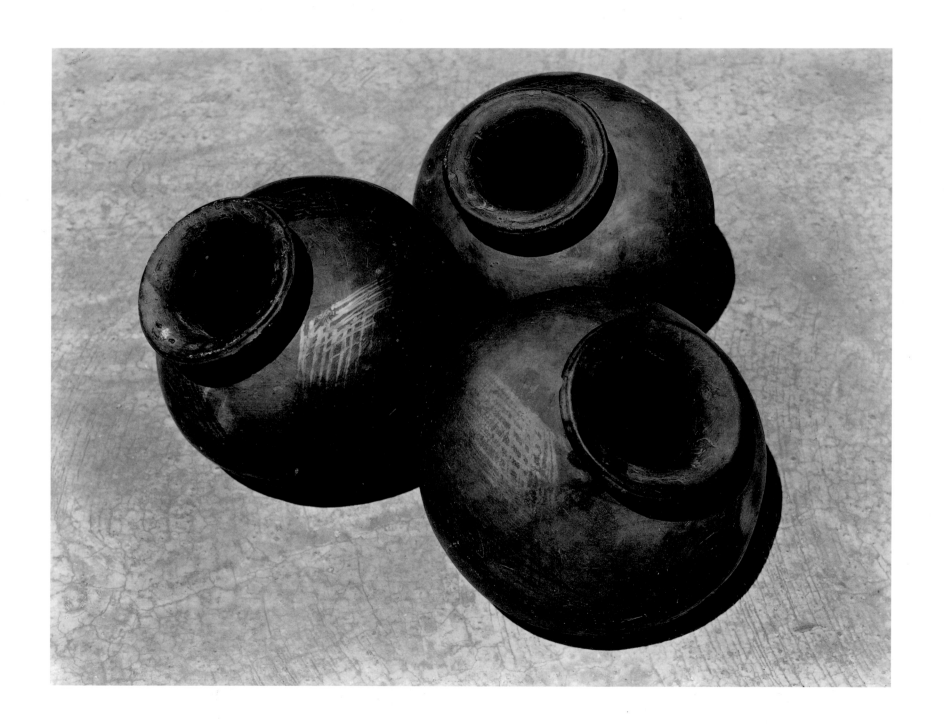

PLATE 23

Jarros de Oaxaca, 1926

PLATE 24
Arcos, Oaxaca,
1926, platinum

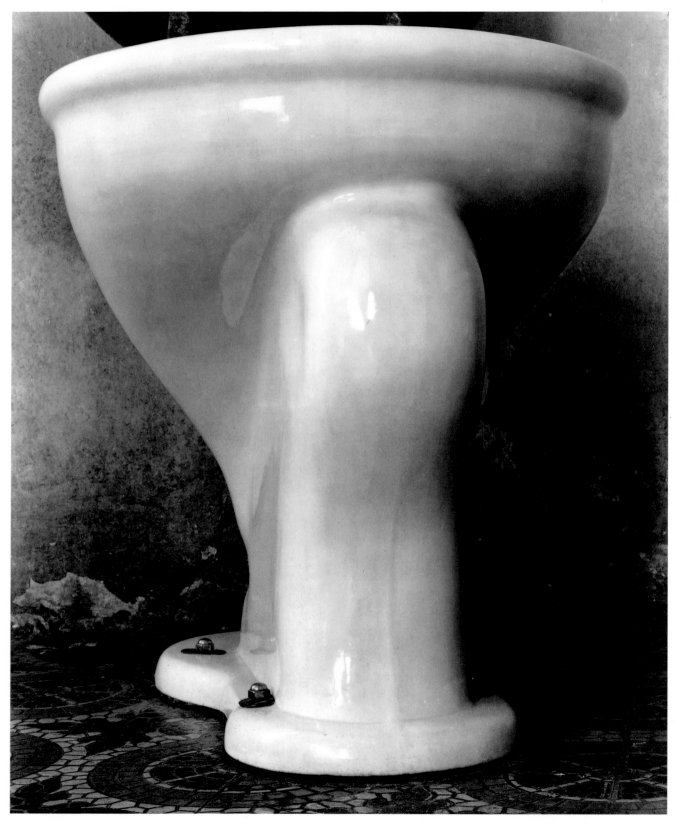

PLATE 25
Excusado, Mexico, 1925

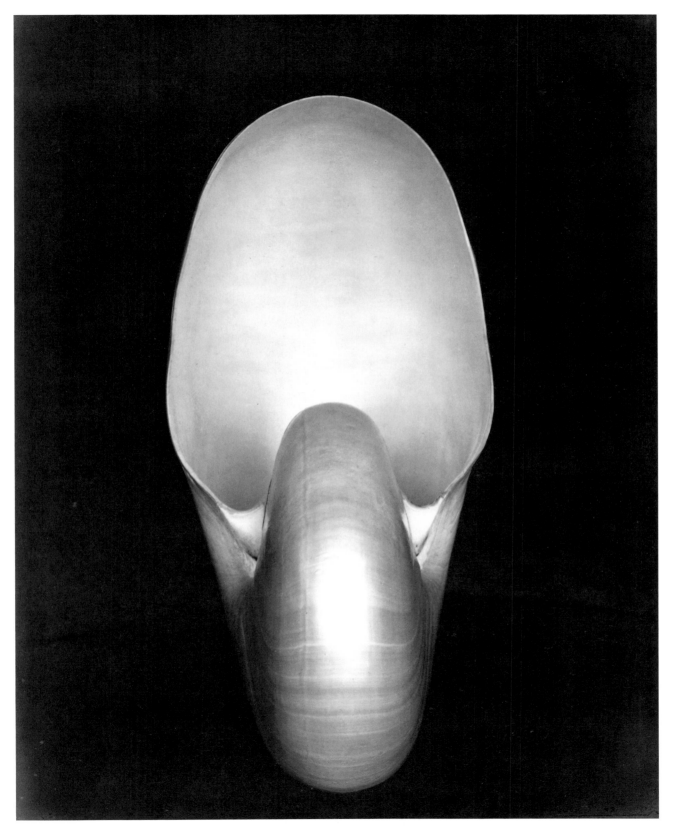

PLATE 26

Shell, 1927

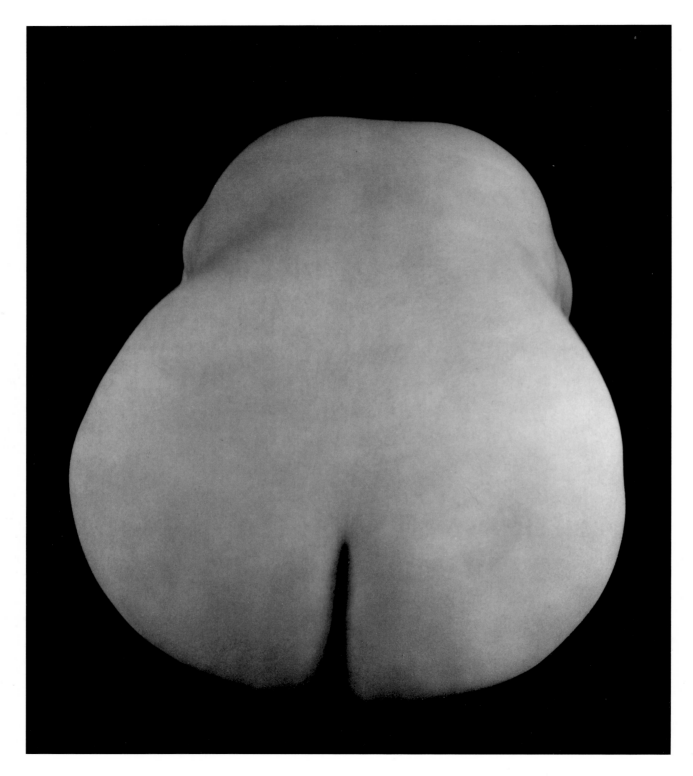

PLATE 27
Nude, 1925

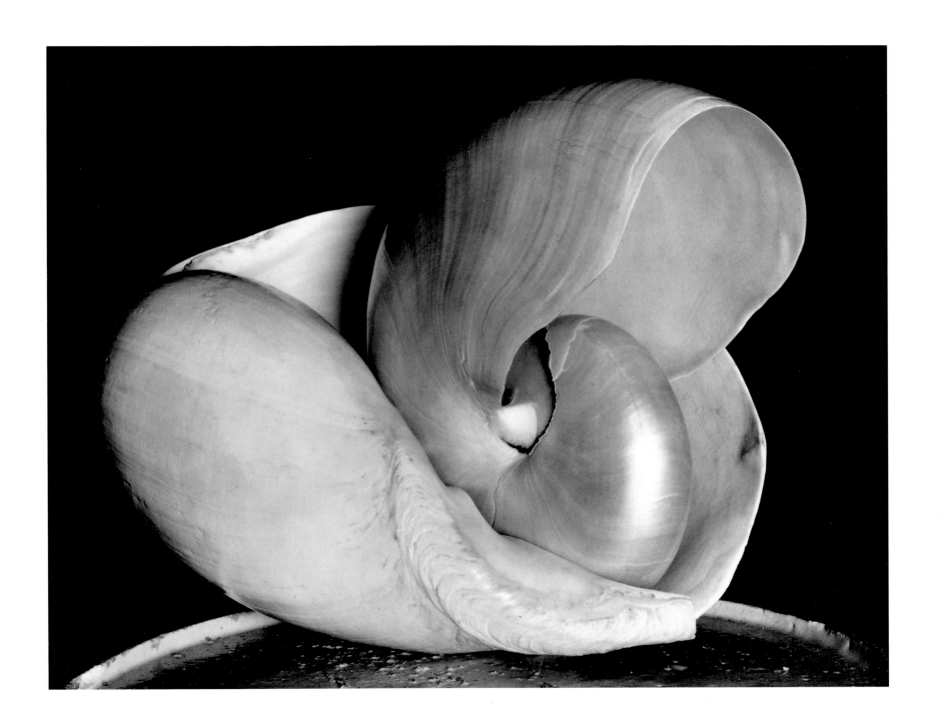

PLATE 28

Shells, 1927

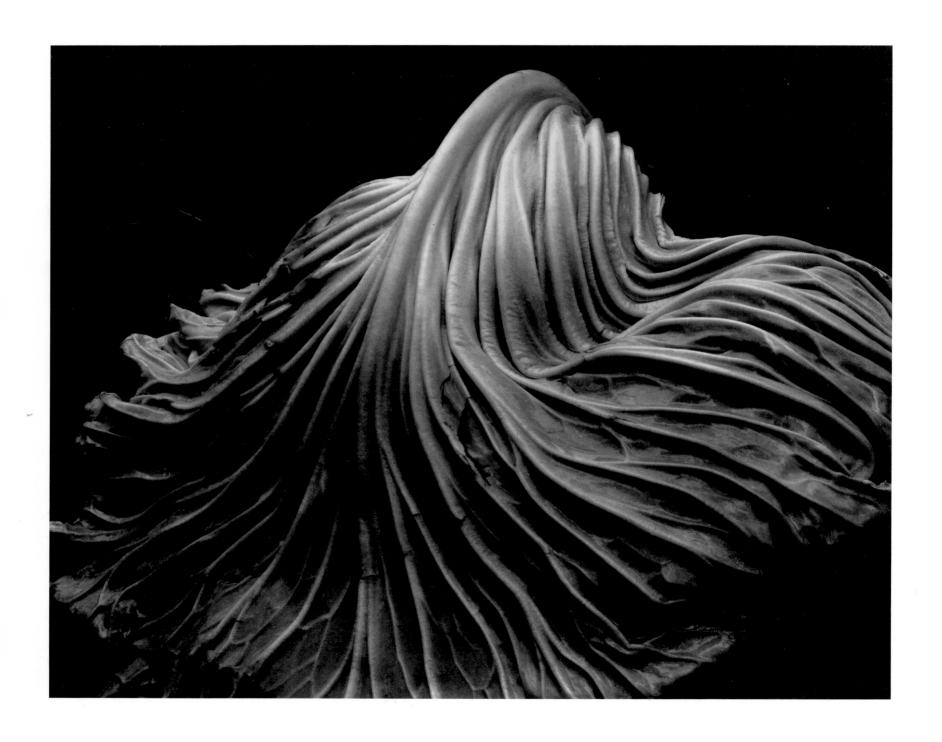

PLATE 29

Cabbage Leaf, 1931

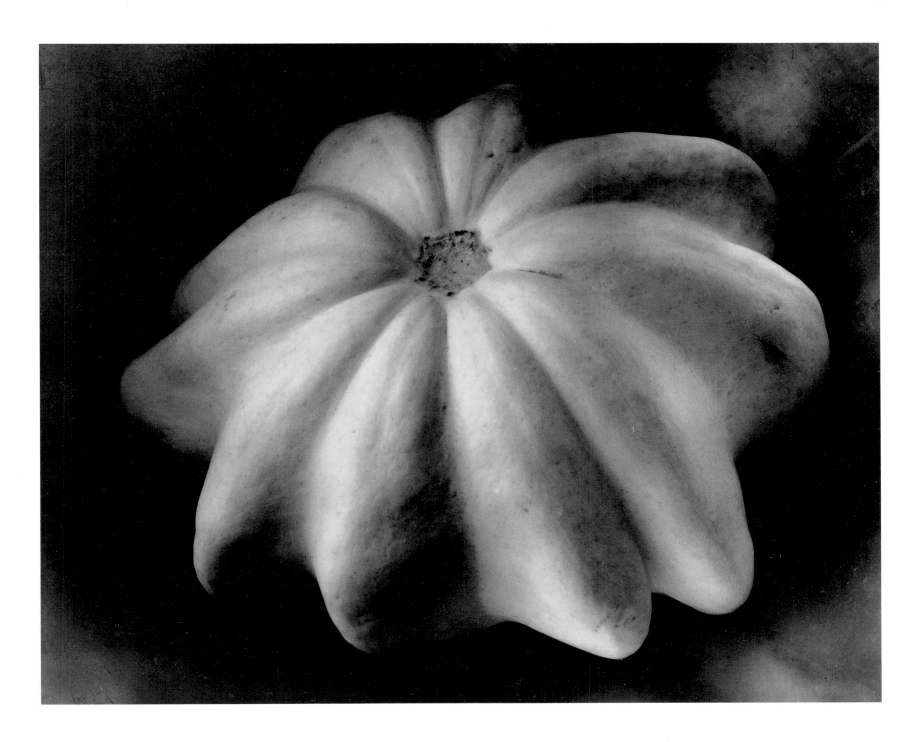

PLATE 30
Winter Squash, 1930

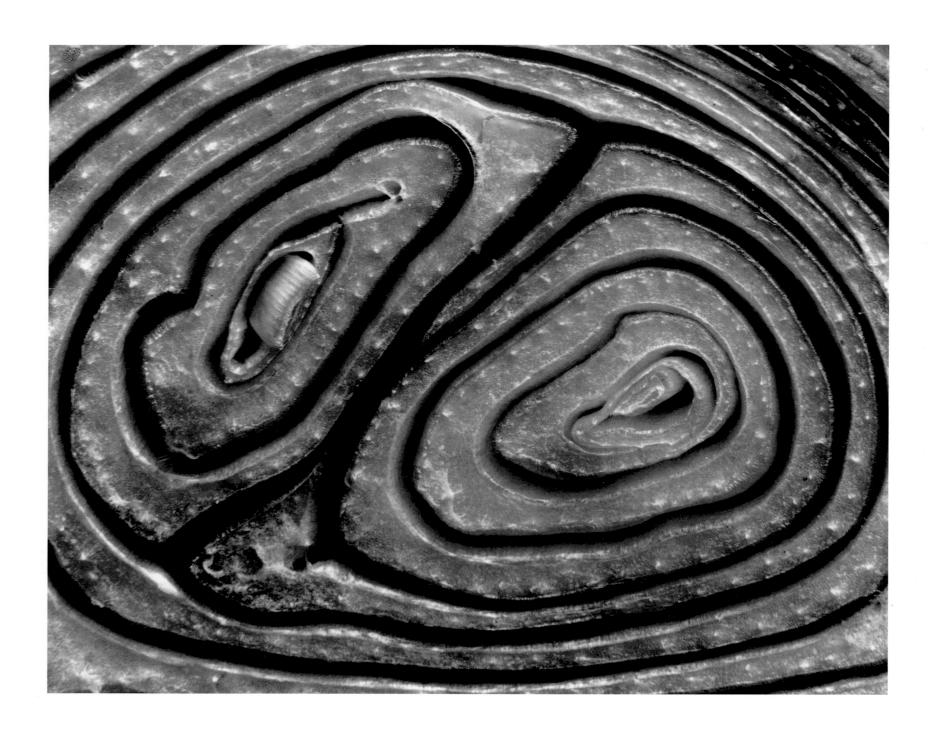

PLATE 31

Onion, 1930

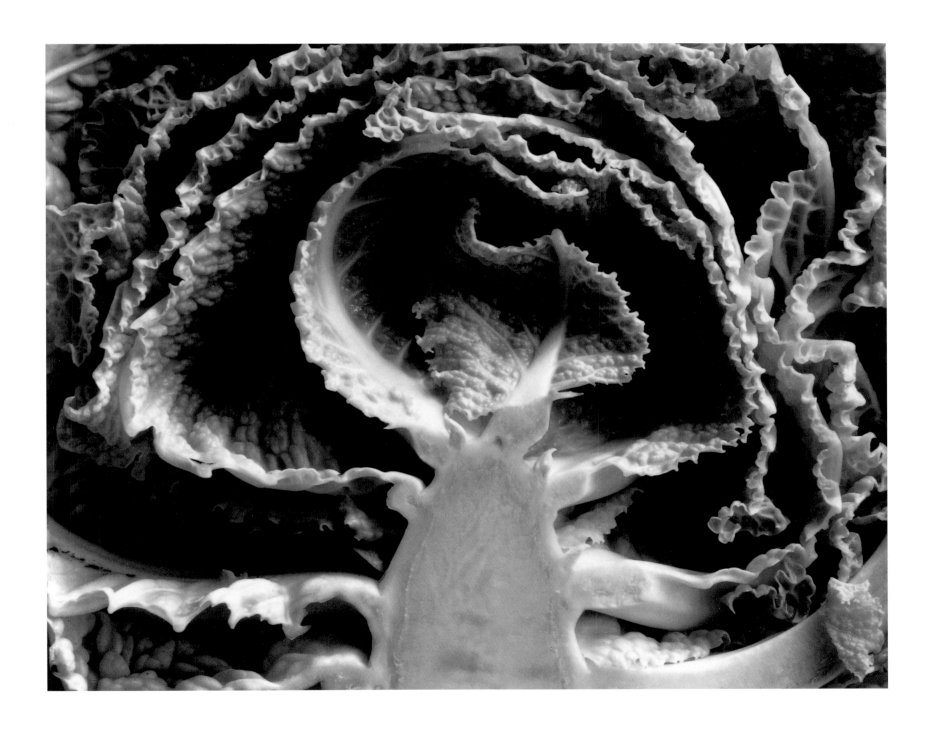

PLATE 32
Kale Halved, 1930

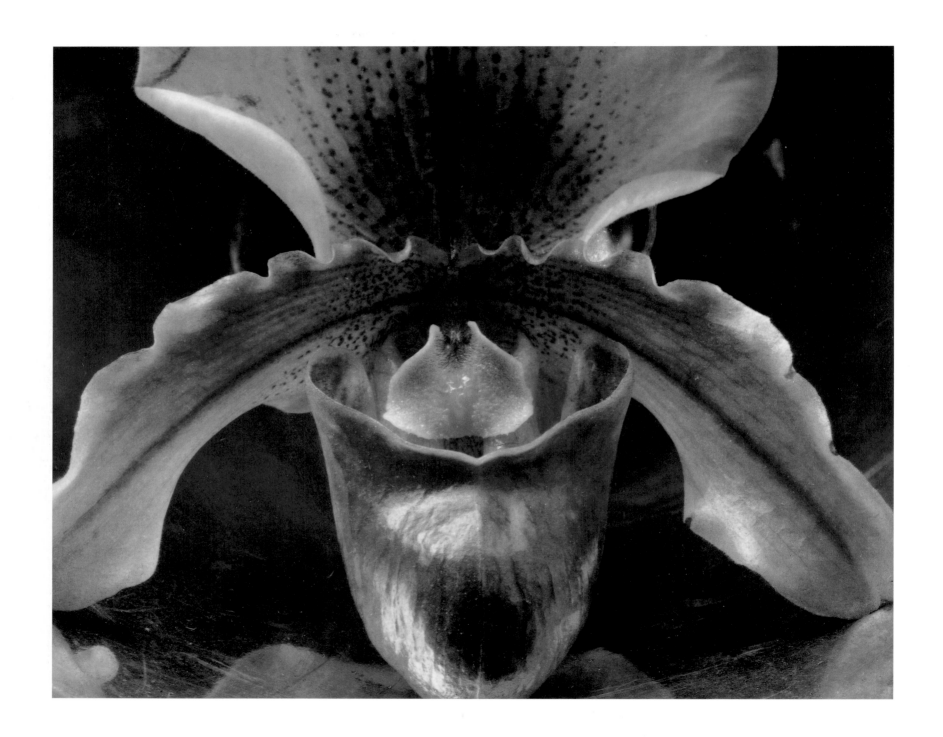

PLATE 33

Orchid, 1931

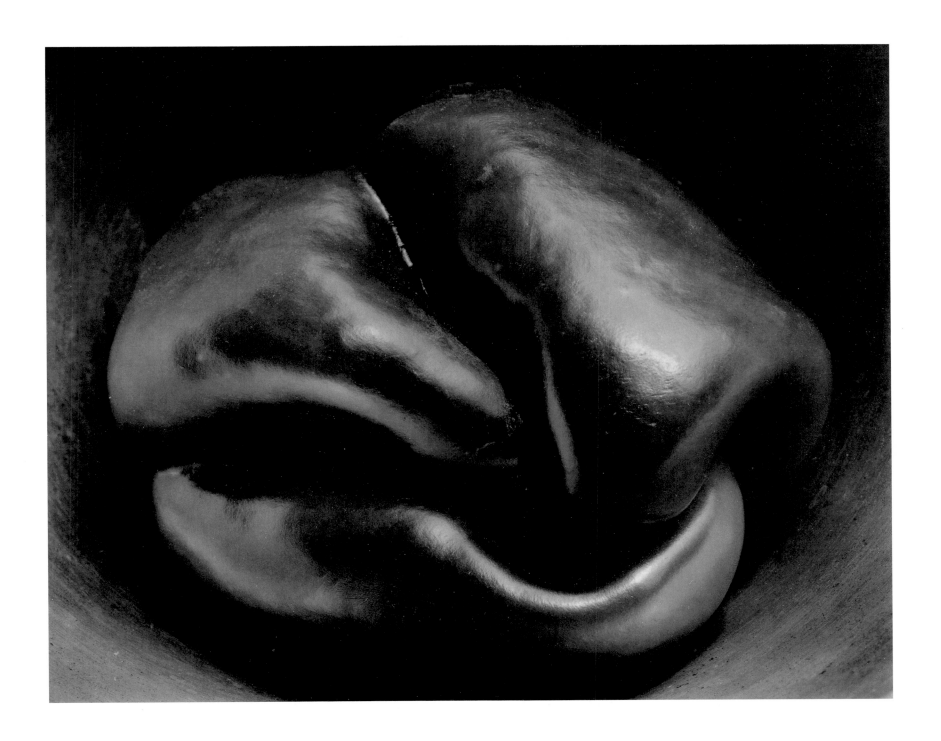

PLATE 34

Pepper, 1930

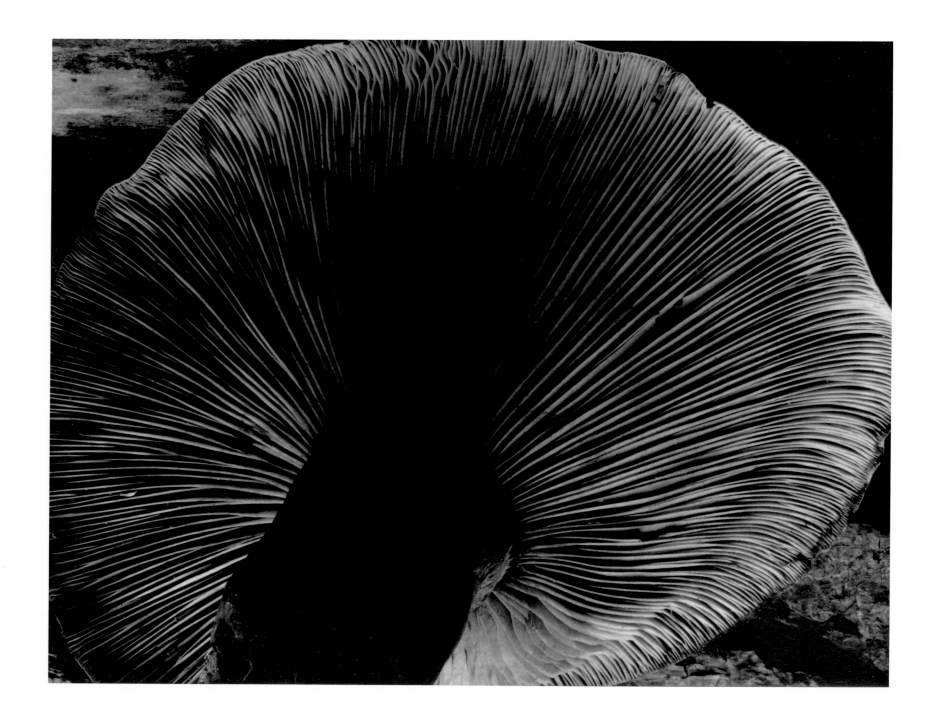

PLATE 35
Toadstool, 1931

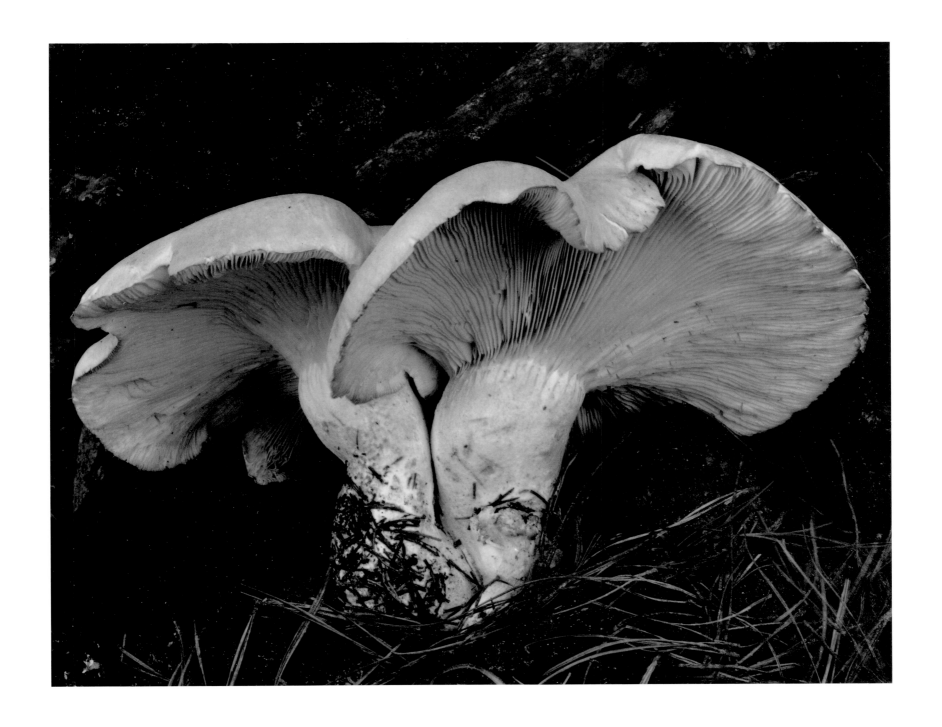

PLATE 36
Toadstool, 1932

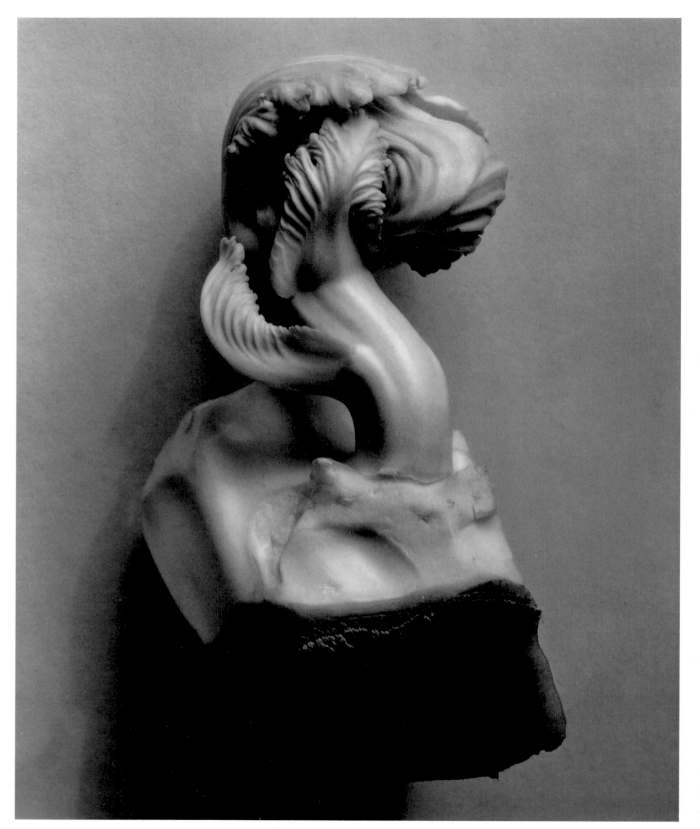

PLATE 37
Cabbage Fragment,
1931

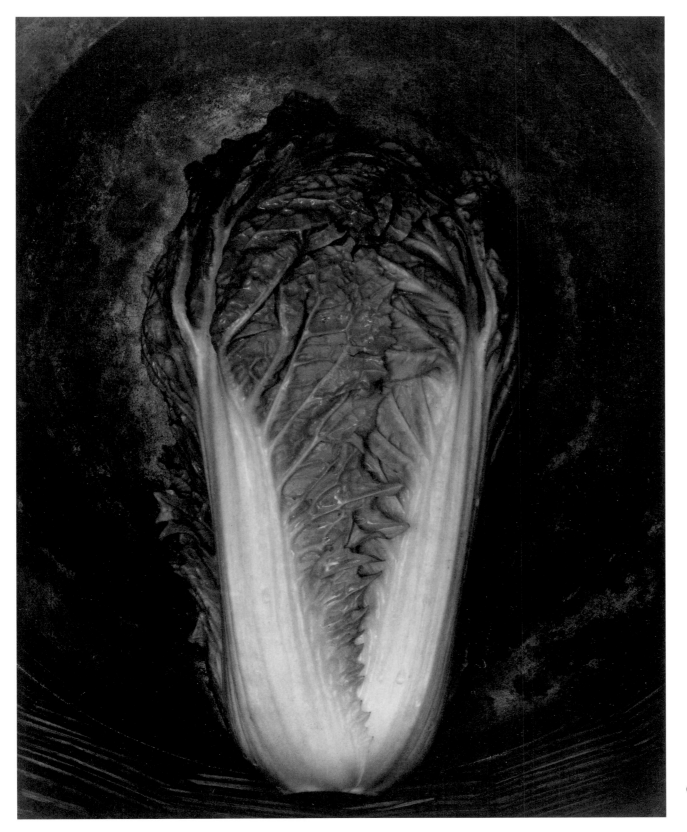

PLATE 38
Cabbage and Basket,
1928

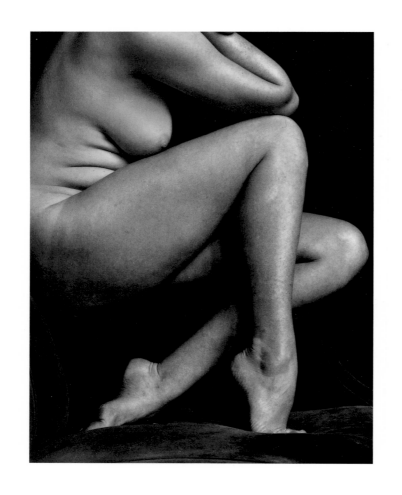

PLATE 39

Nude, 1933

PLATE 40

Nude, 1933

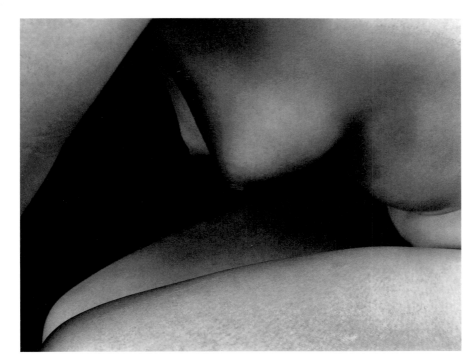

PLATE 41
Nude, 1934

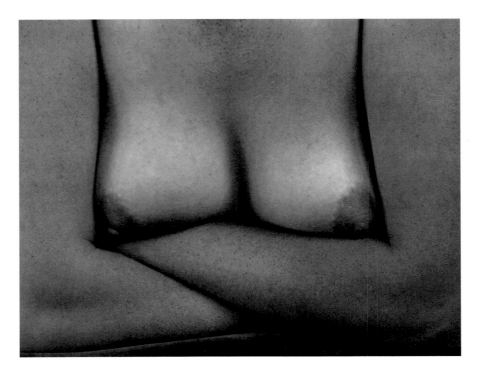

PLATE 42
Nude, 1934

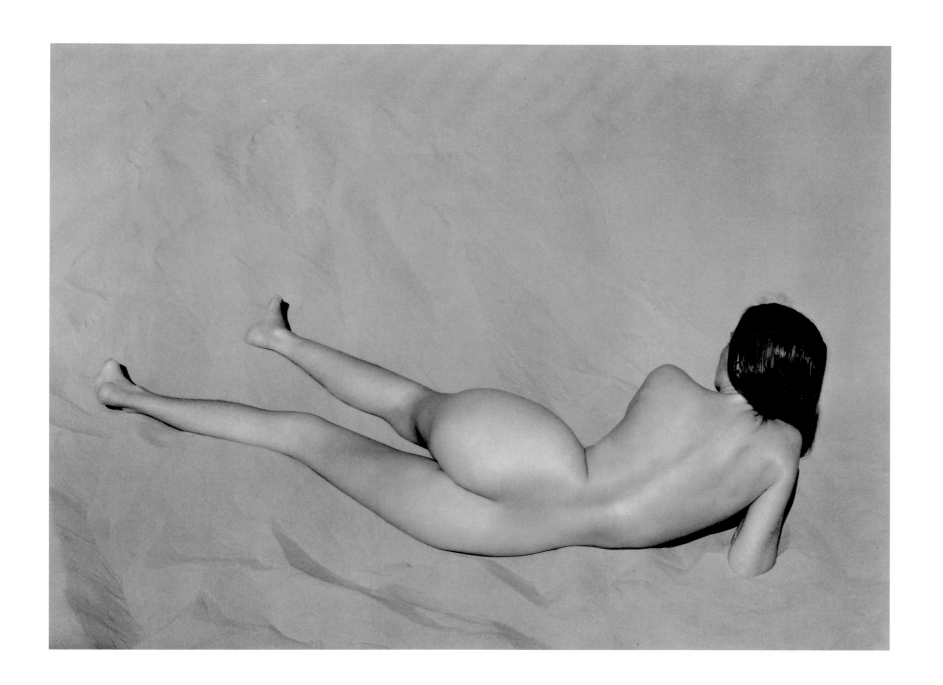

PLATE 43
Nude, 1936

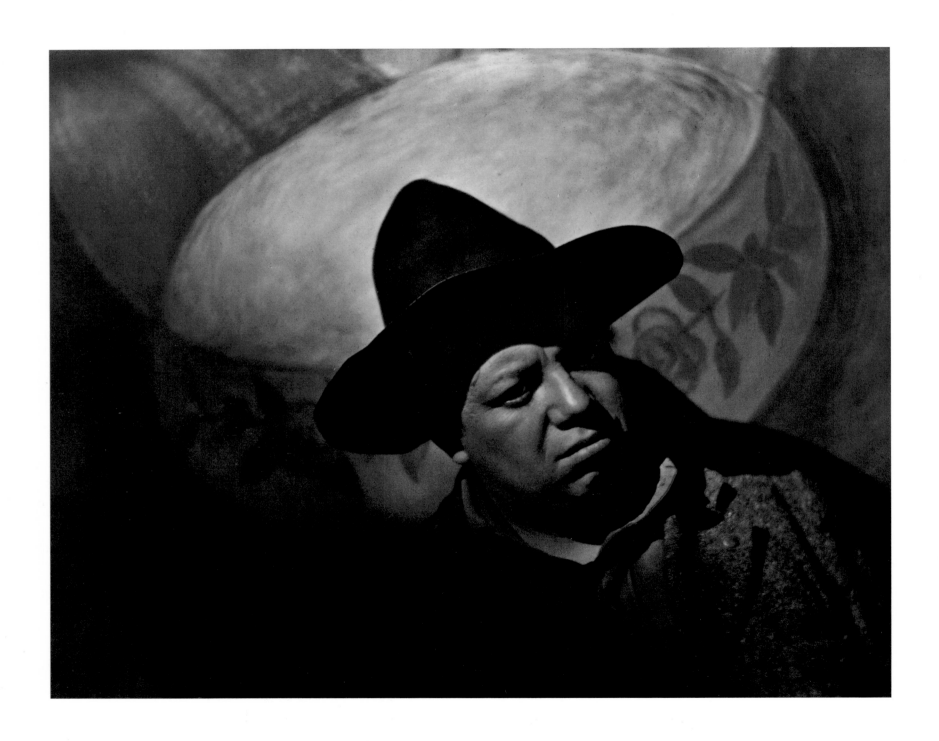

PLATE 44
Diego Rivera, Mexico, 1924

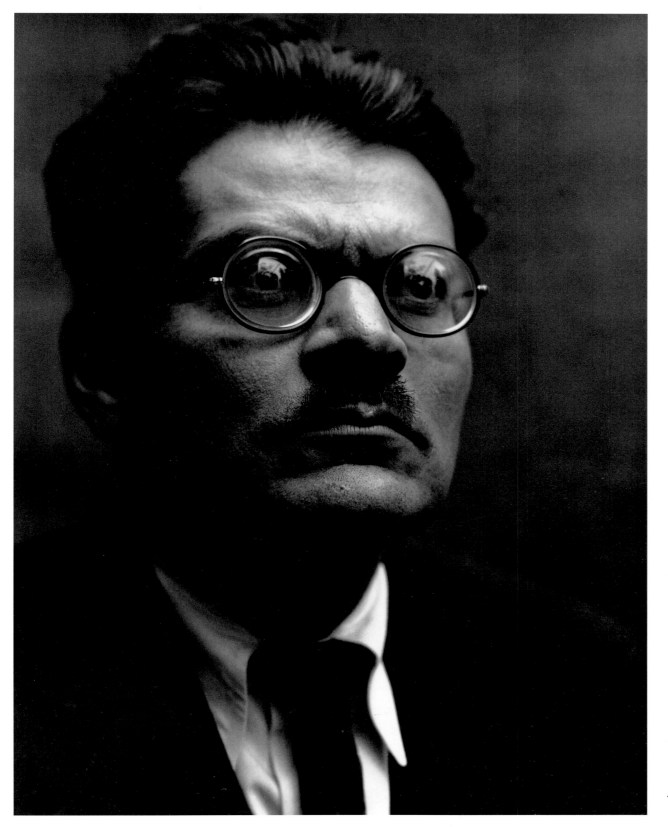

PLATE 45
José Clemente Orozco,
1930

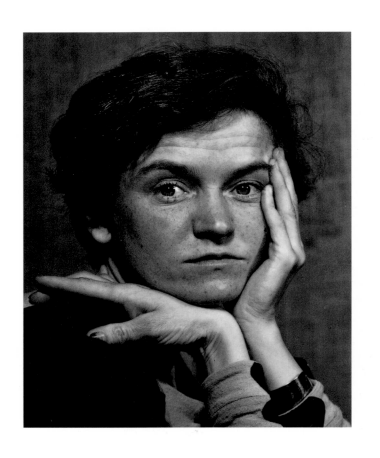

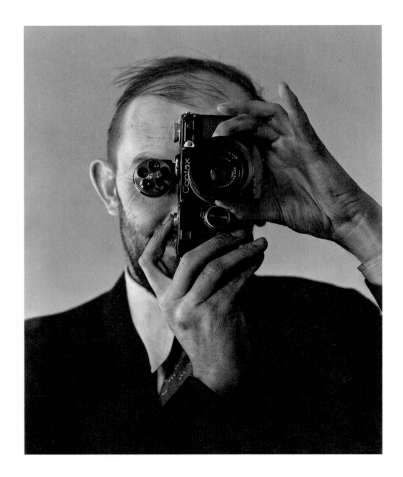

PLATE 46

Sonya, 1934

PLATE 47

Ansel Adams (After He Got a Contax Camera), 1936

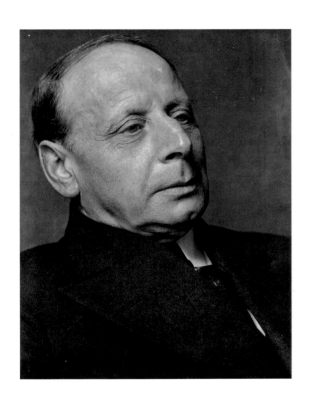

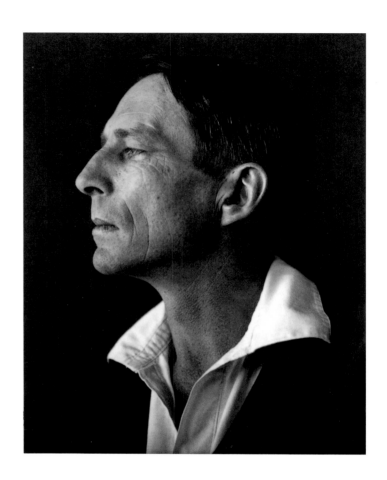

PLATE 48

Albert Bender, 1928

PLATE 49

Robinson Jeffers, 1933

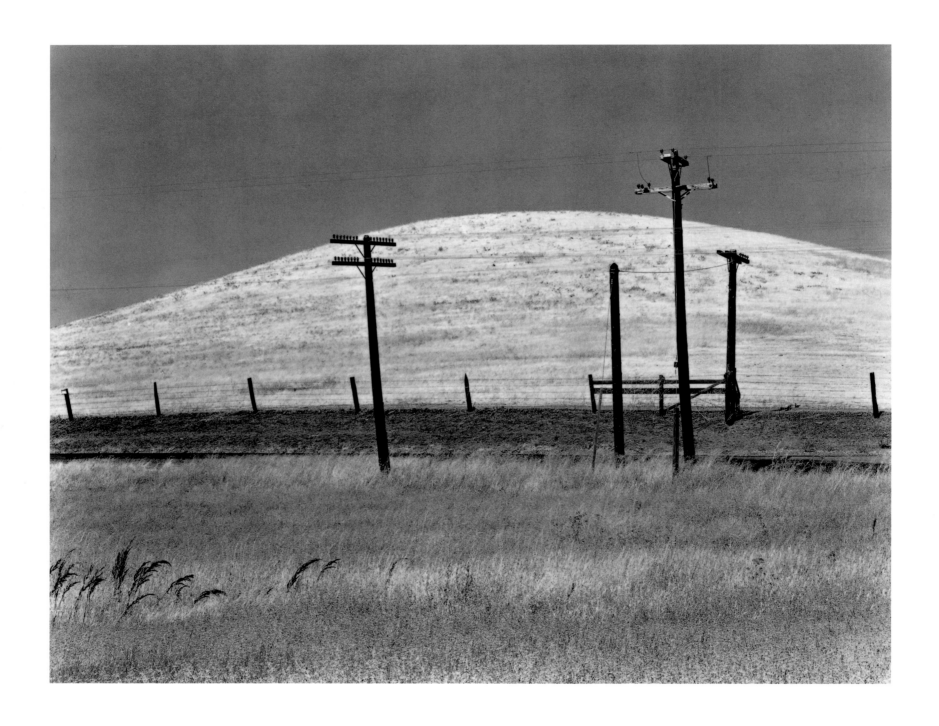

PLATE 50

Hill and Telephone Poles, 1937

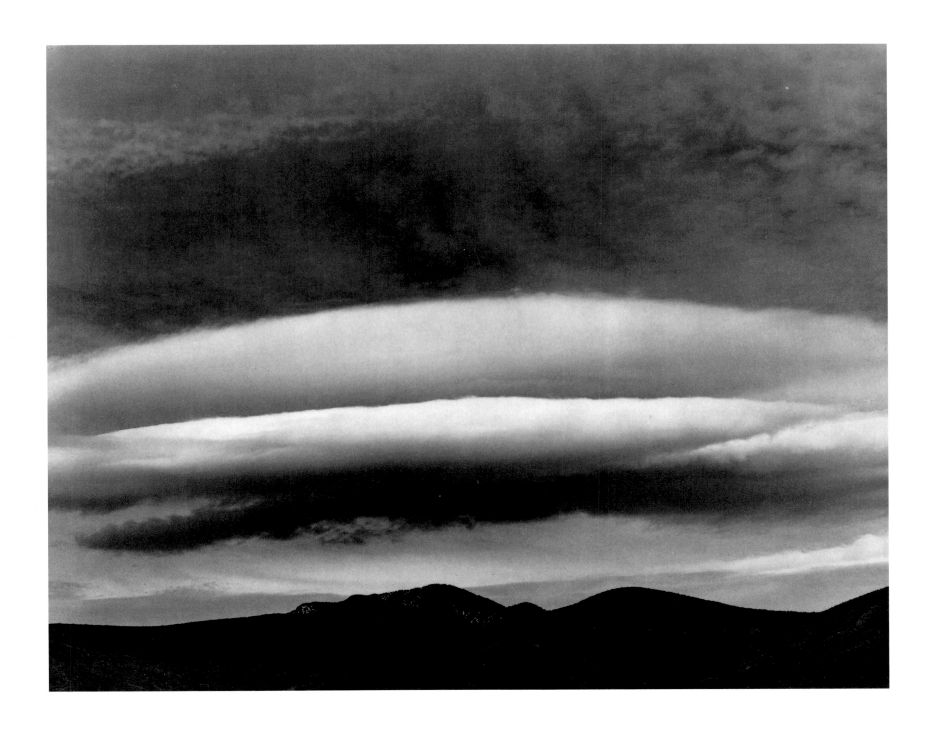

PLATE 51

Cloud, the Panamints, 1937

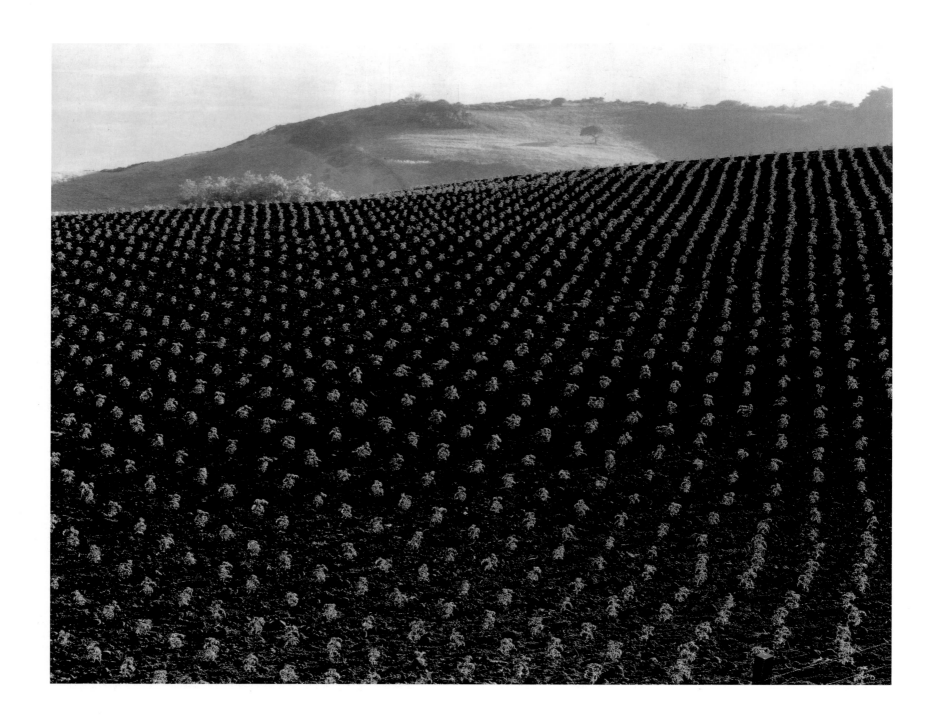

PLATE 52

Tomato Field, 1937

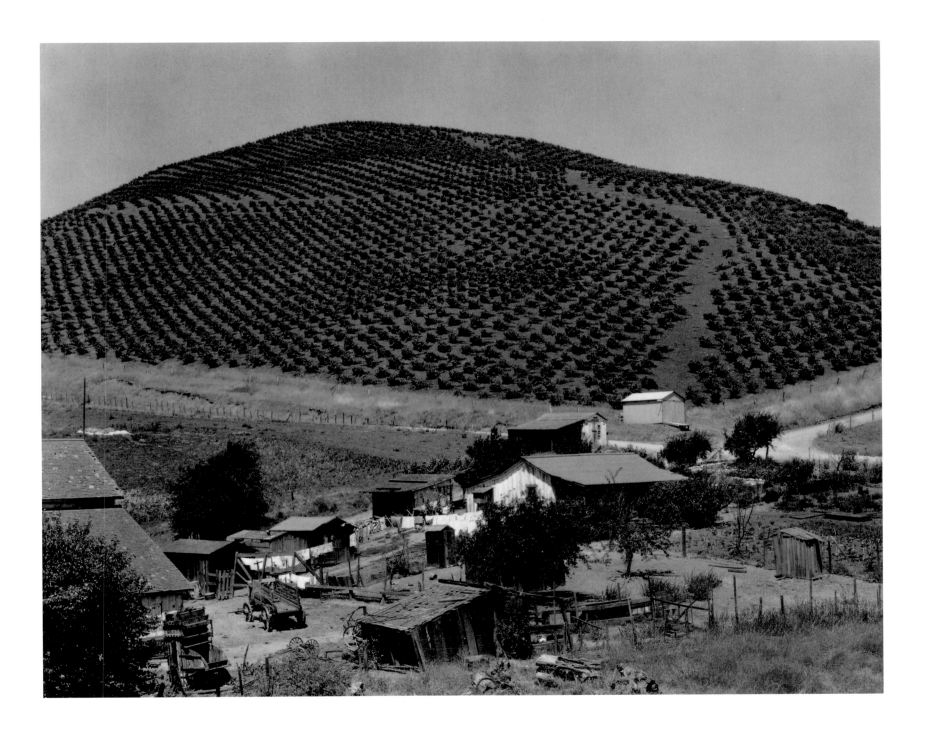

PLATE 53
Prunedale Cutoff, 1933

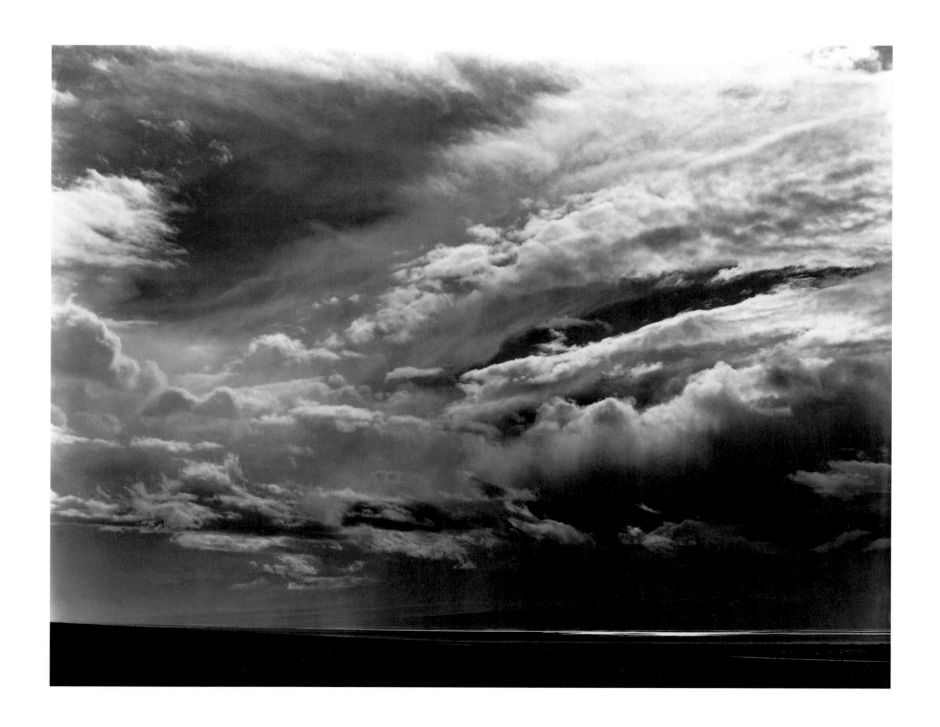

PLATE 54

Clouds, Death Valley, 1939

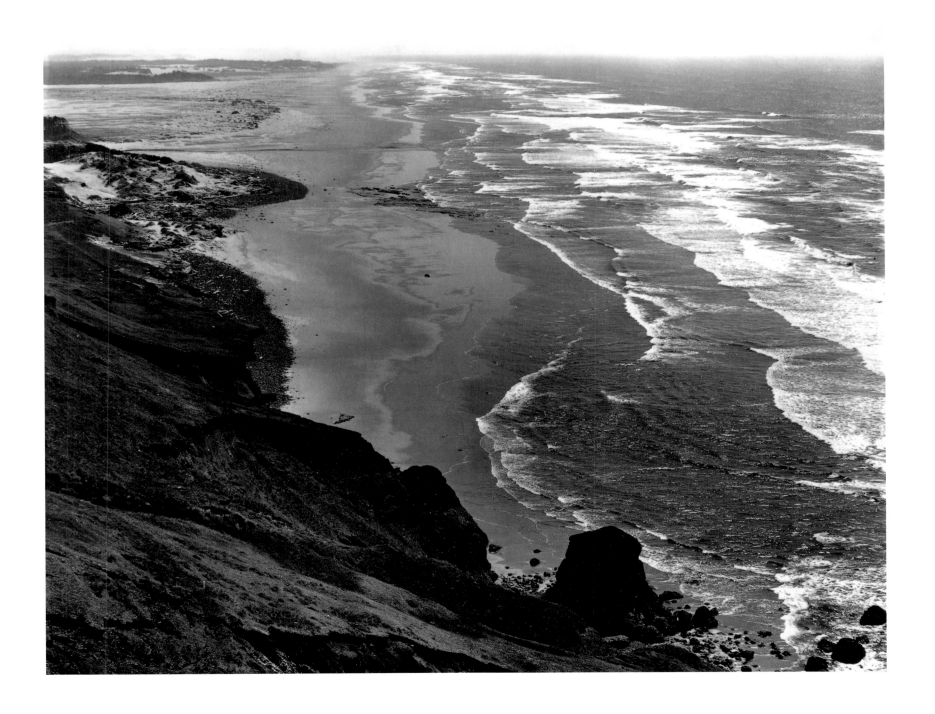

PLATE 55
Oregon, 1939

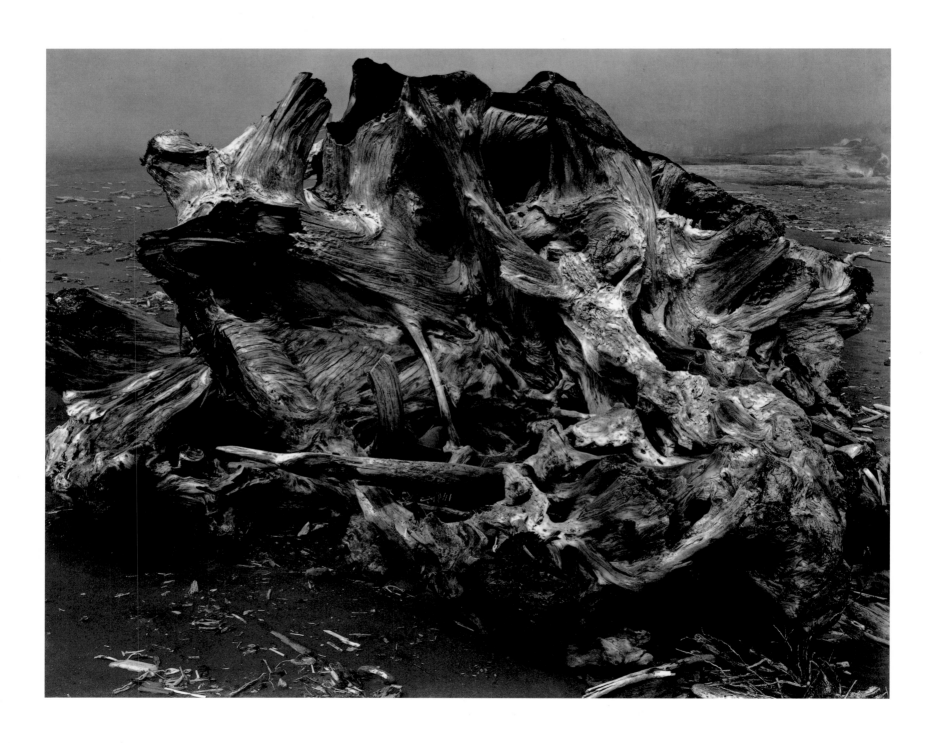

PLATE 56
Stump, Crescent City, 1937

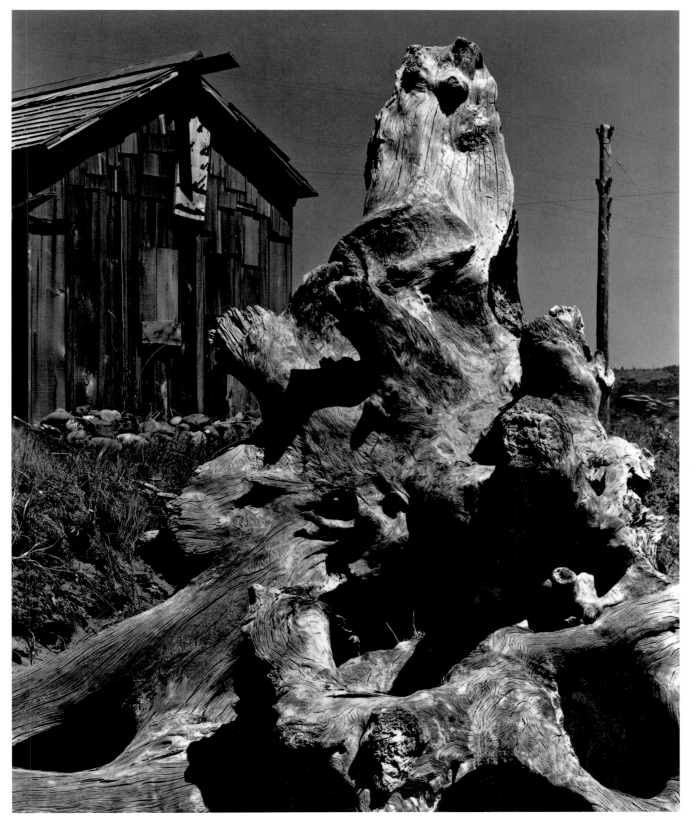

PLATE 57
Crescent Beach, 1937

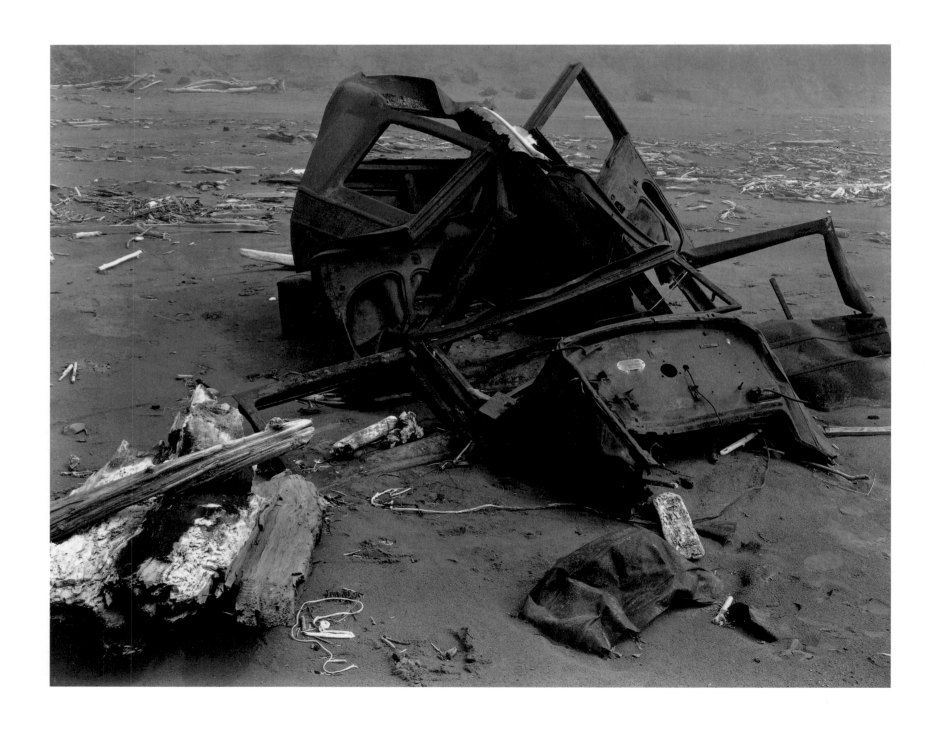

PLATE 58

Wrecked Auto, Crescent City, 1937

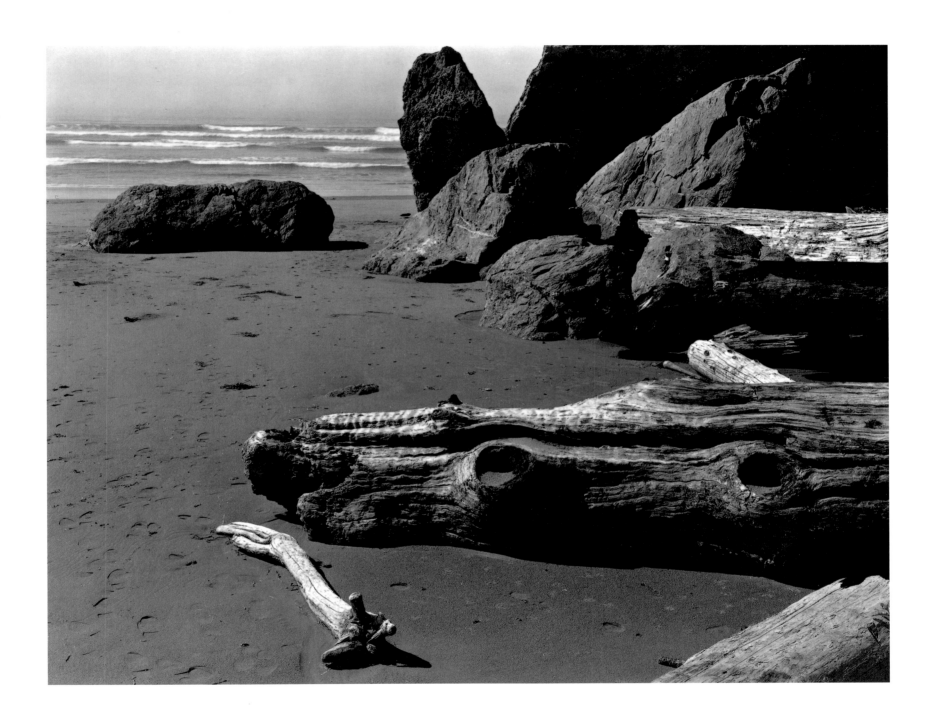

PLATE 59

Moonstone Beach, 1937

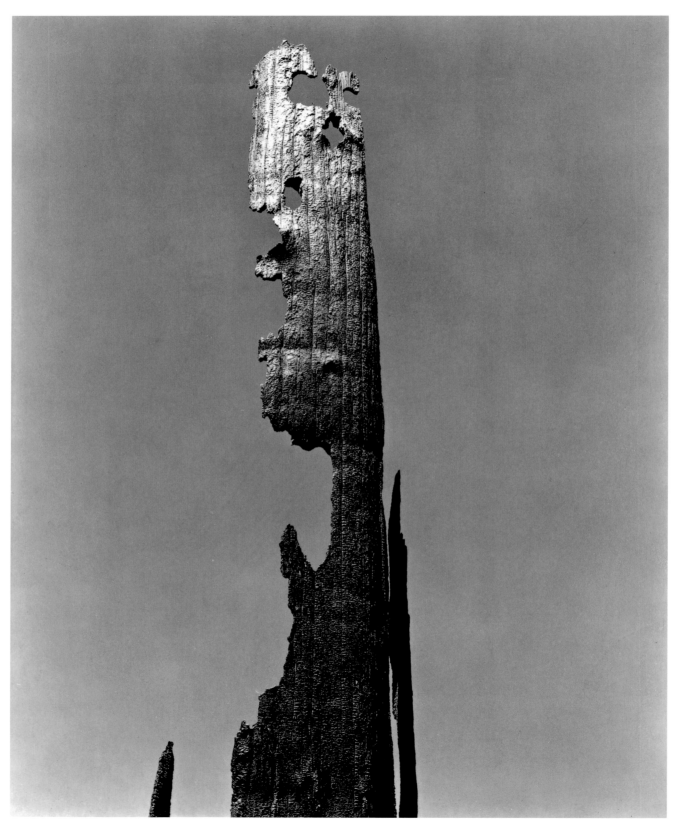

PLATE 60

Burned Stump, 1937

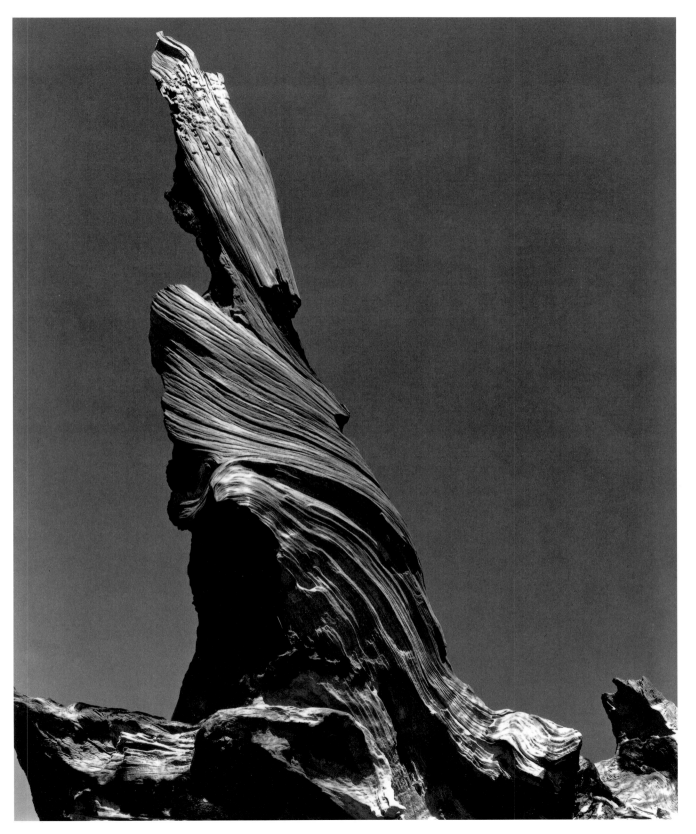

PLATE 61
Driftwood Stump, 1937

PLATE 62
St. Bernard Cemetery, 1941

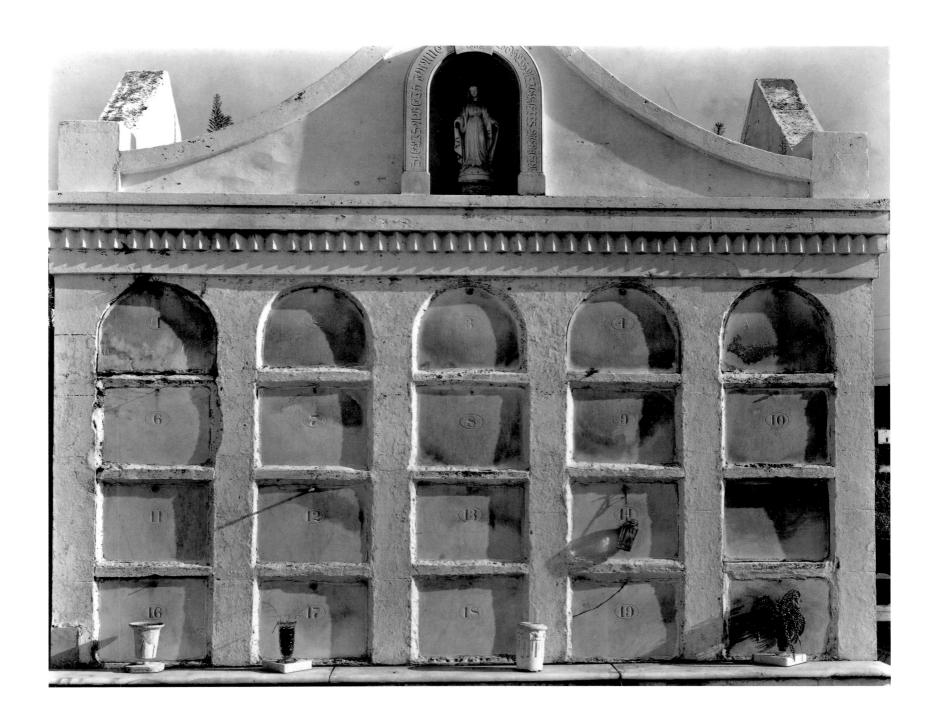

PLATE 63
St. Roche Cemetery, New Orleans, 1941

PLATE 64

Connecticut Barn, 1941

PLATE 65
MGM Studios, 1939

PLATE 66
MGM Studios, 1939

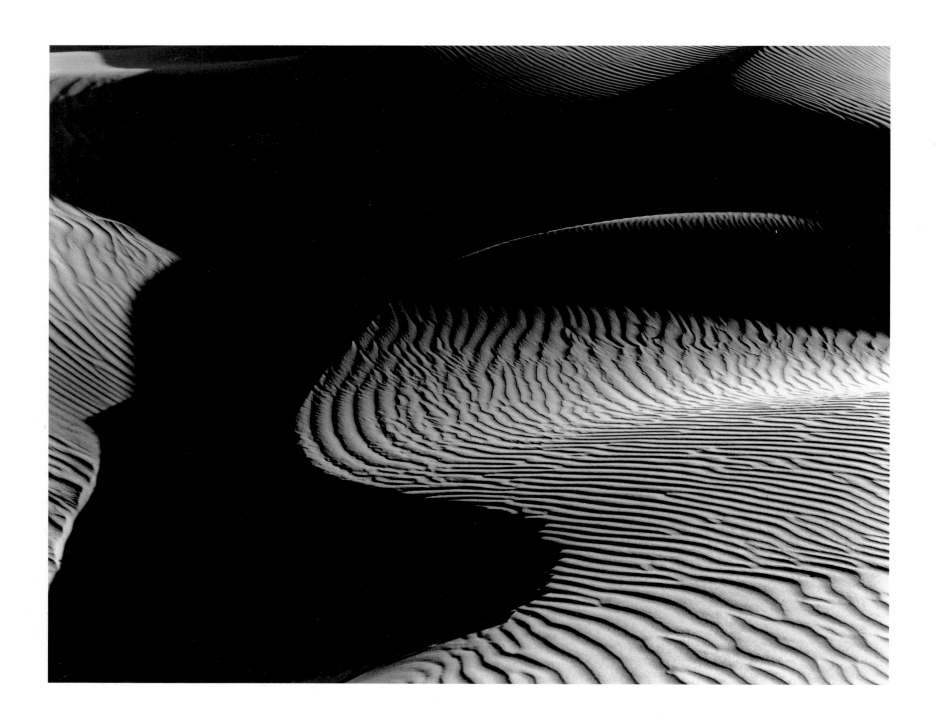

PLATE 67

Dunes, Oceano, 1936

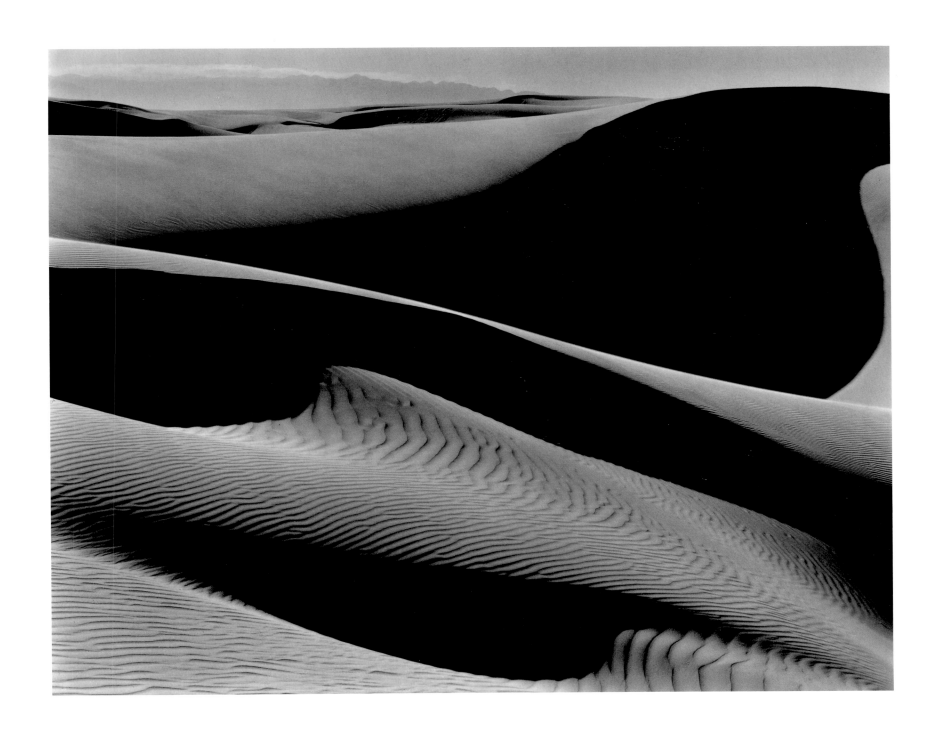

PLATE 68

Dunes, Oceano, 1936

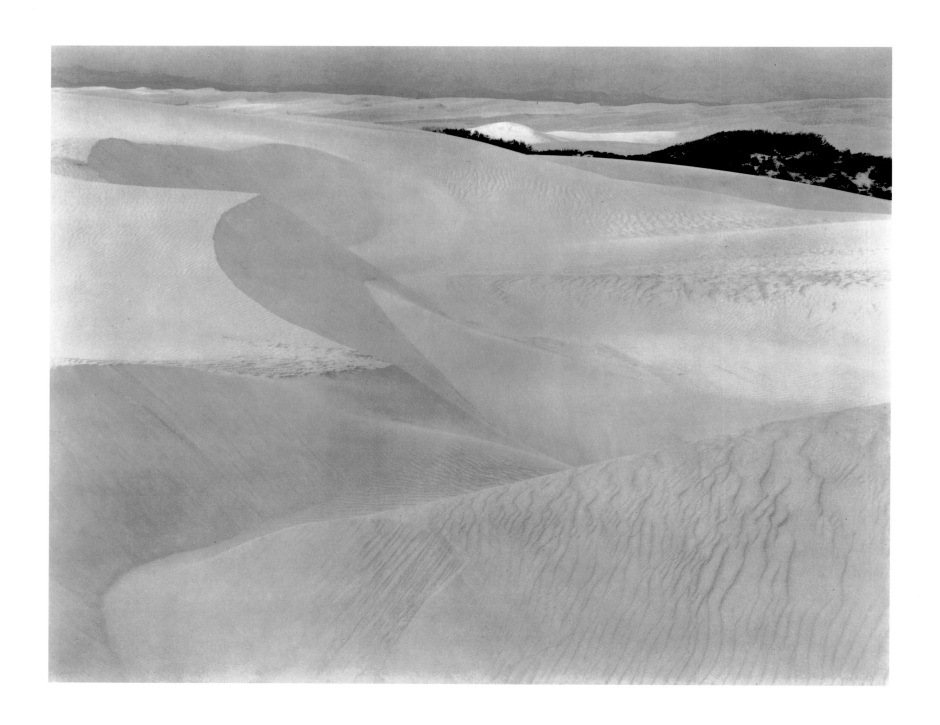

PLATE 69

Sand Dunes, 1939

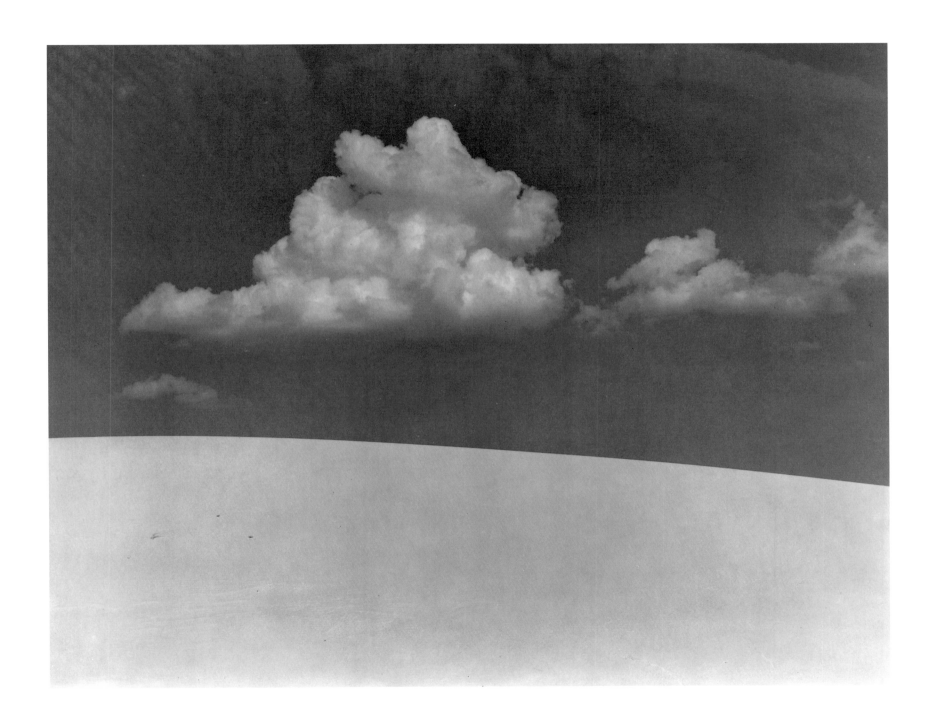

PLATE 70

White Sands, 1941

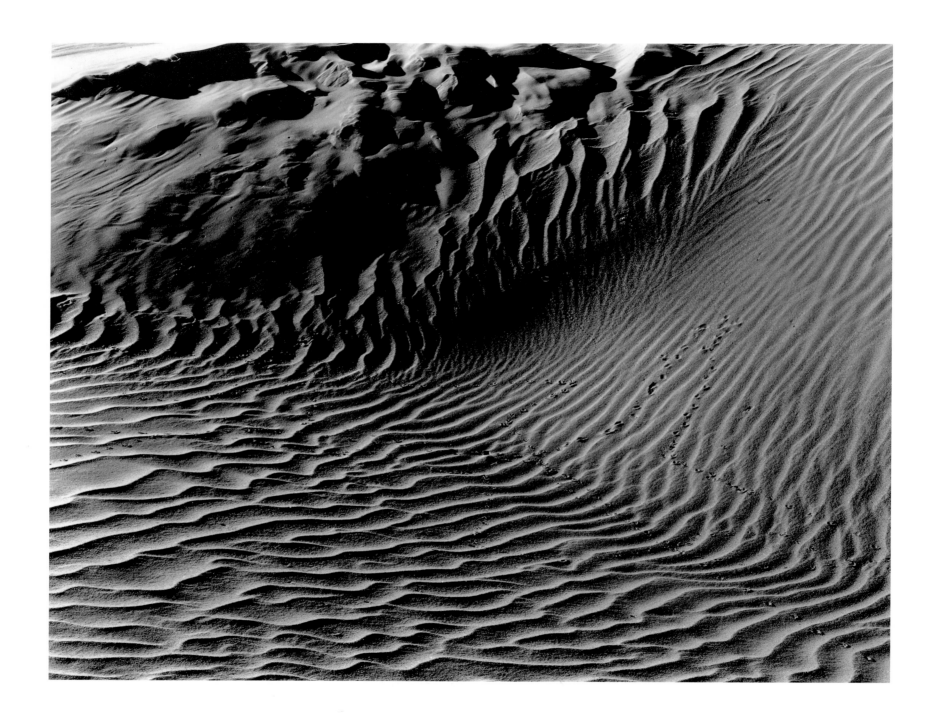

PLATE 71

Dunes, Oceano, 1936

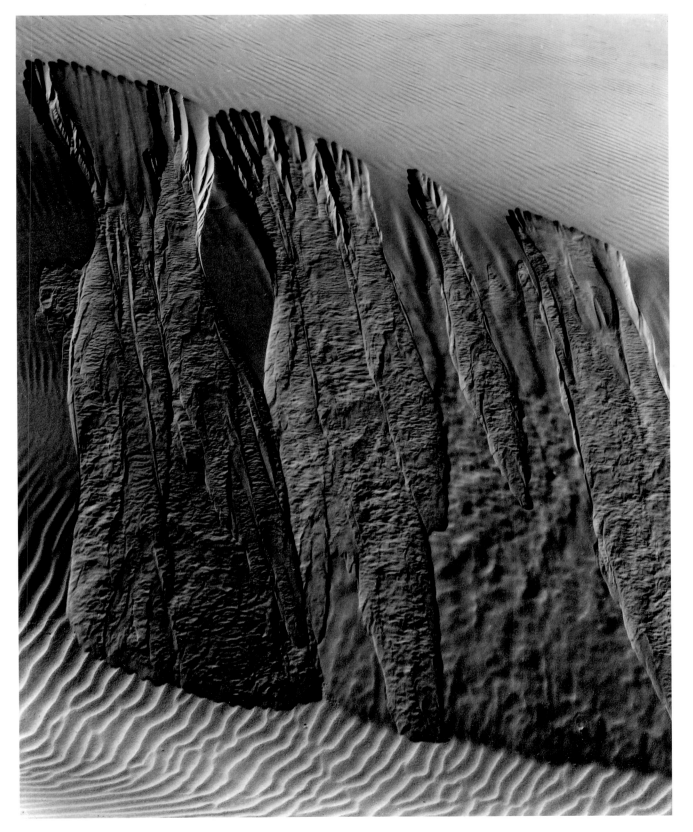

PLATE 72
Sand Erosion, Oceano,
1934

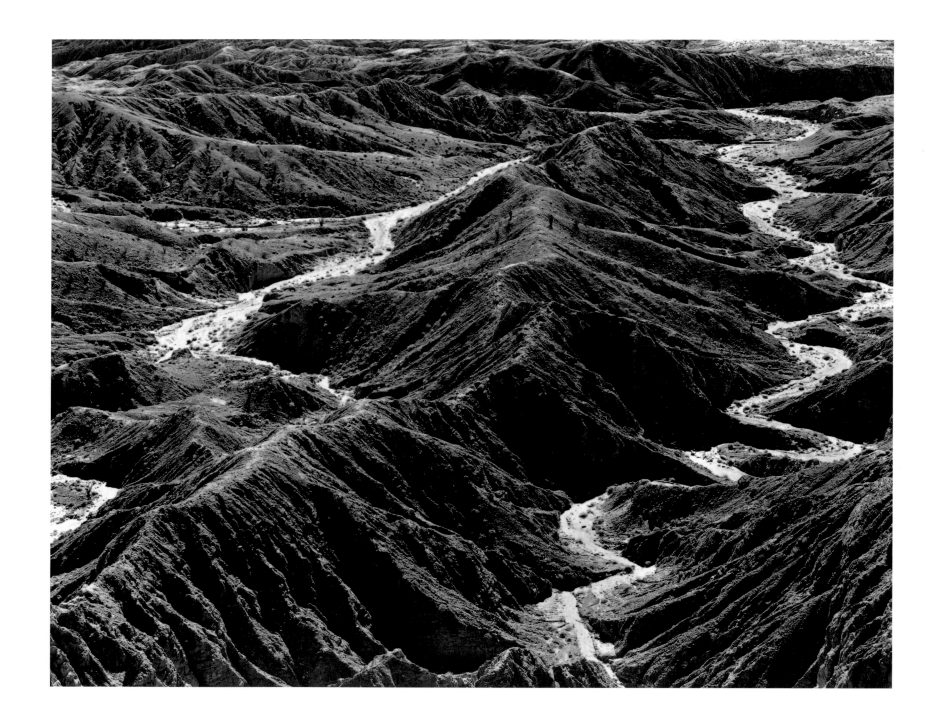

PLATE 73

Borego Desert, 1938

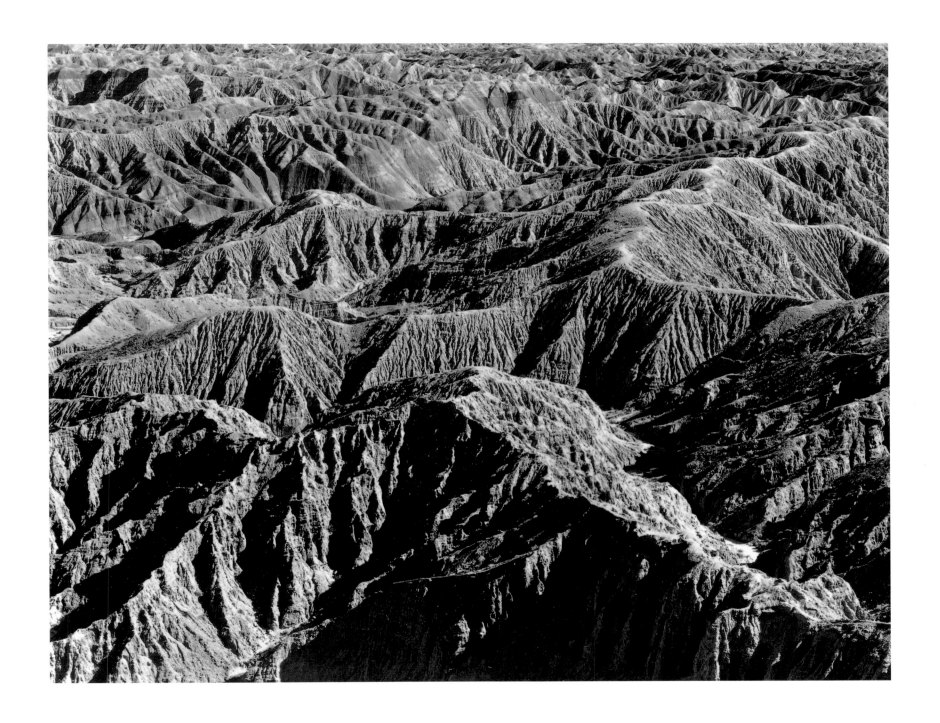

PLATE 74
Badlands, Borego Desert, 1938

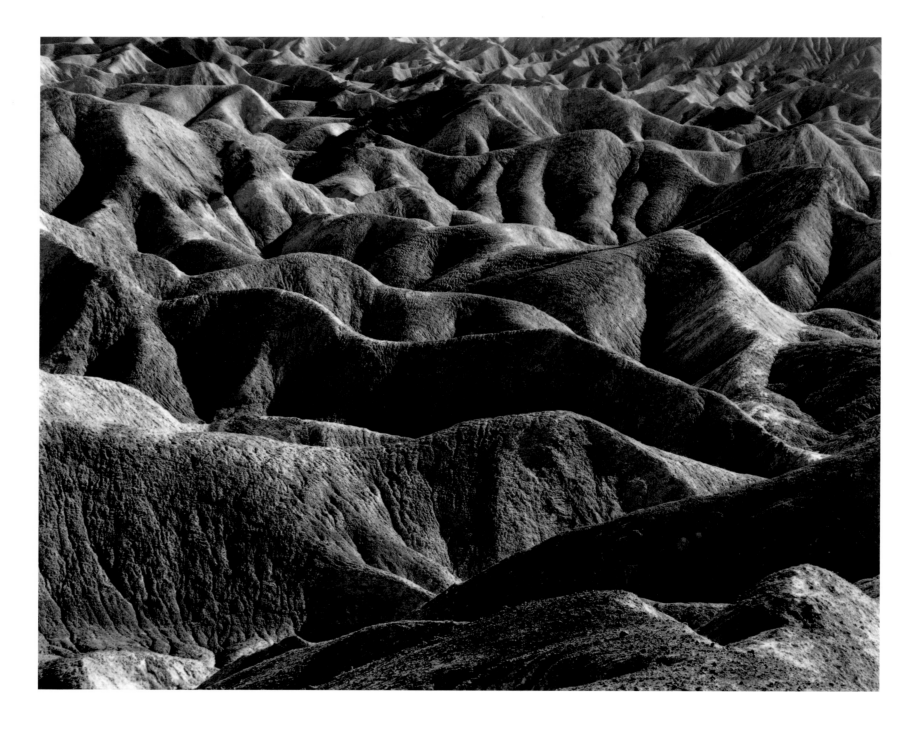

PLATE 75

Manley's Trail, Golden Canyon, 1938

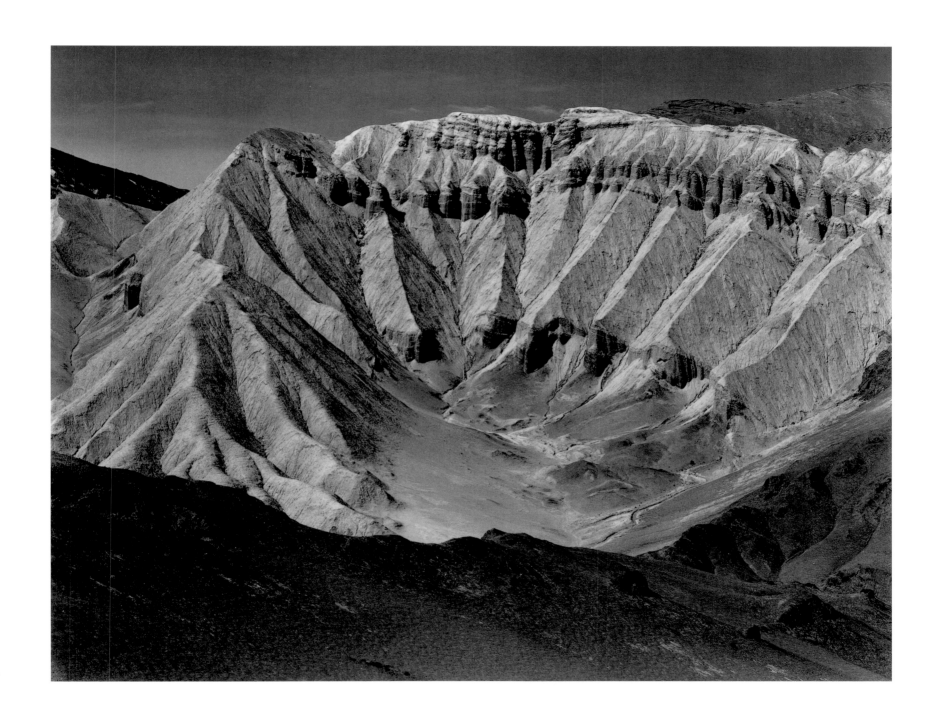

PLATE 76
Twenty Mule Team Canyon, 1938

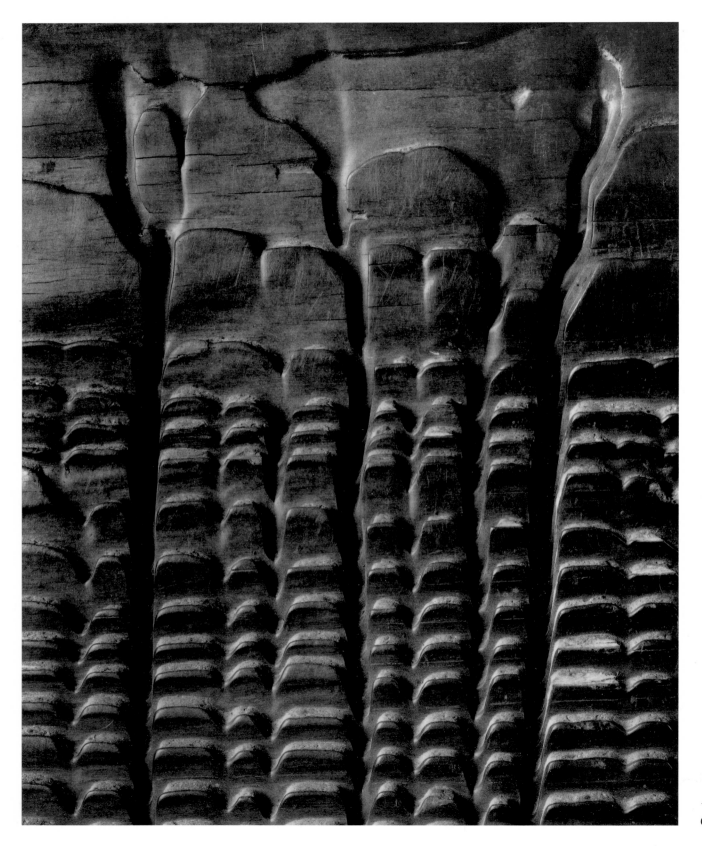

PLATE 77
Eroded Board from
Grain Sifter, 1931

PLATE 78
Sandstone Concretion and Stump, 1936

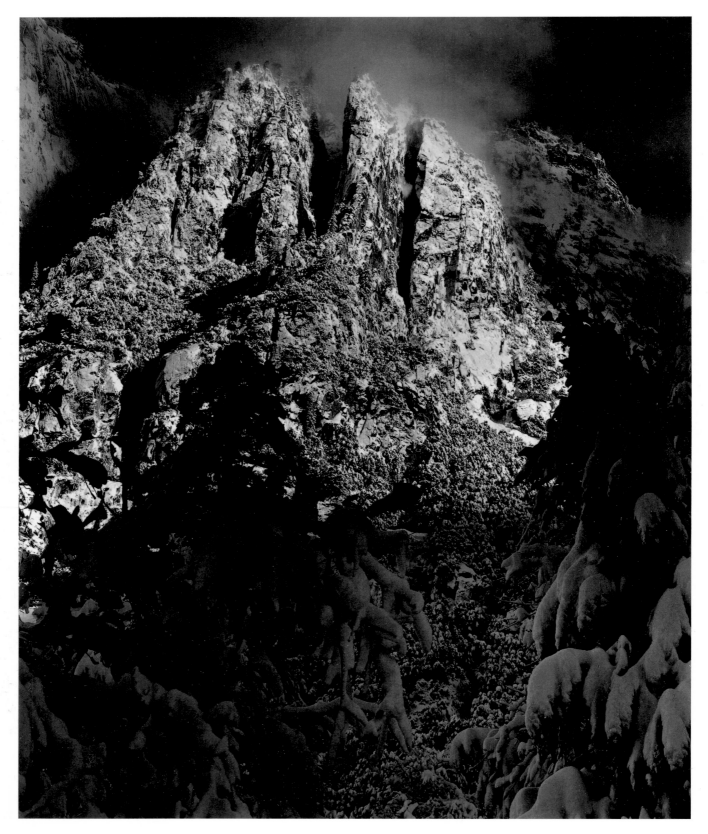

PLATE 79
Yosemite, 1938

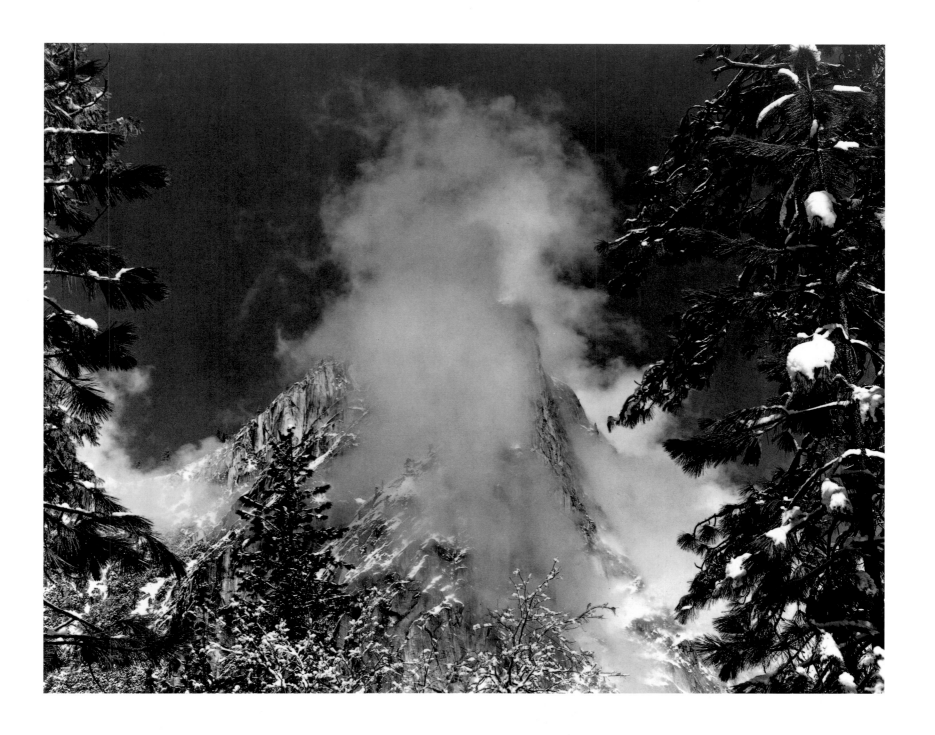

PLATE 80
Yosemite Mists, 1938

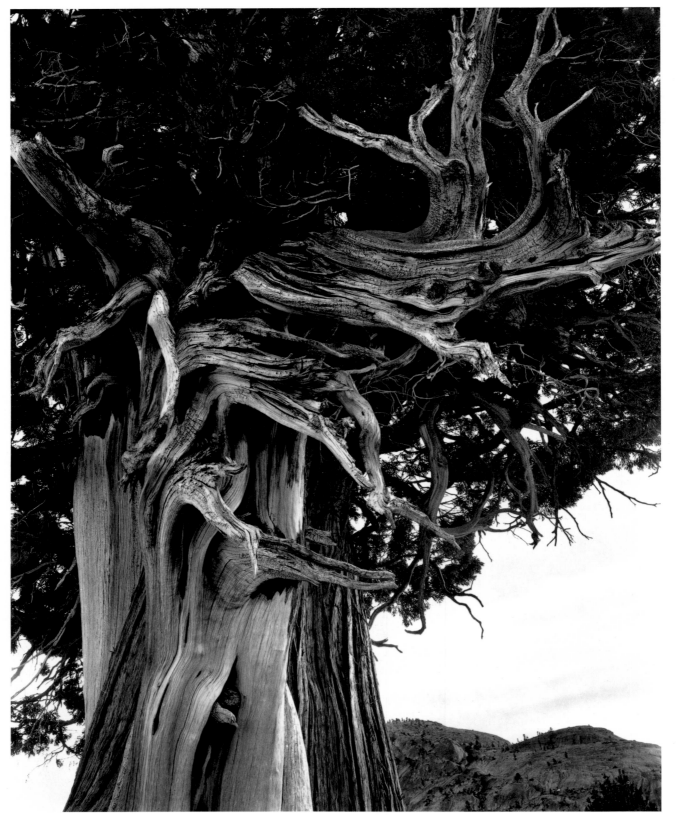

PLATE 81
Juniper,
1937

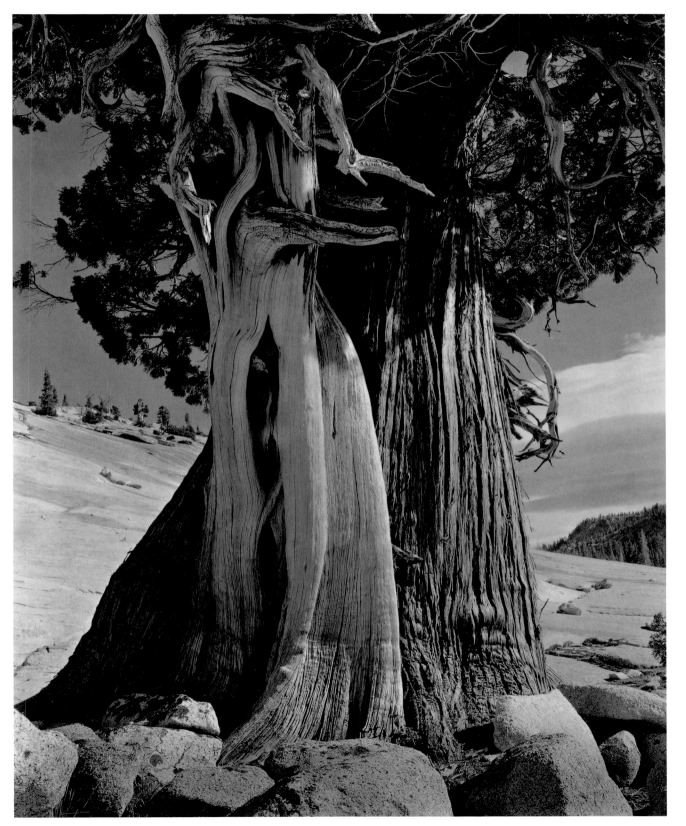

PLATE 82
Juniper at Lake Tenaya,
1937

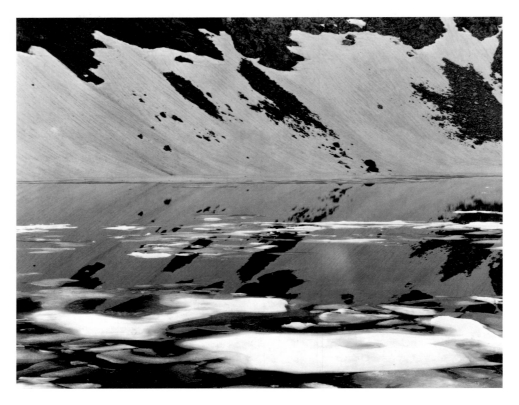

PLATE 83
Iceberg Lake, Ediza, 1937

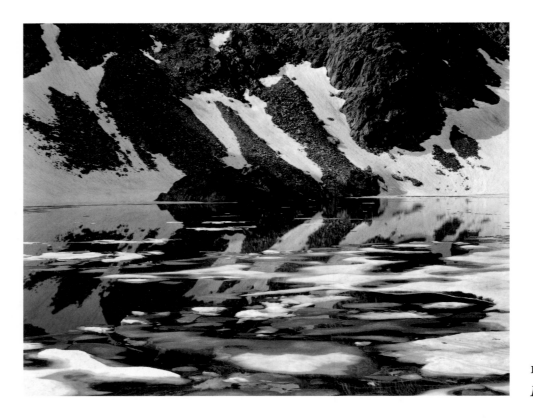

PLATE 84
Iceberg Lake, Ediza, 1937

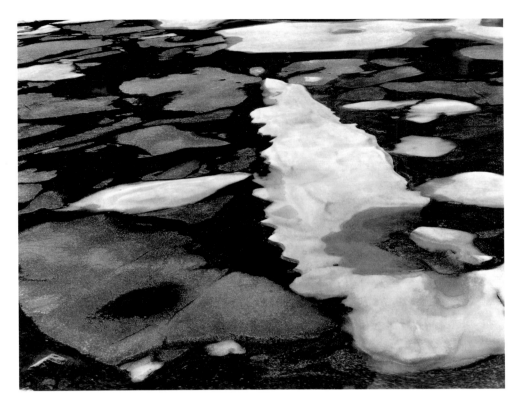

PLATE 85
Iceberg Lake, Ediza, 1937

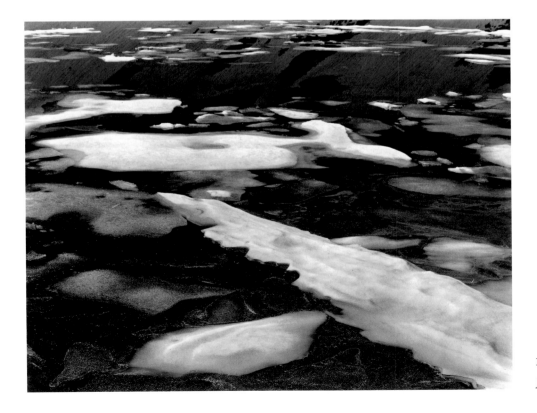

PLATE 86
Iceberg Lake, Ediza, 1939

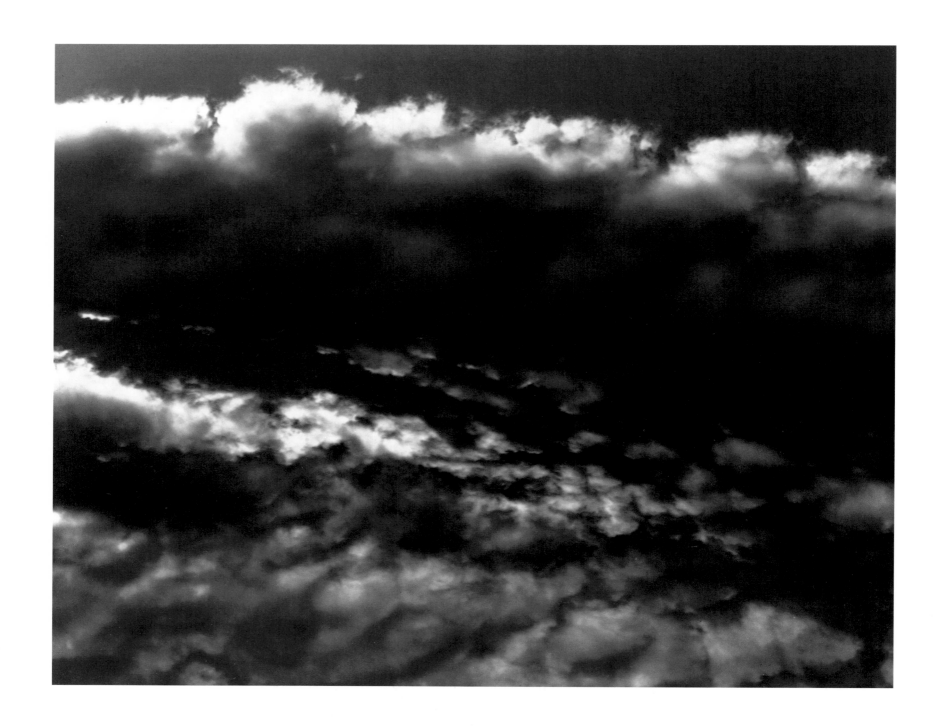

PLATE 87

Clouds, ca. 1936

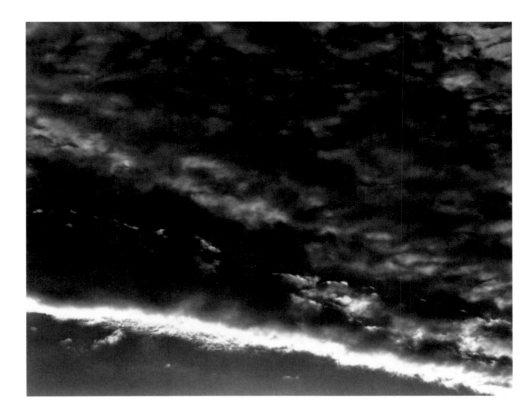

PLATE 88
Clouds, 1936

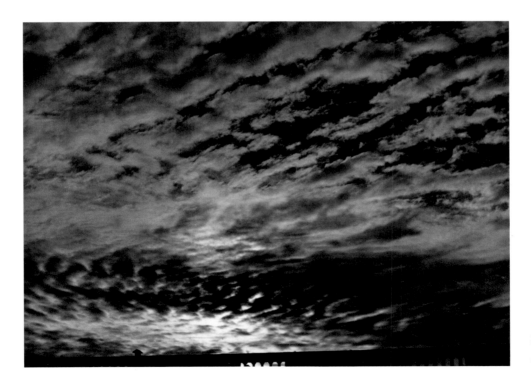

PLATE 89
Clouds, 1925

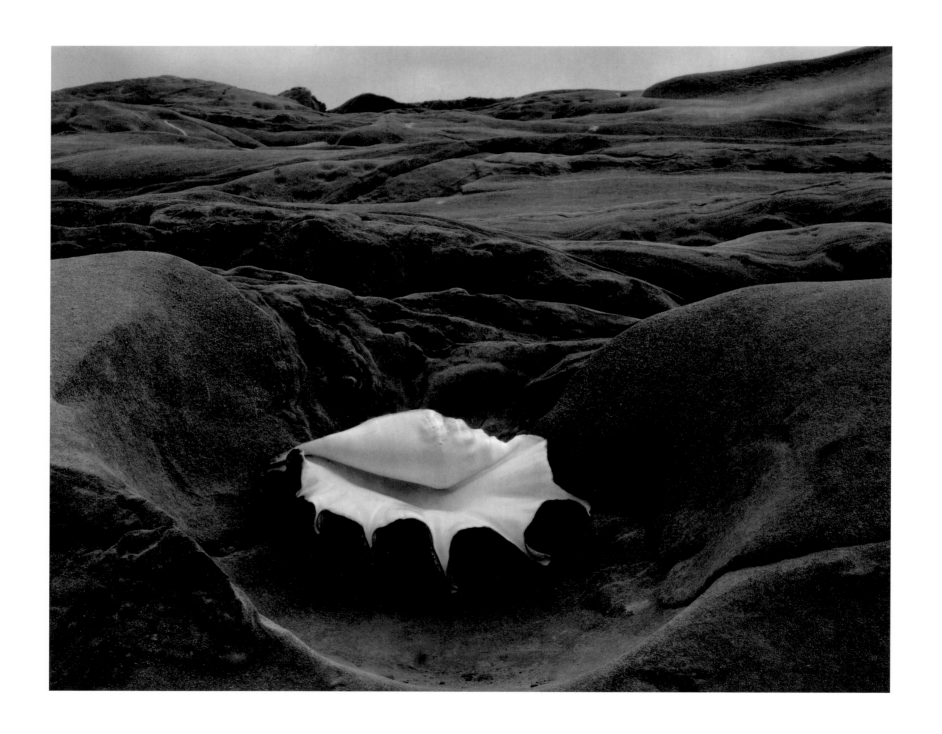

PLATE 90

Shell & Rock – Arrangement, 1931

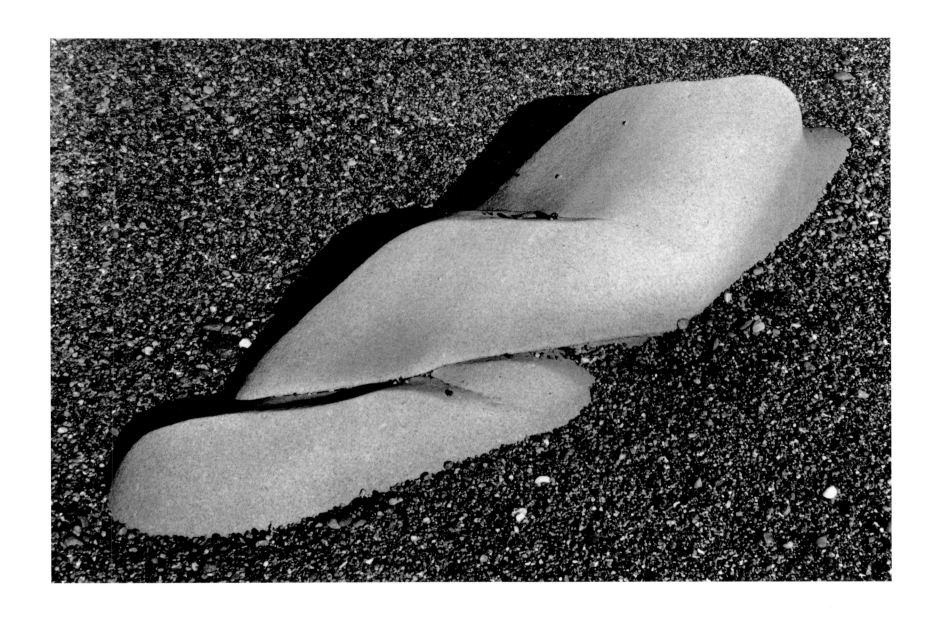

PLATE 91
Point Lobos, 1930

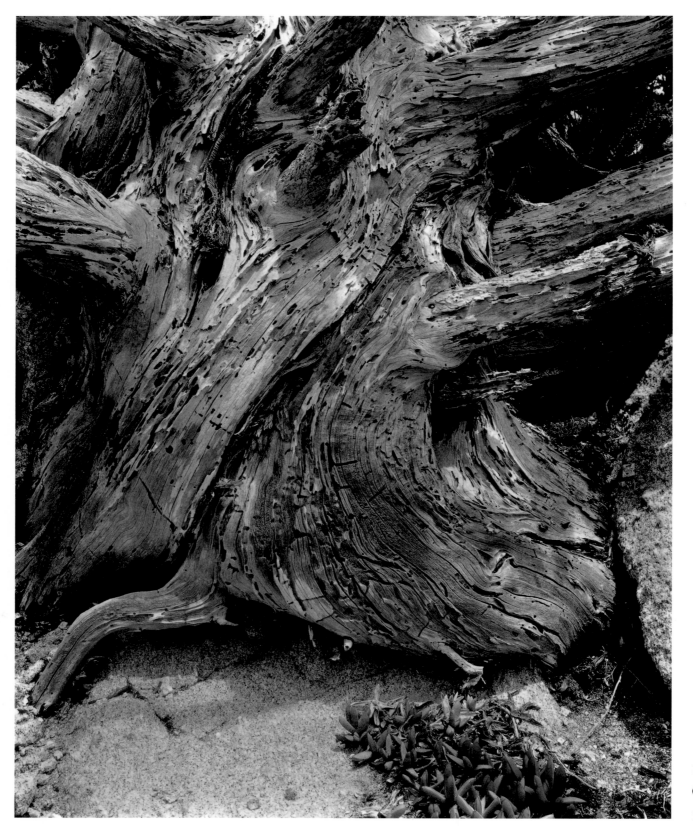

PLATE 92

Cypress, Point Lobos,
1931

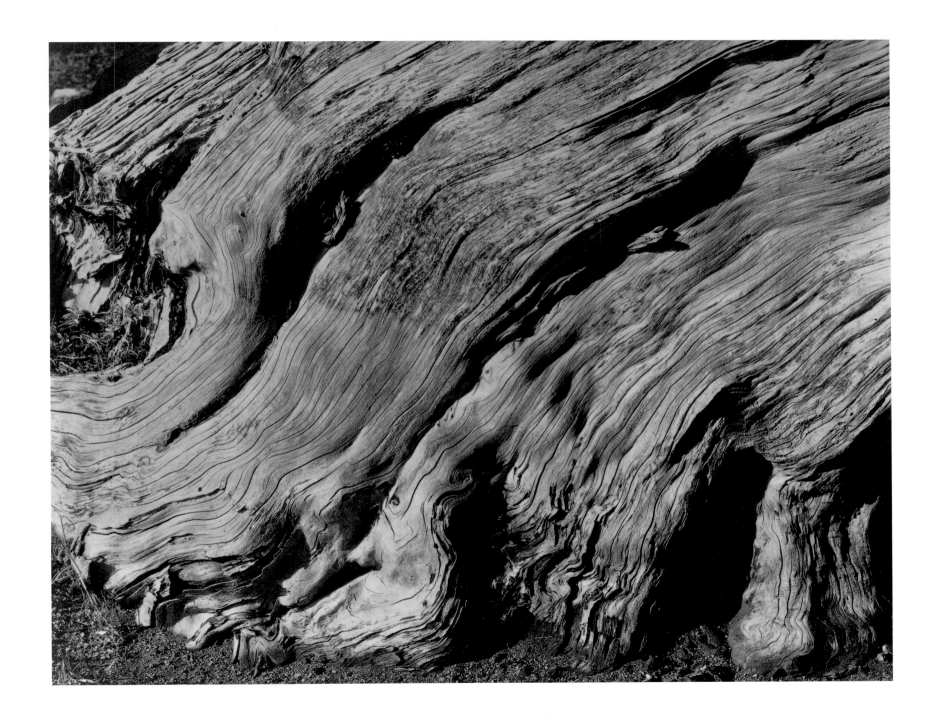

PLATE 93

Cypress, Point Lobos, 1929

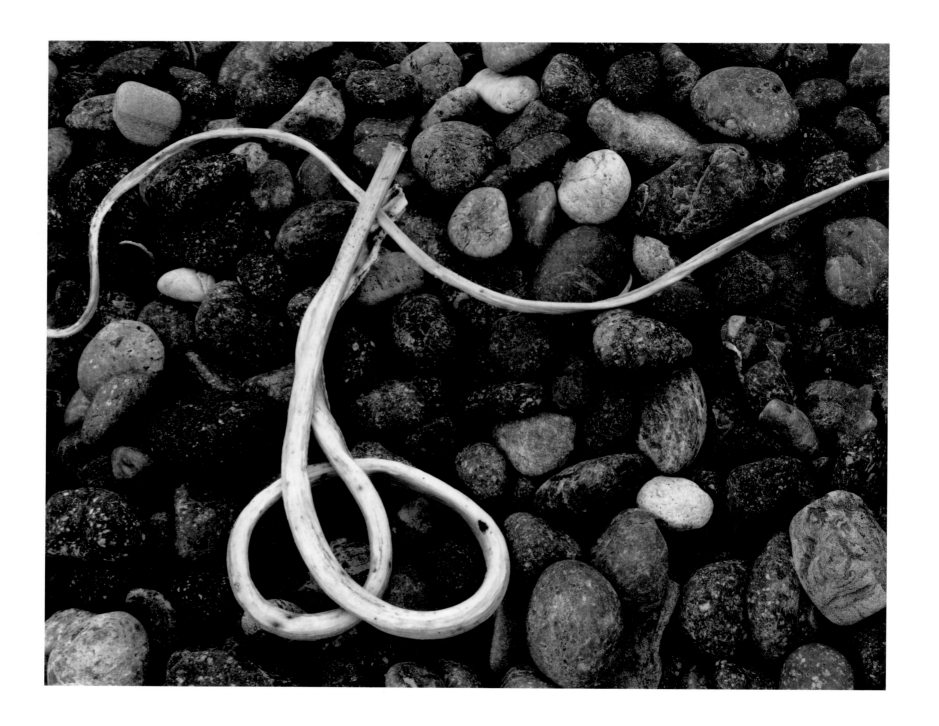

PLATE 94
Kelp, 1934

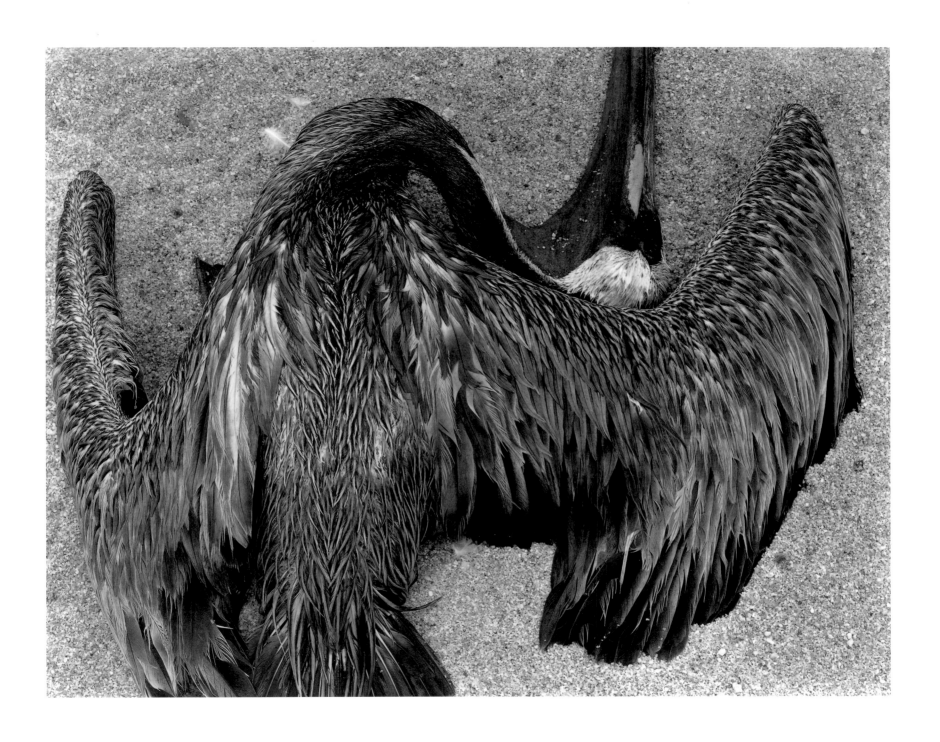

PLATE 95

Pelican, Point Lobos, 1942

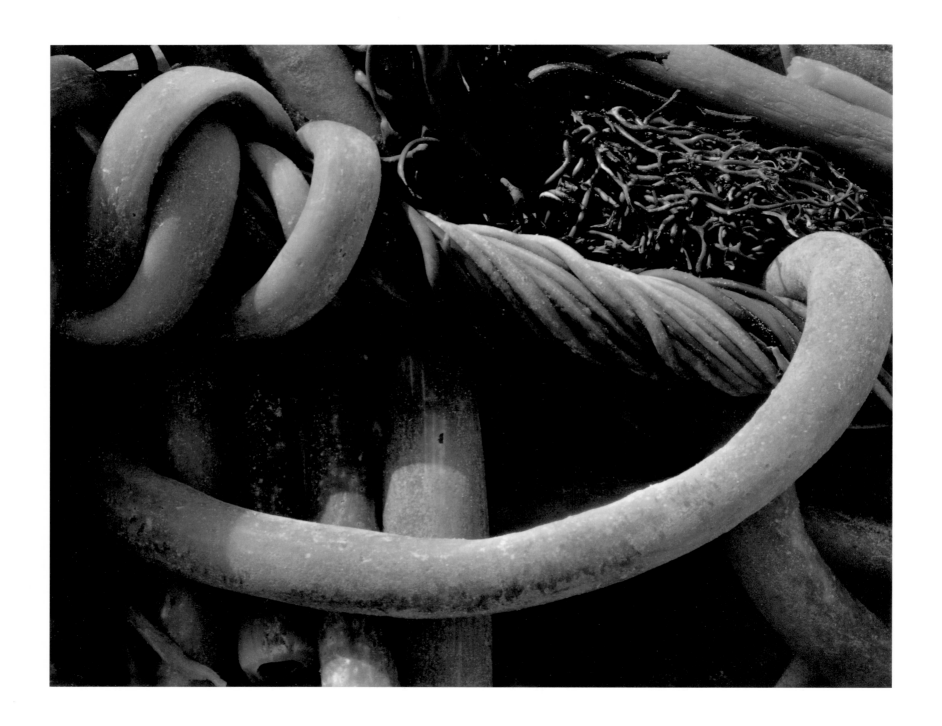

PLATE 96
Kelp, 1930

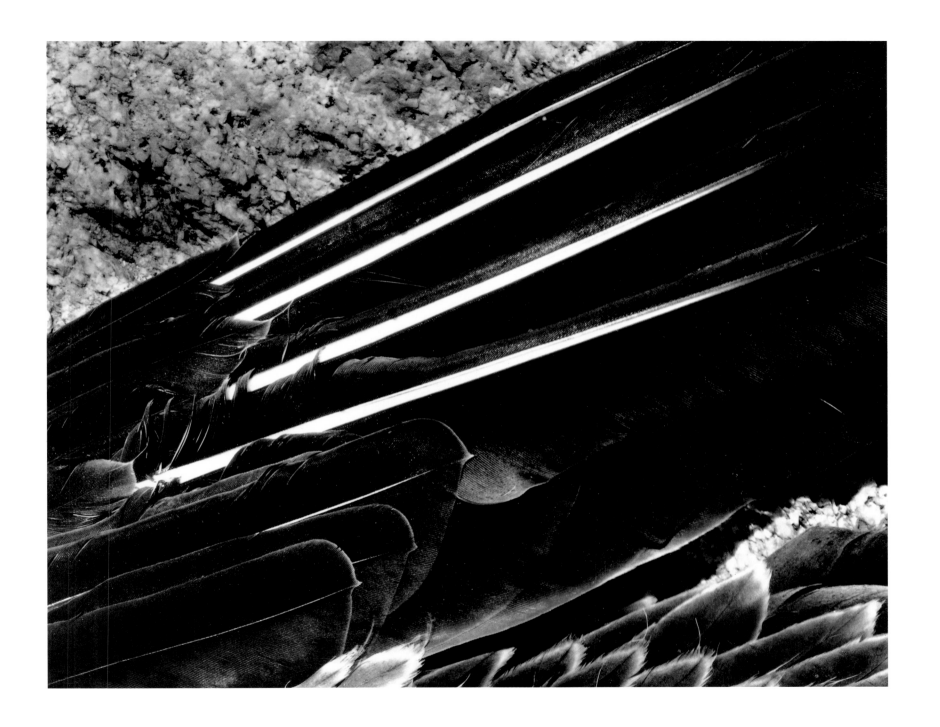

PLATE 97

Wing of Pelican, 1931

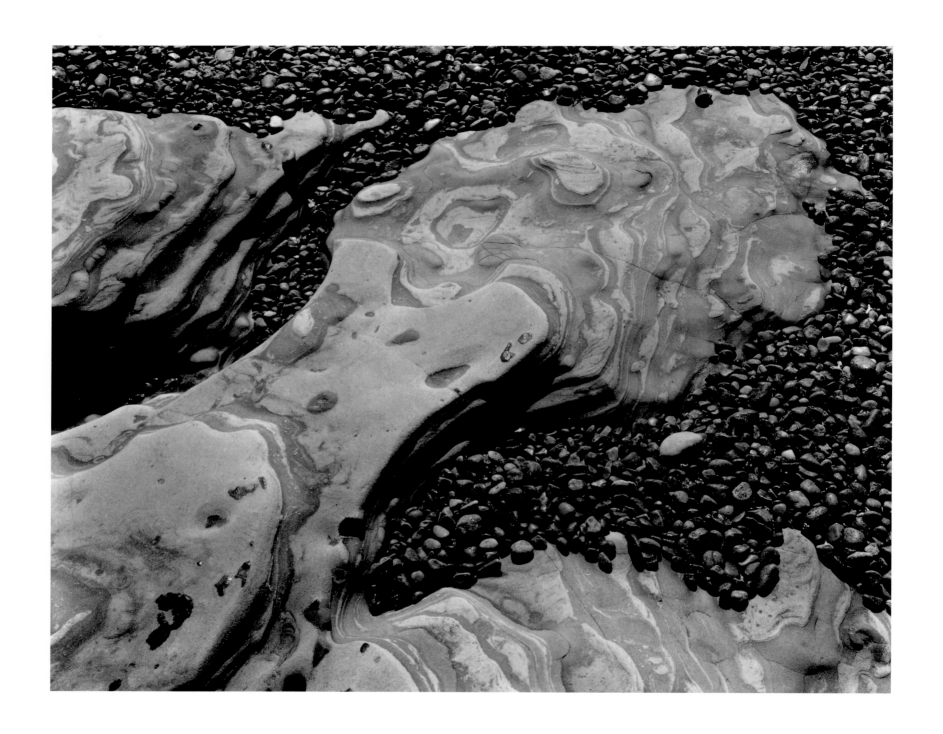

PLATE 98
Point Lobos, 1930

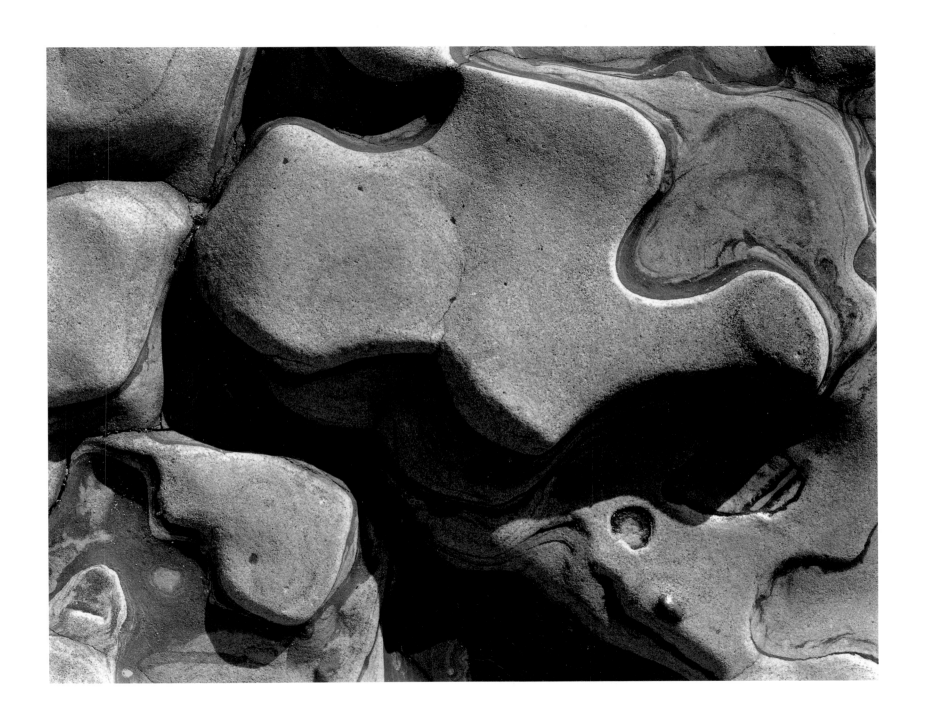

PLATE 99

Rock, Point Lobos, 1946

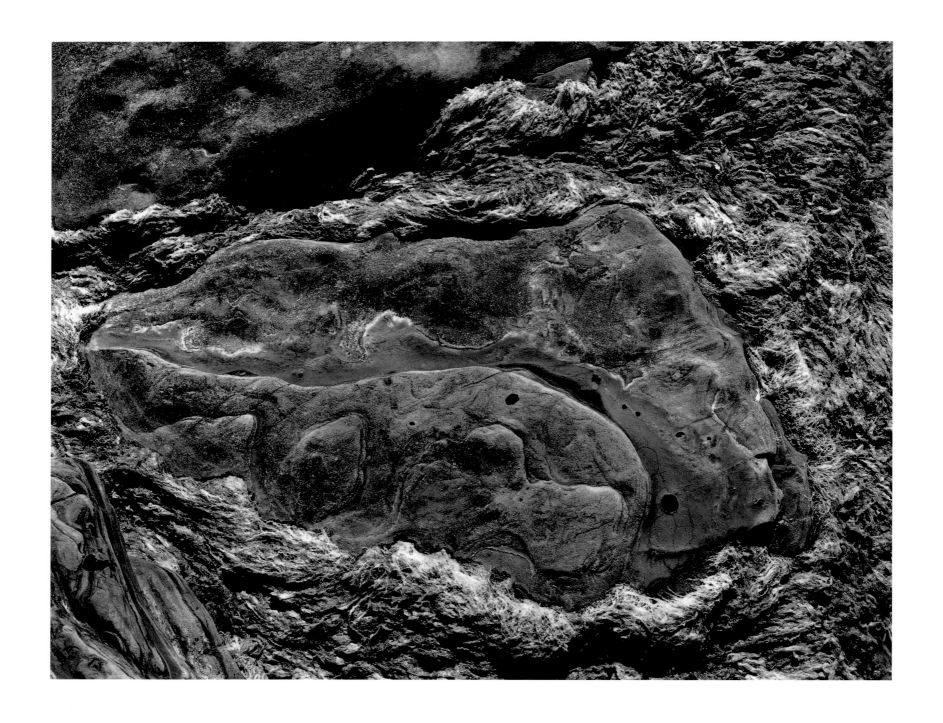

PLATE 100

Rock, Point Lobos, ca. 1938

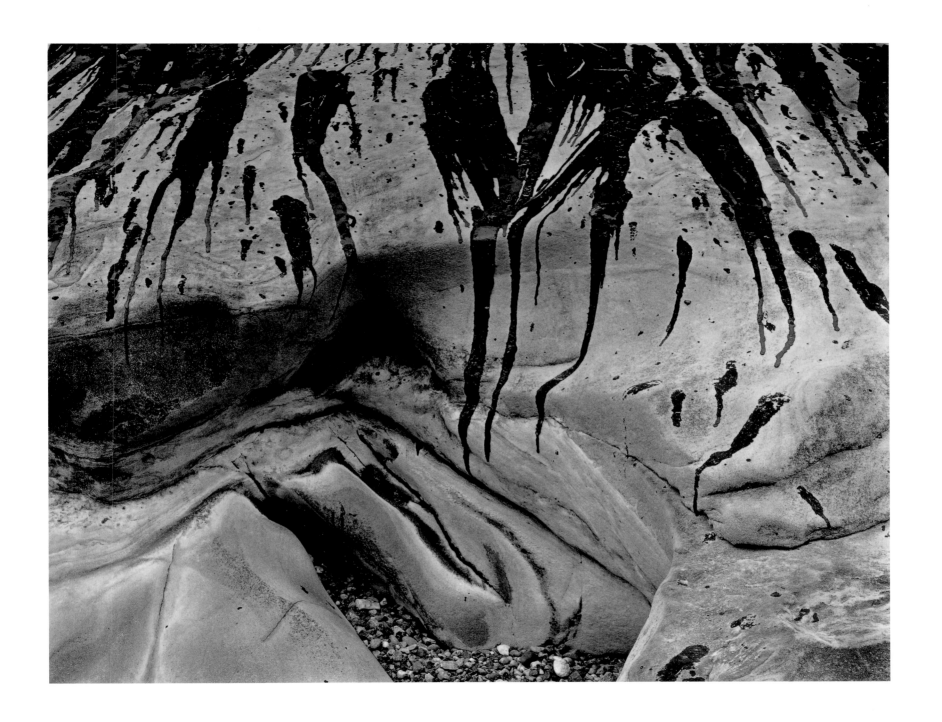

PLATE 101

Tar on Rock, Point Lobos, 1939

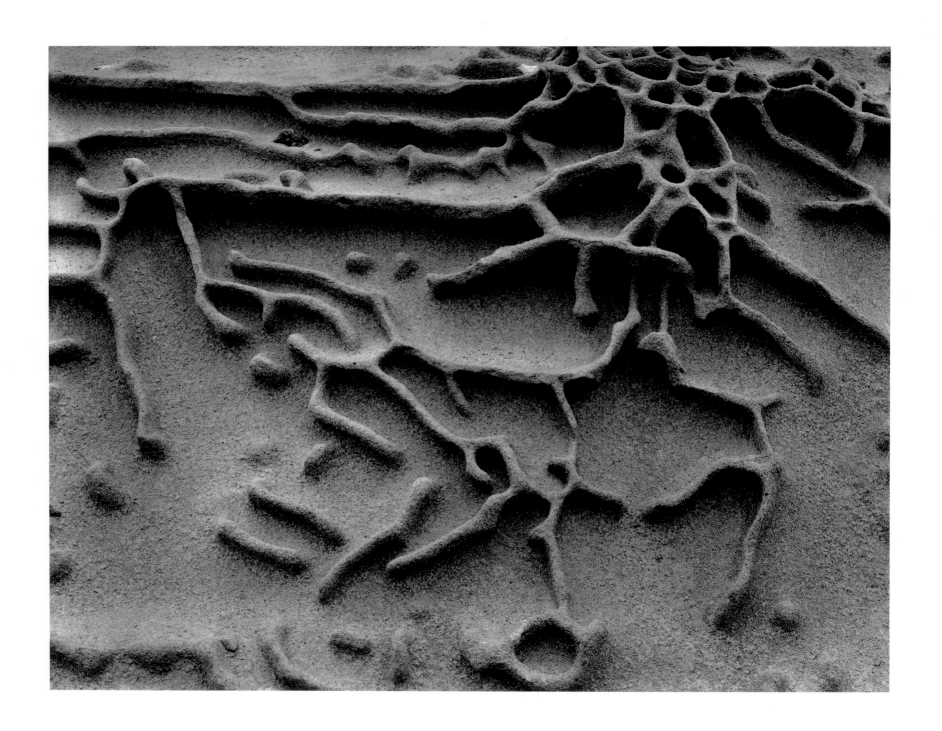

PLATE 102

Sandstone Erosion, Point Lobos, 1942

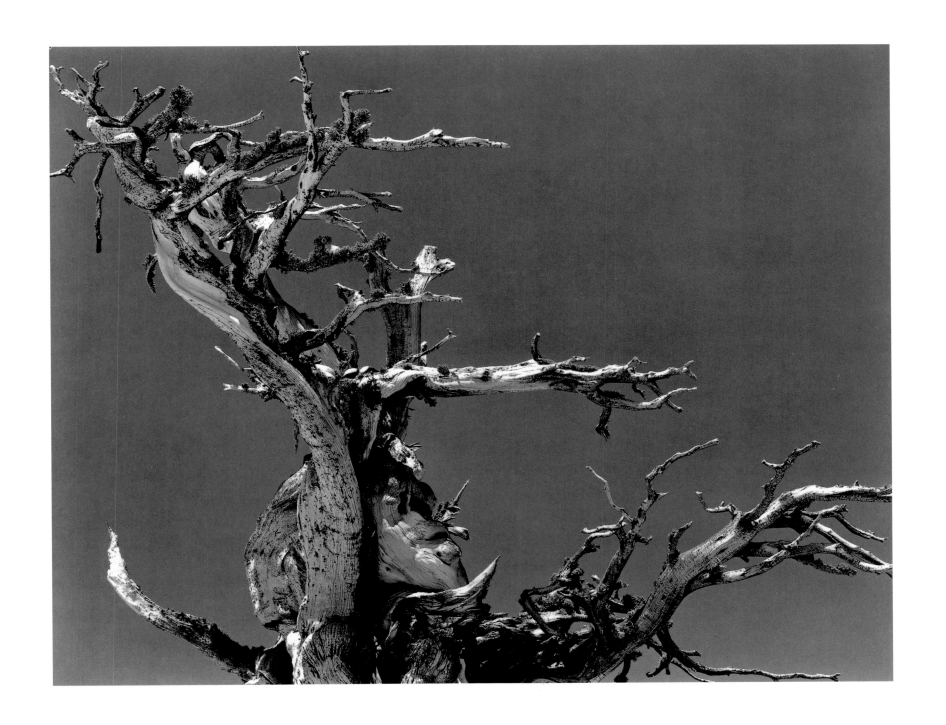

PLATE 103

Juniper, Lake Tenaya, 1937

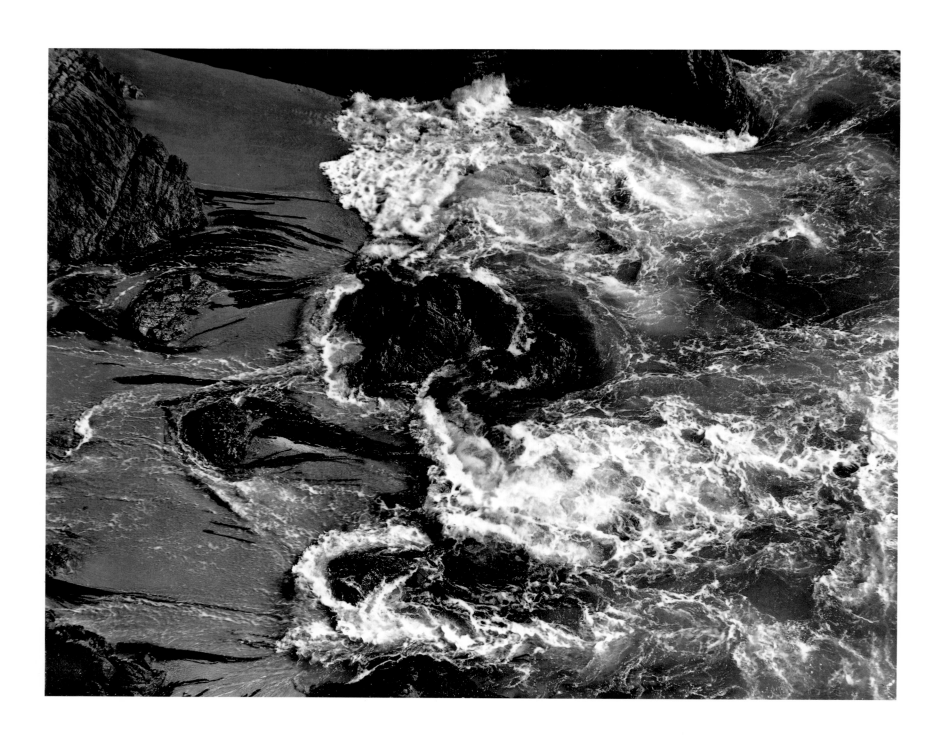

PLATE 104

Surf on Sand, 1938

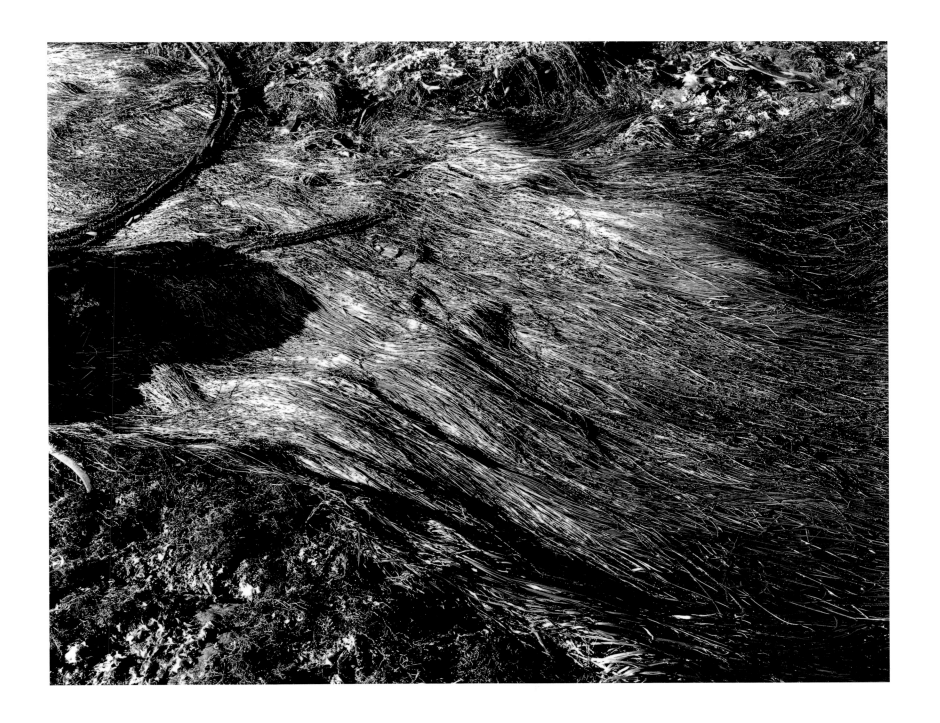

PLATE 105

Wet Seaweed, 1938

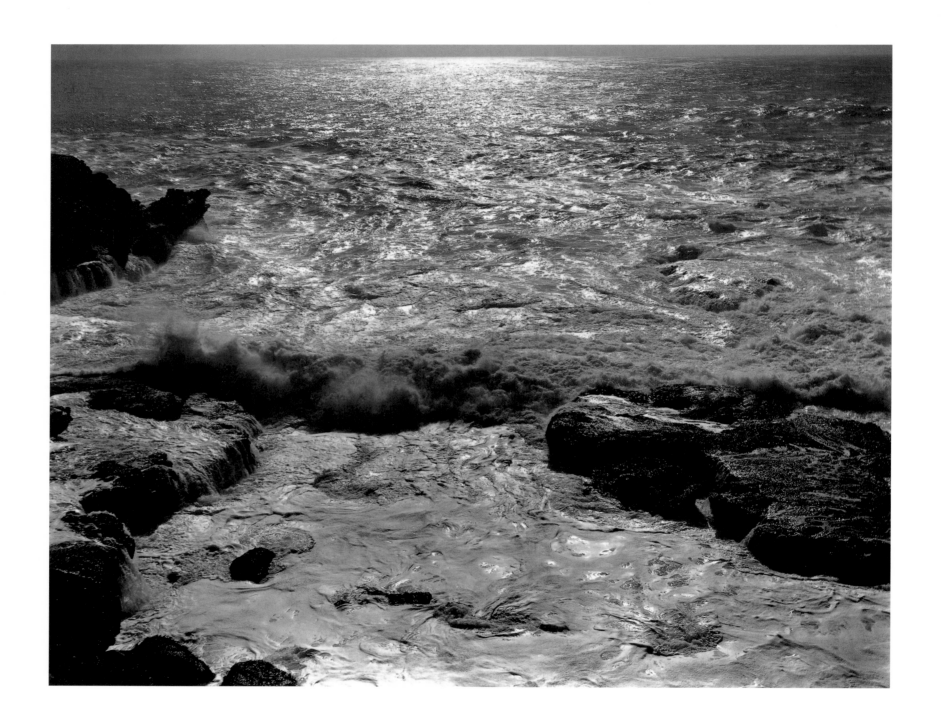

PLATE 106

Point Lobos, 1938

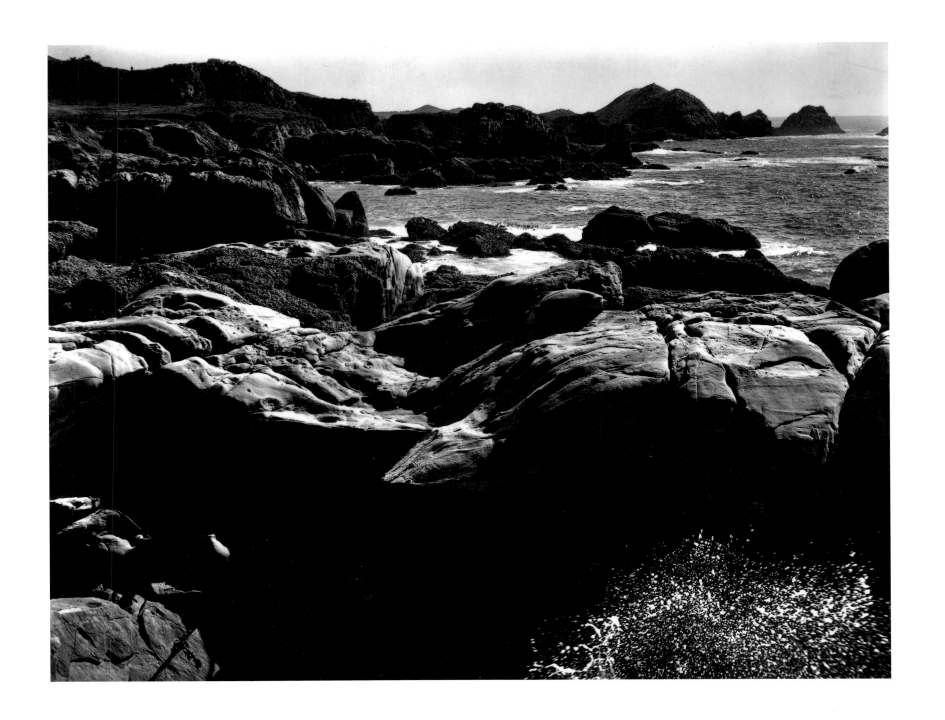

PLATE 107

Coast View, Point Lobos, 1938

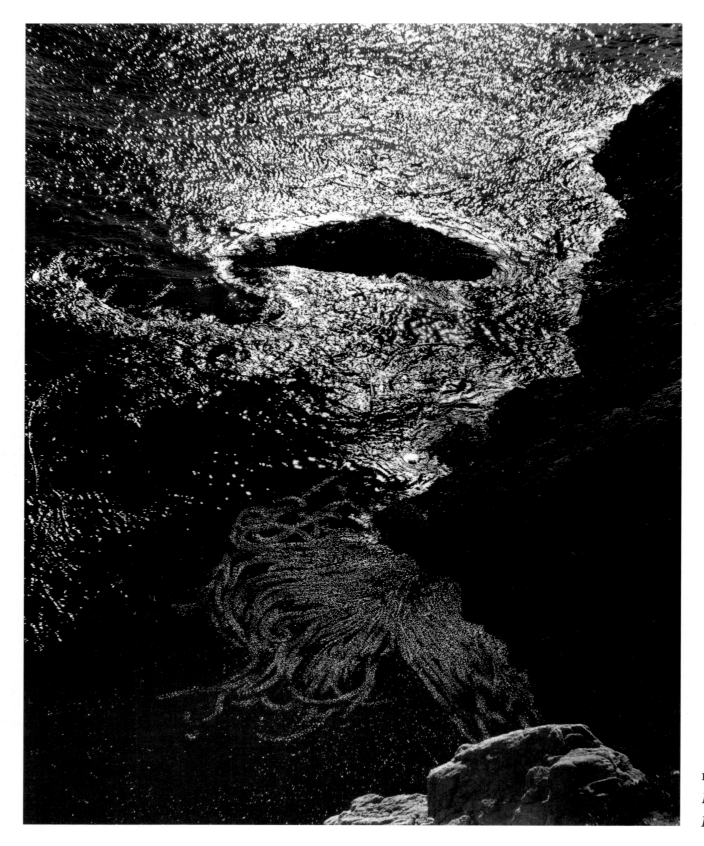

PLATE 108
Kelp, China Cove,
Point Lobos, 1940

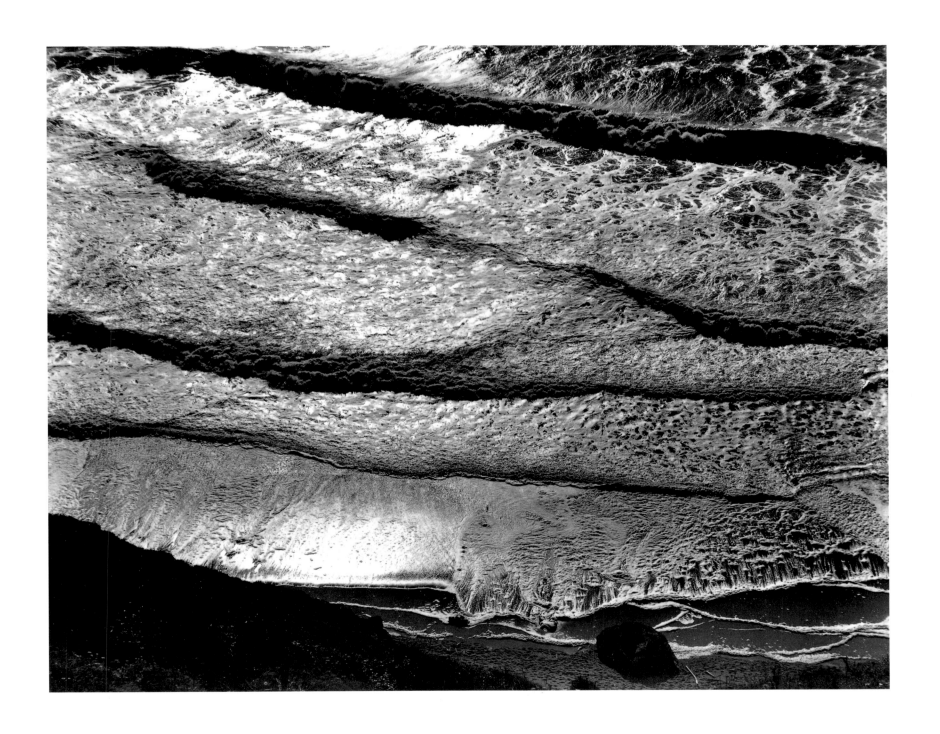

PLATE 109

Surf, Orick, 1937

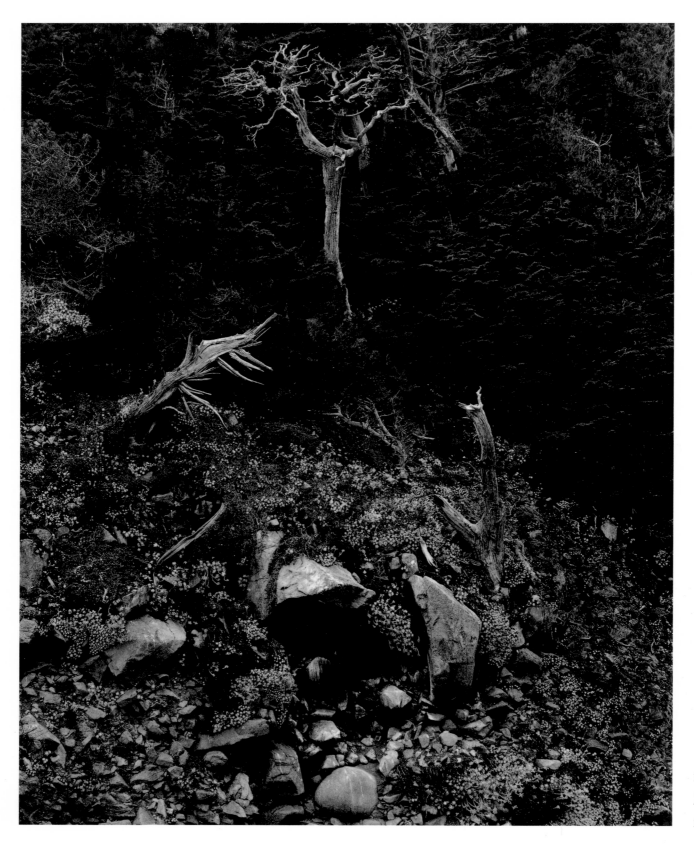

PLATE 110

Point Lobos,
1946

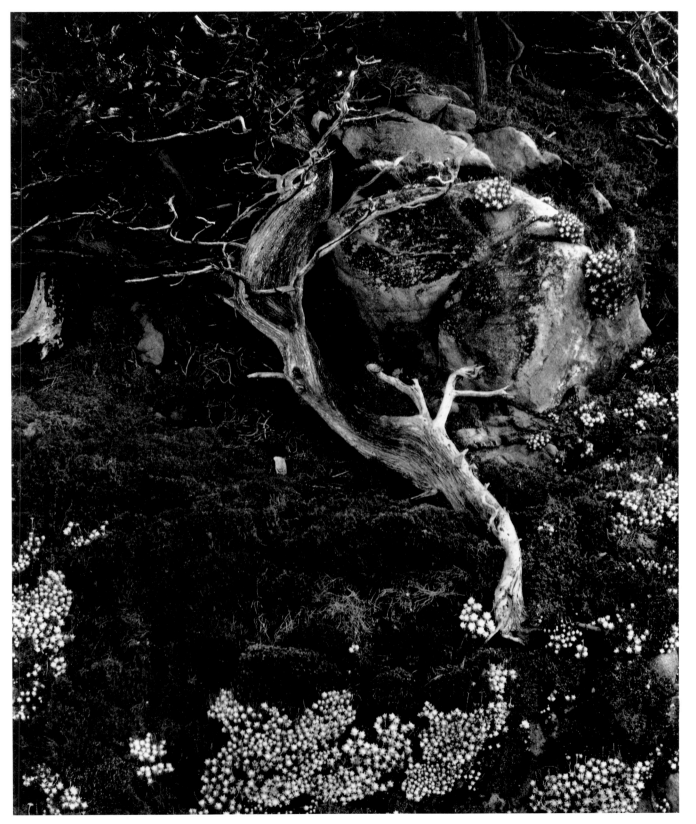

PLATE III

Cypress, Point Lobos,

1930

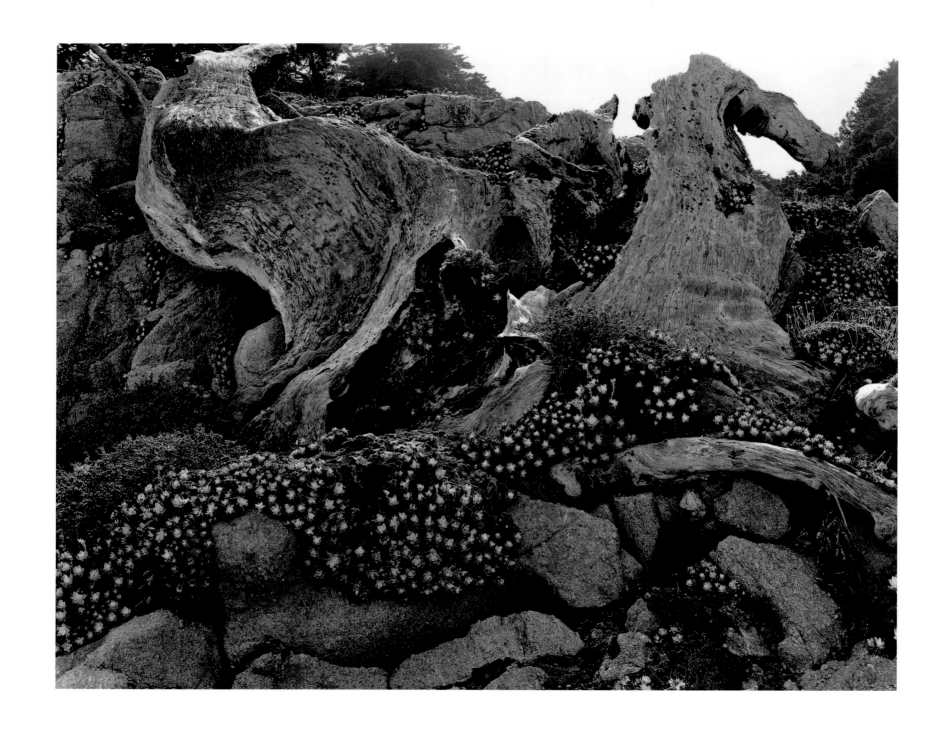

PLATE 112

Stonecrop and Cypress, Point Lobos, 1939

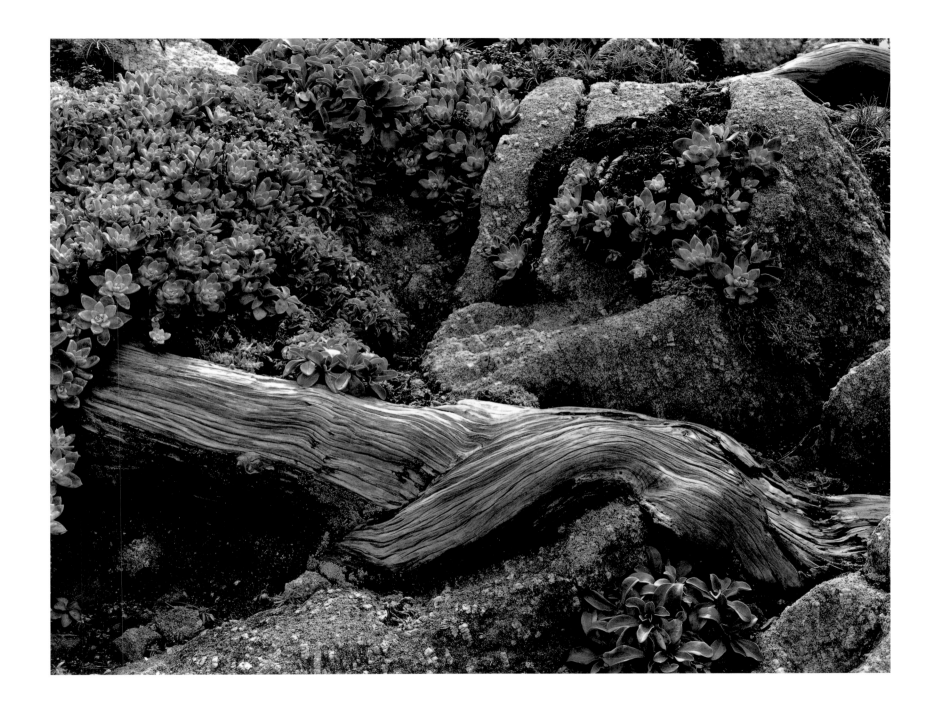

PLATE 113

Cypress and Stonecrop, 1941

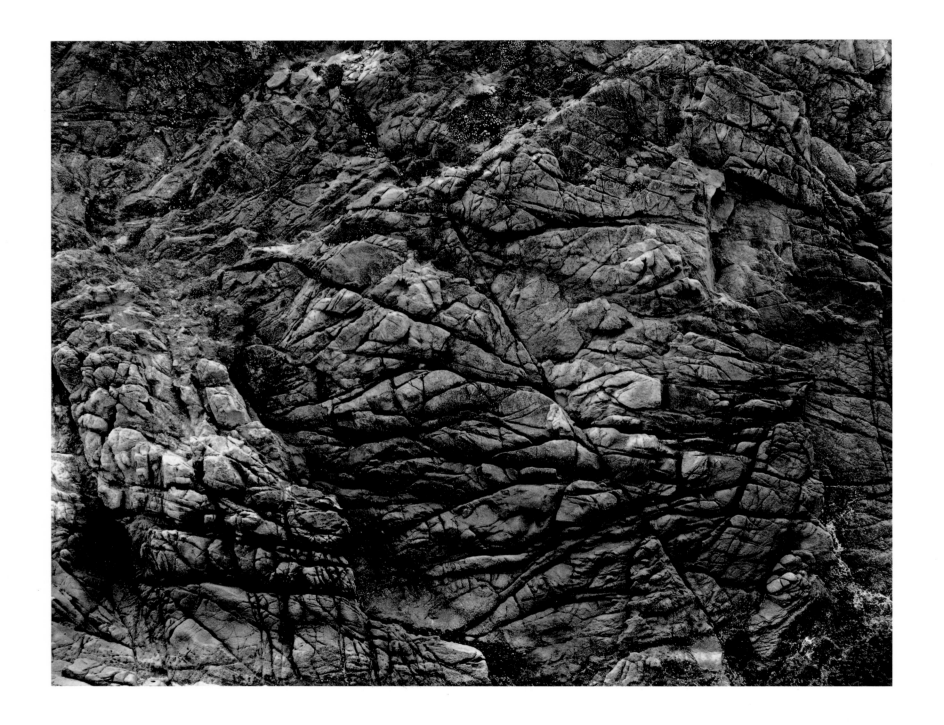

PLATE 114

Granite, Point Lobos, 1944

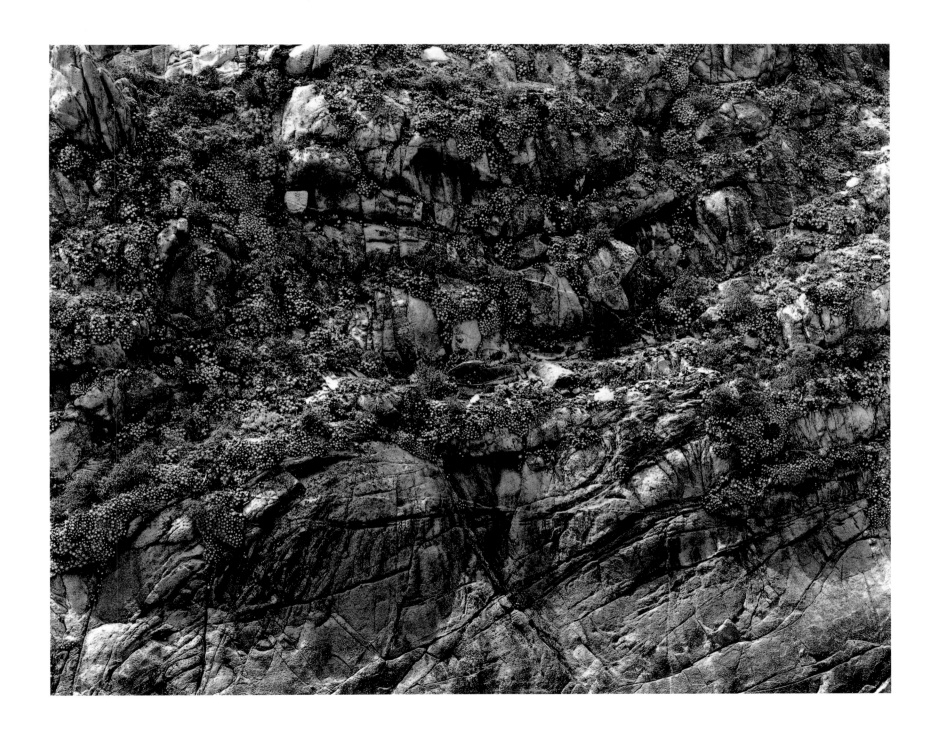

PLATE 115

Stonecrop, Point Lobos, 1944

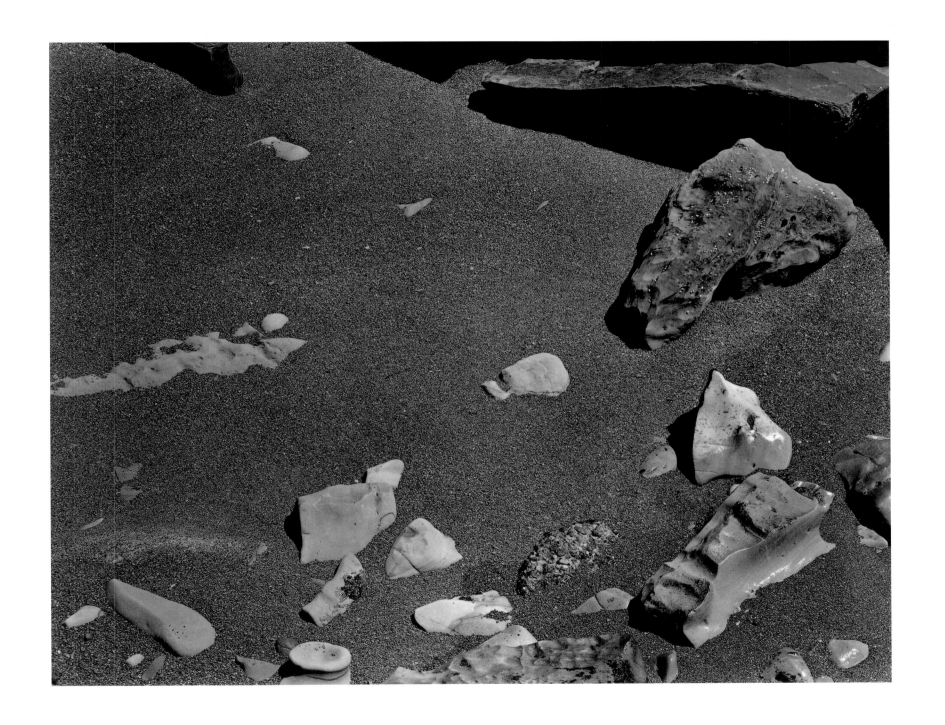

PLATE 116

Rocks and Pebbles, 1948

PLATE 117

Waterfront, Monterey, 1946, Kodachrome transparency

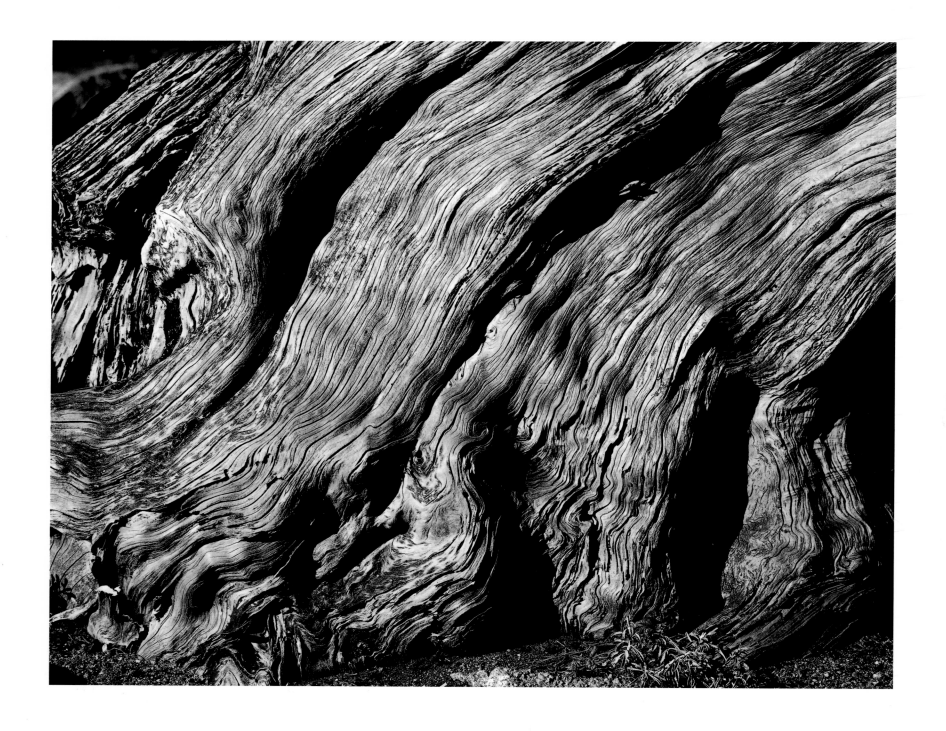

PLATE 118

Cypress, Point Lobos, 1947, Kodachrome transparency

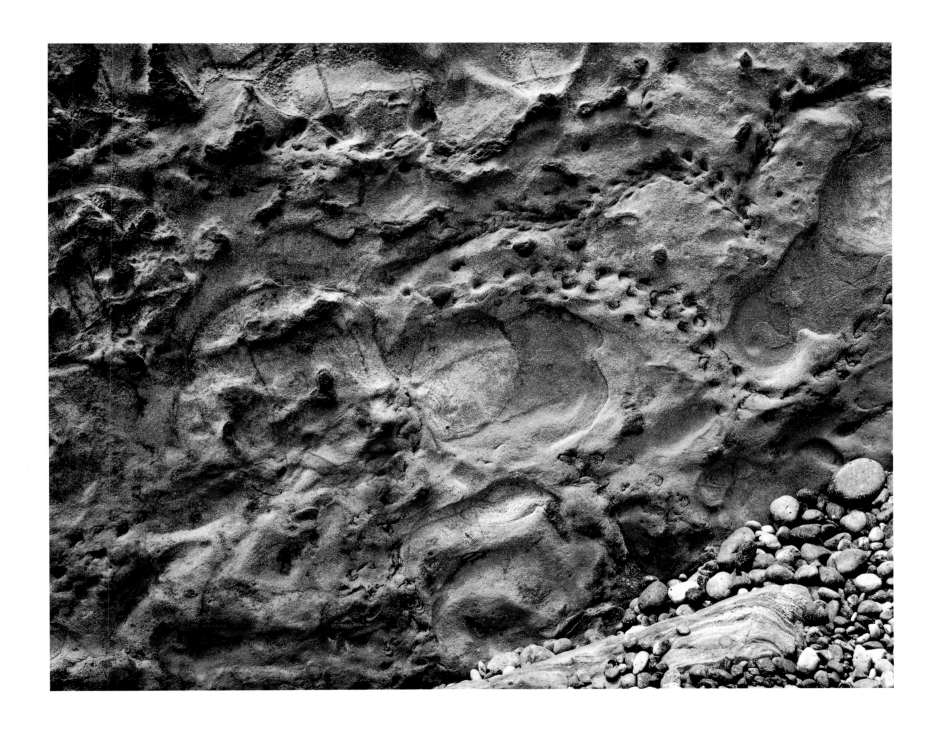

PLATE 119

Point Lobos, 1947, Kodachrome transparency

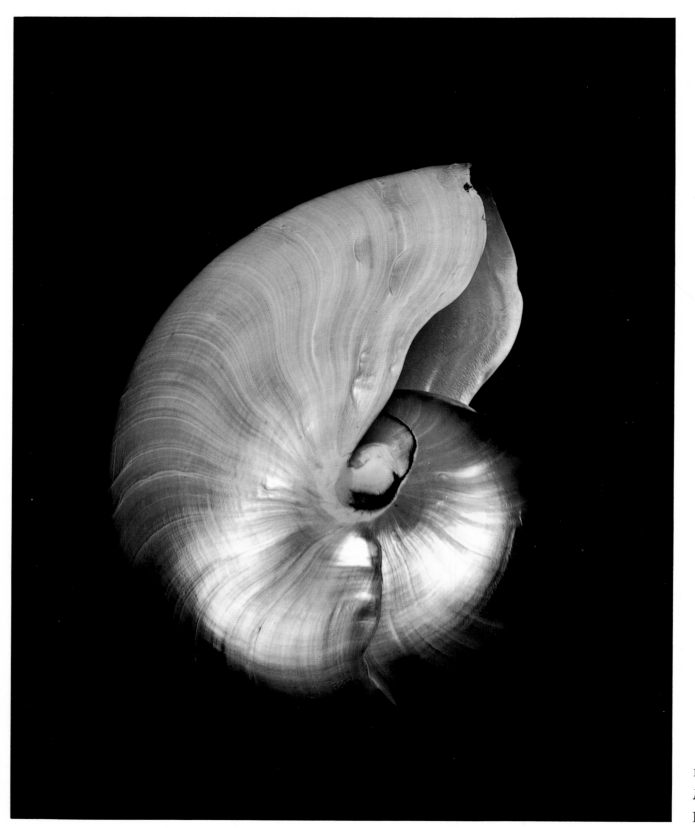

PLATE 120
Nautilus Shell, 1947,
Kodachrome transparency

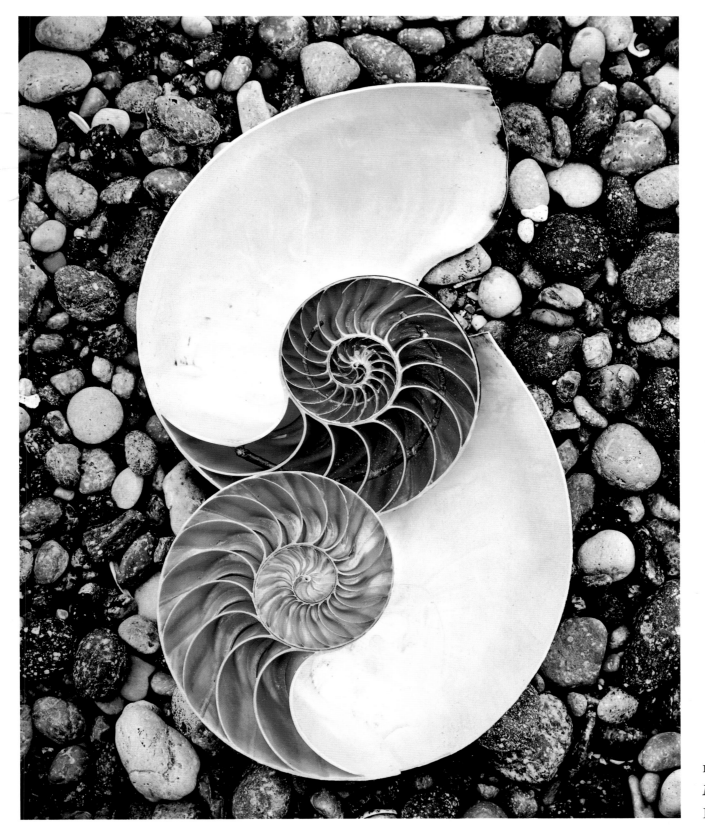

PLATE 121
Nautilus Shells, 1947,
Kodachrome transparency

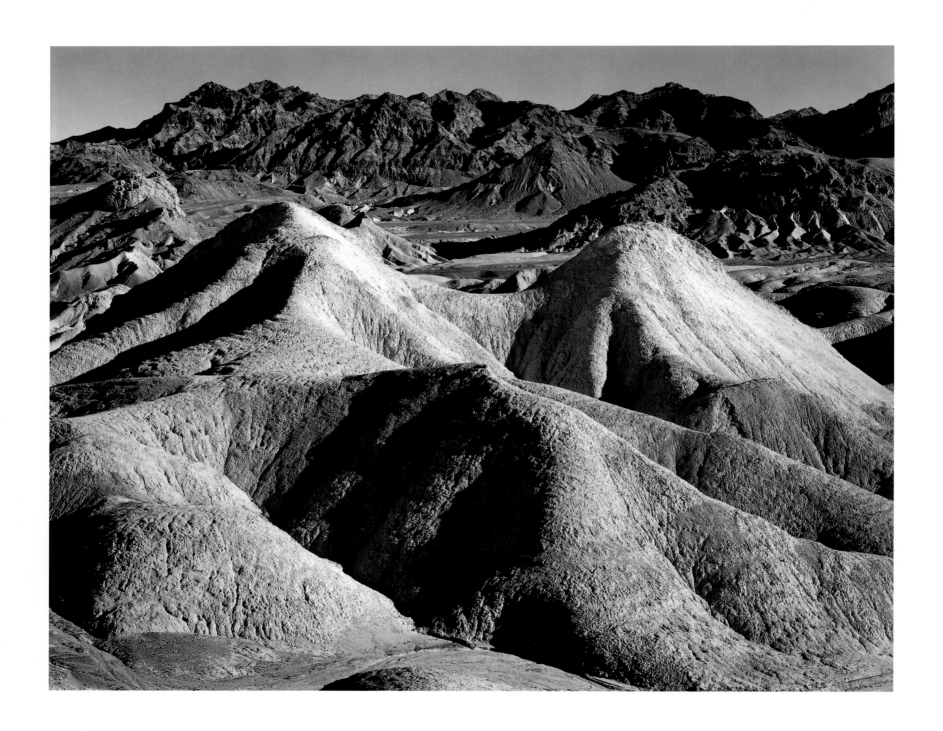

PLATE 122

Death Valley, Corkscrew Canyon, 1947, Kodachrome transparency

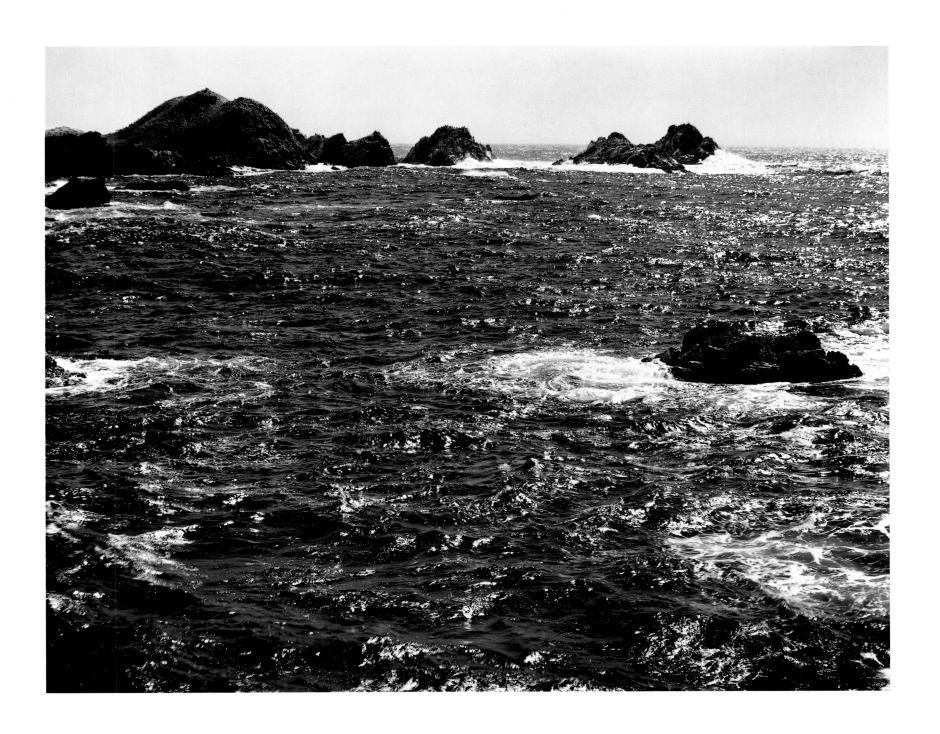

Point Lobos, 1946, Kodachrome transparency

CATALOG

Unless otherwise noted, the photographs are gelatin-silver prints.

2.

5.

7.

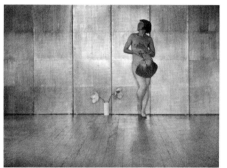

4.

6.

10.

1. *Lake Michigan, Chicago*
 1904, platinum, 9.0 x 11.9 cm (Plate 1)

2. *Spring, Washington Park, Chicago*
 1903, platinum, 11.5 x 8.5 cm

3. *Cloud Study, Mexico*
 1924, platinum, 15.7 x 23.0 cm (Plate 12)

4. *Nude, Margrethe, Glendale Studio*
 1923, platinum, 19.0 x 24.1 cm

5. *Margrethe on Couch, Glendale Studio*
 ca. 1920, platinum, 18.9 x 24.0 cm

6. *Tina Modotti in Robe, Glendale Studio*
 1921, platinum, 18.9 x 23.8 cm

7. *Betty in Her Attic*
 ca. 1921, platinum, 23.3 x 19.0 cm

8. *Epilogue*
 1919, platinum, 24.5 x 18.7 cm (Plate 3)

9. *Prologue to a Sad Spring*
 1920, platinum, 23.8 x 18.7 cm (Plate 2)

10. *Ramiel in His Attic*
 1920, platinum, 23.6 x 18.7 cm

11.

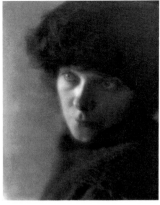

15.

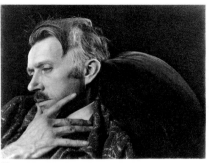

19.

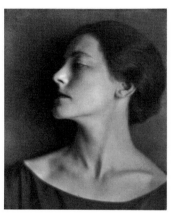

14.

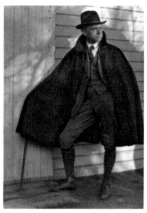

17.

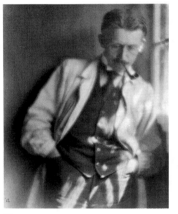

20.

11. *Scene Shifter*
 1921, platinum, 24.0 x 19.1 cm

12. *Sunny Corner in an Attic*
 1921, platinum, 19.0 x 24.0 cm (Plate 8)

13. *Tina Modotti*
 ca. 1924, 4.5 x 6.5 cm (Plate 14)

14. *Victoria Marin*
 1926, platinum, 24.2 x 19.3 cm

15. *Margrethe in Glendale Studio*
 ca. 1920, platinum, 24.1 x 18.5 cm

16. *Head of an Italian Girl*
 1921, platinum, 24.2 x 19.0 cm (Plate 6)

17. *Johan Hagemeyer*
 1921, platinum, 12.1 x 18.9 cm

18. *Johan Hagemeyer*
 1921, platinum, 24.2 x 19.0 cm (Plate 4)

19. *Johan Hagemeyer with Neurasthenia*
 1925, 18.1 x 23.7 cm

20. *Johan Hagemeyer*
 ca. 1918, 24.3 x 19.0 cm

21. *Sadakichi Hartmann*
 ca. 1920, platinum, 24.3 x 19.4 cm (Plate 5)

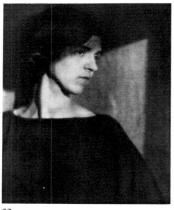
22.

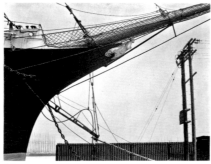
26.

31.

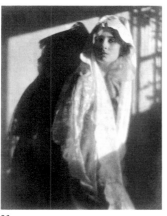
23.

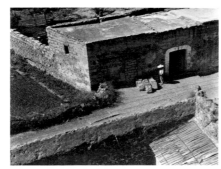
28.

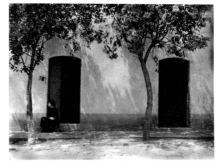
33.

22. *Type Antique*
 1918, platinum, 24.3 x 19.4 cm

23. *Enrique*
 1919, 24.0 x 18.3 cm

24. *Triangulation: George Hopkins*
 1919, 19.2 x 24.3 cm (Plate 9)

25. *The White Iris*
 1921, platinum, 24.1 x 19.0 cm (Plate 7)

26. *Ships, Alameda, San Francisco*
 1925, 19.0 x 23.7 cm

27. *Casa de Vecindad, D.F.*
 1926, 18.9 x 24.0 cm (Plate 20)

28. *Calle Mayor or Pissing Indian,
 Tepotzotlan, Mexico*
 1924, 19.0 x 24.0 cm

29. *Pulquería, Mexico*
 1926, 19.0 x 23.7 cm (Plate 22)

30. *Aqueduct, Los Remedios*
 1924, 19.0 x 24.0 cm (Plate 18)

31. *Pulquería, Mexico City*
 1926, 23.9 x 19.1 cm

32. *Desde la Azotea with Trees*
 1924, 19.1 x 24.1 cm (Plate 19)

33. *Tina, Mexico*
 1923, 19.1 x 24.3 cm

34. *Jarros de Oaxaca*
 1926, 19.0 x 23.9 cm (Plate 23)

35. *Excusado, Mexico*
 1925, 24.1 x 19.2 cm (Plate 25)

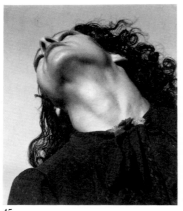

45.

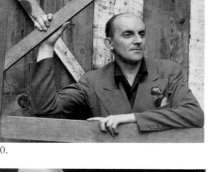

50.

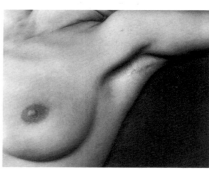

54.

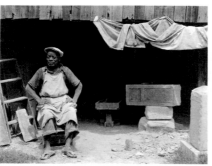

49.

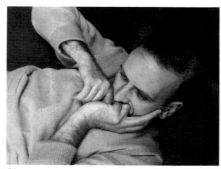

51.

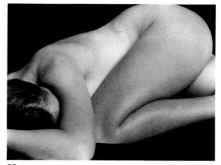

55.

36. *Arcos, Oaxaca*
 1926, platinum, 24.2 x 18.9 cm
 (Plate 24)

37. *Palma, Cuernavaca, with Leaves*
 1924, 23.3 x 18.8 cm (Plate 13)

38. *Pulquería, Mexico City*
 1926, 24.0 x 18.8 cm (Plate 21)

39. *Circus Tent*
 1924, 23.6 x 17.8 cm (Plate 17)

40. *Diego Rivera, Mexico*
 1924, 19.0 x 23.7 cm (Plate 44)

41. *Manuel Hernández Galván, Mexico*
 1924, 20.8 x 18.4 cm (Plate 16)

42. *Guadalupe Marín de Rivera, Mexico*
 1924, 22.9 x 17.8 cm (Plate 15)

43. *José Clemente Orozco*
 1930, 24.2 x 18.6 cm (Plate 45)

44. *Albert Bender*
 1928, 9.7 x 7.2 cm (Plate 48)

45. *Teresina*
 1933, 11.0 x 9.2 cm

46. *Robinson Jeffers*
 1933, 11.7 x 9.1 cm (Plate 49)

47. *Sonya*
 1934, 10.9 x 8.7 cm (Plate 46)

48. *Ansel Adams (After He Got a Contax
 Camera)*
 1936, 11.8 x 9.3 cm (Plate 47)

49. *William Edmondson, Sculptor, Tennessee*
 1941, 19.0 x 23.9 cm

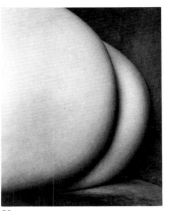

58.

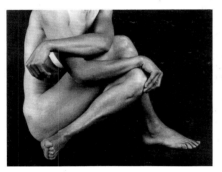

59.

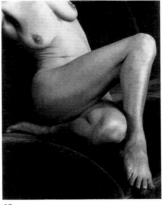

60.

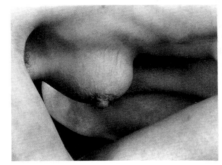

61.

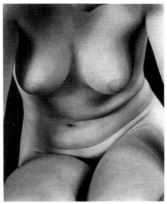

62.

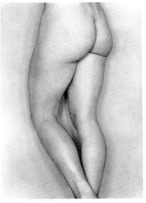

63.

50. *Ansel Adams*
 1943, 19.3 x 24.5 cm

51. *Frederick Sommer*
 1944, 19.2 x 24.8 cm

52. *Nude*
 1933, 11.9 x 9.3 cm (Plate 39)

53. *Nude*
 1933, 10.6 x 8.2 cm (Plate 40)

54. *Nude*
 1933, 9.3 x 11.8 cm

55. *Nude*
 1934, 9.5 x 11.8 cm

56. *Nude*
 1934, 9.2 x 11.7 cm (Plate 42)

57. *Nude*
 1925, 22.2 x 18.9 cm (Plate 27)

58. *Nude*
 1934, 11.7 x 9.2 cm

59. *Nude*
 1934, 9.3 x 11.8 cm

60. *Nude*
 1934, 11.7 x 9.0 cm

61. *Nude*
 1934, 9.2 x 11.7 cm

62. *Nude*
 1934, 11.8 x 9.2 cm

63. *Nude*
 1927, 23.9 x 16.4 cm

64. *Nude*
 1934, 9.2 x 11.7 cm (Plate 41)

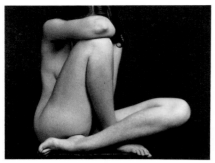
65.

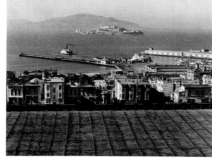
68.

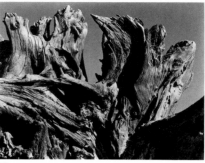
75.

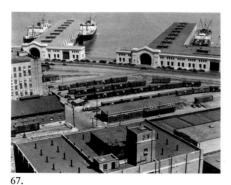
67.

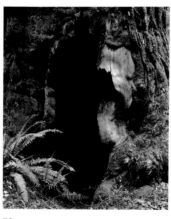
72.

78.

65. *Nude*
1934, 9.0 x 11.6 cm

66. *Nude*
1936, 17.8 x 24.0 cm (Plate 43)

67. *Embarcadero, San Francisco*
1937, 18.9 x 23.9 cm

68. *Sausalito Ferry, San Francisco*
1937, 19.1 x 24.1 cm

69. *Driftwood Stump*
1937, 24.3 x 19.9 cm (Plate 61)

70. *Moonstone Beach*
1937, 18.9 x 24.1 cm (Plate 59)

71. *Burned Stump*
1937, 24.5 x 19.3 cm (Plate 60)

72. *Redwood*
1937, 24.3 x 19.0 cm

73. *Wrecked Auto, Crescent City*
1937, 19.3 x 24.4 cm (Plate 58)

74. *Crescent Beach*
1937, 24.3 x 19.3 cm (Plate 57)

75. *Stump, Crescent City*
1937, 19.5 x 24.5 cm

76. *Stump, Crescent City*
1937, 19.2 x 24.5 cm (Plate 56)

77. *Tomato Field*
1937, 19.1 x 24.0 cm (Plate 52)

78. *Wildflowers, Laguna*
1937, 19.8 x 24.2 cm

79. *Oregon*
1939, 19.3 x 24.3 cm (Plate 55)

80.

88.

93.

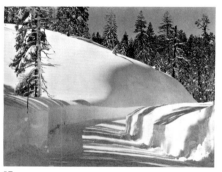
87.

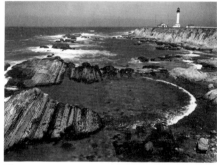
90.

95.

80. *Bandon, Oregon*
 1939, 24.4 x 19.3 cm

81. *Surf, Orick*
 1937, 19.4 x 24.4 cm (Plate 109)

82. *Iceberg Lake, Ediza*
 1937, 19.3 x 24.3 cm (Plate 84)

83. *Iceberg Lake, Ediza*
 1937, 19.2 x 24.2 cm (Plate 85)

84. *Iceberg Lake, Ediza*
 1937, 19.1 x 24.3 cm (Plate 83)

85. *Iceberg Lake*
 1939, 18.9 x 24.1 cm (Plate 86)

86. *Yosemite Mists*
 1938, 18.9 x 23.8 cm (Plate 80)

87. *Road in Snow, Yosemite*
 1938, 19.2 x 24.2 cm

88. *Ansel Adams's Darkroom, Yosemite*
 1938, 18.9 x 23.9 cm

89. *Yosemite*
 1938, 23.5 x 19.9 cm (Plate 79)

90. *Lighthouse, Point Arena*
 1937, 19.1 x 24.3 cm

91. *Hill and Telephone Poles*
 1937, 18.8 x 24.0 cm (Plate 50)

92. *Prunedale Cutoff*
 1933, 18.8 x 23.2 cm (Plate 53)

93. *Lettuce Field*
 1934, 19.2 x 24.3 cm

94. *St. Bernard Cemetery*
 1941, 18.7 x 24.2 cm (Plate 62)

95. *Meraux, New Orleans*
 1941, 24.3 x 19.4 cm

97.

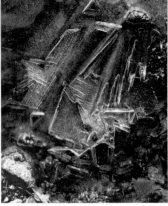

101.

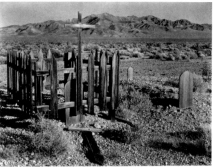

103.

98.

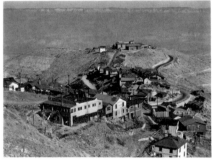

102.

104.

96. *St. Roche Cemetery, New Orleans*
 1941, 19.1 x 24.3 cm (Plate 63)

97. *Belle Grove Plantation*
 1941, 24.1 x 19.0 cm

98. *Burned Car, Mojave Desert*
 1938, 23.9 x 18.9 cm

99. *Sandstone Concretion and Stump*
 1936, 24.4 x 19.2 cm (Plate 78)

100. *Eroded Board from Grain Sifter*
 1931, 24.2 x 19.1 cm (Plate 77)

101. *Melting Ice, Arizona*
 1938, 24.1 x 19.1 cm

102. *Jerome, Arizona*
 1938, 19.1 x 24.0 cm

103. *Grave, Rhyolite Valley*
 1938, 19.3 x 24.2 cm

104. *Rhyolite, Nevada*
 1938, 19.3 x 24.5 cm

 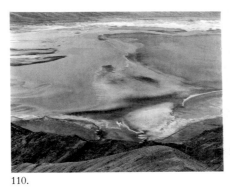 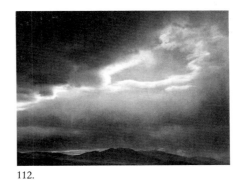

105. 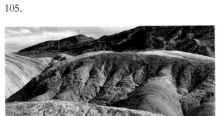 110. 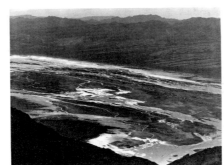 112.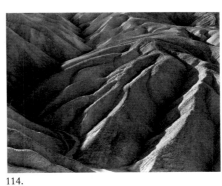

109. 111. 114.

105. *Rhyolite, Nevada*
 1938, 19.1 x 24.2 cm

106. *Borego Desert*
 1938, 19.1 x 24.2 cm (Plate 73)

107. *Badlands, Borego Desert*
 1938, 19.1 x 24.2 cm (Plate 74)

108. *Manley's Trail, Golden Canyon*
 1938, 19.4 x 24.3 cm (Plate 75)

109. *Corkscrew Canyon, Death Valley*
 1938, 19.0 x 24.2 cm

110. *Dante's View, Death Valley*
 1938, 19.0 x 24.1 cm

111. *Dante's View*
 1938, 19.0 x 24.0 cm

112. *Death Valley*
 1939, 19.4 x 24.5 cm

113. *Clouds, Death Valley*
 1939, 19.4 x 24.5 cm (Plate 54)

114. *Zabriskie Point*
 1938, 19.0 x 24.2 cm

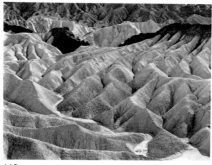
115.

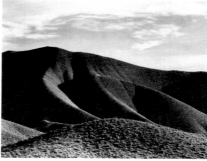
118.

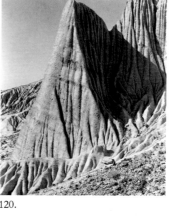
120.

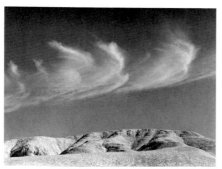
117.

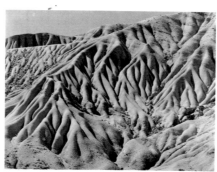
119.

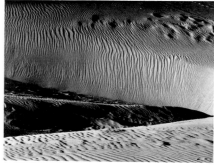
123.

115. *Zabriskie Point*
1938, 19.1 x 24.2 cm

116. *Cloud, the Panamints*
1937, 19.2 x 24.2 cm (Plate 51)

117. *Clouds, the Panamints, Death Valley*
1938, 18.9 x 24.0 cm

118. *The Panamints*
1938, 19.0 x 23.9 cm

119. *Red Rock Canyon*
1937, 19.3 x 24.4 cm

120. *Red Rock Canyon*
1937, 24.4 x 19.4 cm

121. *Twenty Mule Team Canyon*
1938, 18.8 x 24.0 cm (Plate 76)

122. *Sand Erosion, Oceano*
1934, 24.1 x 19.1 cm (Plate 72)

123. *Dunes, Oceano*
1936, 19.3 x 24.3 cm

124. *Dunes, Oceano*
1936, 19.3 x 24.5 cm

125. *Dunes, Oceano*
1936, 19.2 x 24.2 cm (Plate 68)

126. *Dunes, Oceano*
1936, 18.9 x 24.1 cm

127. *Dunes, Oceano*
1936, 19.0 x 24.0 cm (Plate 67)

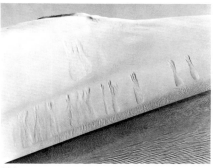

124.

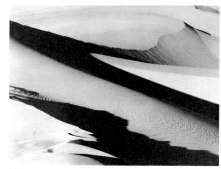

129.

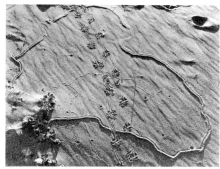

133.

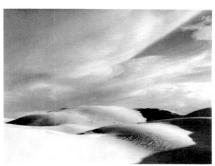

126.

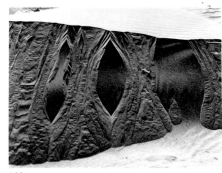

130.

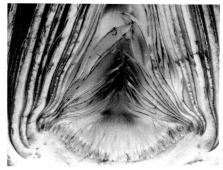

139.

128. *Sand Dunes*
1939, 19.0 x 24.1 cm (Plate 69)

129. *Sand Dunes*
1934, 19.2 x 24.4 cm

130. *Dunes, Oceano*
1936, 19.2 x 24.5 cm

131. *White Sands*
1941, 18.9 x 23.8 cm (Plate 70)

132. *Dunes, Oceano*
1936, 19.3 x 24.4 cm (Plate 71)

133. *Tracks in Sand*
1937, 18.7 x 23.5 cm

134. *Shell*
1927, 24.6 x 19.0 cm (Plate 26)

135. *Cabbage Leaf*
1931, 19.1 x 24.1 cm (Plate 29)

136. *Winter Squash*
1930, 19.1 x 23.4 cm (Plate 30)

137. *Cabbage and Basket*
1928, 24.0 x 18.7 cm (Plate 38)

138. *Cabbage Fragment*
1931, 23.6 x 18.8 cm (Plate 37)

139. *Artichoke Halved*
1930, 18.9 x 23.6 cm

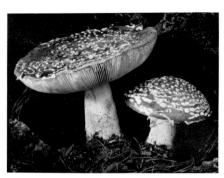

140.

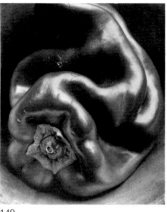

149.

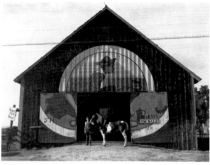

152.

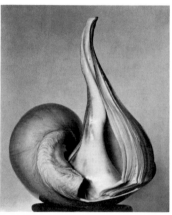

143.

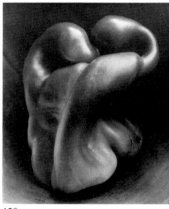

150.

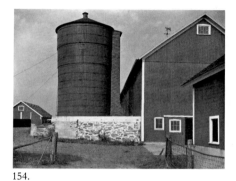

154.

140. *Toadstool*
 1934, 19.1 x 24.3 cm

141. *Pepper*
 1930, 19.0 x 23.7 cm (Plate 34)

142. *Onion*
 1930, 19.0 x 24.1 cm (Plate 31)

143. *Shell*
 1927, 23.5 x 18.6 cm

144. *Shells*
 1927, 19.3 x 24.1 cm (Plate 28)

145. *Toadstool*
 1932, 18.8 x 23.8 cm (Plate 36)

146. *Orchid*
 1931, 19.0 x 23.7 cm (Plate 33)

147. *Kale Halved*
 1930, 18.9 x 24.0 cm (Plate 32)

148. *Toadstool*
 1931, 19.0 x 24.0 cm (Plate 35)

149. *Pepper*
 1930, 23.8 x 19.0 cm

150. *Pepper*
 1930, 24.4 x 19.3 cm

151. *Shell & Rock – Arrangement*
 1931, 19.0 x 23.8 cm (Plate 90)

152. *Salinas, Horses for Sale*
 1939, 19.4 x 24.5 cm

153. *Connecticut Barn*
 1941, 19.5 x 24.3 cm (Plate 64)

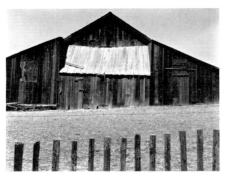

155.

156.

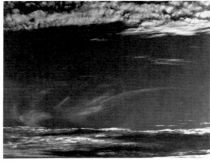

158.

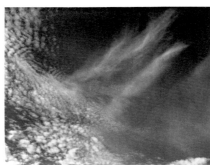

159.

162.

163.

154. *Connecticut Barn*
 1941, 19.1 x 24.4 cm

155. *Barn, Castroville*
 1934, 19.3 x 24.4 cm

156. *Abandoned Piano Close-up*
 1941, 24.2 x 19.1 cm

157. *Clouds*
 ca. 1936, 19.2 x 24.4 cm (Plate 87)

158. *Clouds*
 1936, 19.3 x 24.4 cm

159. *Cloud*
 1936, 19.3 x 24.3 cm

160. *Clouds*
 1936, 19.2 x 24.4 cm (Plate 88)

161. *Clouds*
 1925, 17.4 x 23.9 cm (Plate 89)

162. *Plant Study*
 1942, 24.2 x 19.3 cm

163. *False Hellebore at Lake Ediza*
 1937, 19.1 x 24.3 cm

164. *MGM Studios*
 1939, 19.3 x 24.4 cm (Plate 66)

165. *MGM Studios*
 1939, 24.5 x 19.3 cm (Plate 65)

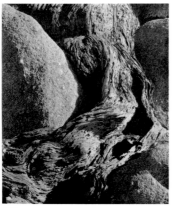

166.

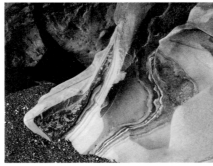

169.

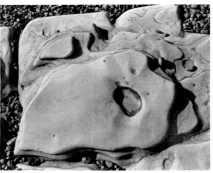

172.

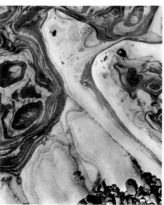

167.

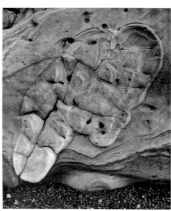

170.

173.

166. *Cypress, Pebble Beach*
 1929, 23.7 x 18.9 cm

167. *Point Lobos*
 1930, 24.1 x 19.2 cm

168. *Point Lobos*
 1930, 19.3 x 24.1 cm (Plate 98)

169. *Point Lobos*
 1930, 19.0 x 23.8 cm

170. *Point Lobos*
 1930, 24.0 x 19.3 cm

171. *Point Lobos*
 1930, 16.1 x 23.9 cm (Plate 91)

172. *Point Lobos*
 1930, 19.0 x 23.1 cm

173. *Point Lobos*
 ca. 1938, 24.4 x 19.3 cm

174. *Rock, Point Lobos*
 ca. 1938, 19.2 x 24.5 cm (Plate 100)

175. *Rock, Point Lobos*
 1938, 19.0 x 24.2 cm

176. *Tar on Rock, Point Lobos*
 1939, 19.1 x 24.2 cm (Plate 101)

177. *Salt on Rocks, Point Lobos*
 1942, 19.2 x 24.2 cm

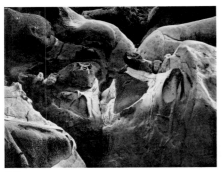

175.

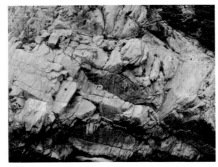

179.

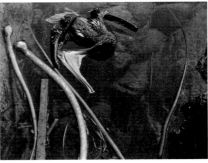

186.

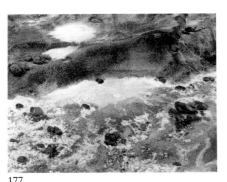

177.

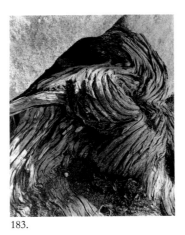

183.

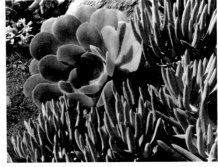

187.

178. *Stonecrop, Point Lobos*
 1944, 19.3 x 24.4 cm (Plate 115)

179. *Granite, Point Lobos*
 1944, 19.1 x 24.2 cm

180. *Granite, Point Lobos*
 1944, 19.2 x 24.2 cm (Plate 114)

181. *Rock, Point Lobos*
 1946, 24.3 x 19.2 cm (Plate 99)

182. *Rocks and Pebbles*
 1948, 19.2 x 24.2 cm (Plate 116)

183. *Cypress Root, Pebble Beach*
 1929, 23.9 x 18.9 cm

184. *Wing of Pelican*
 1931, 19.0 x 23.7 cm (Plate 97)

185. *Pelican, Point Lobos*
 1942, 19.3 x 24.3 cm (Plate 95)

186. *Pelican*
 1945, 19.3 x 24.4 cm

187. *Succulent*
 1930, 19.0 x 24.0 cm

188. *Kelp*
 1930, 19.0 x 23.9 cm (Plate 96)

189. *Kelp*
 1934, 19.0 x 24.1 cm (Plate 94)

190. *Wet Seaweed*
 1938, 19.4 x 24.4 cm (Plate 105)

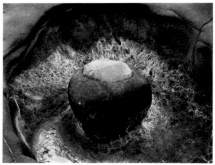
191.

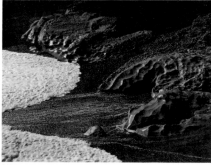
194.

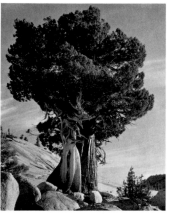
204.

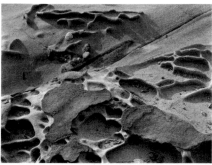
193.

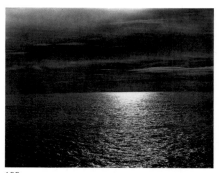
199.

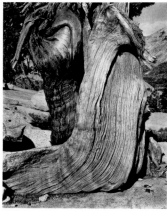
207.

191. *Dry Tidepool, Point Lobos*
 1939, 19.3 x 24.3 cm

192. *Sandstone Erosion, Point Lobos*
 1942, 19.1 x 24.2 cm (Plate 102)

193. *Sandstone Erosion, Point Lobos*
 1945, 19.3 x 24.4 cm

194. *Surf*
 1938, 19.2 x 24.2 cm

195. *Surf on Sand*
 1938, 19.5 x 24.4 cm (Plate 104)

196. *Point Lobos*
 1938, 19.3 x 24.3 cm (Plate 106)

197. *Coast View, Point Lobos*
 1938, 19.4 x 24.5 cm (Plate 107)

198. *Kelp, China Cove, Point Lobos*
 1940, 24.1 x 19.0 cm (Plate 108)

199. *Point Lobos*
 1940, 19.4 x 24.3 cm

200. *Cypress, Point Lobos*
 1929, 19.3 x 24.2 cm (Plate 93)

201. *Cypress, Point Lobos*
 1930, 23.8 x 19.0 cm (Plate 111)

202. *Cypress, Point Lobos*
 1931, 24.2 x 19.3 cm (Plate 92)

203. *Juniper*
 1937, 24.3 x 19.1 cm (Plate 81)

204. *Juniper, Lake Tenaya*
 1937, 18.8 x 14.1 cm

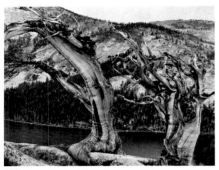

209.

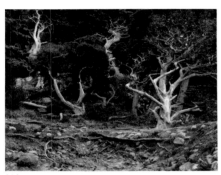

210.

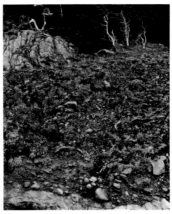

213.

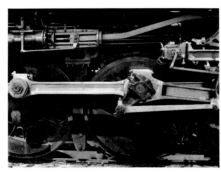

214.

215.

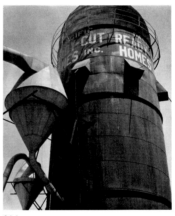

216.

205. *Juniper at Lake Tenaya*
 1937, 24.0 x 18.9 cm (Plate 82)

206. *Juniper, Lake Tenaya*
 1937, 19.1 x 24.4 cm (Plate 103)

207. *Juniper, Lake Tenaya*
 1937, 24.2 x 19.1 cm

208. *Stonecrop and Cypress, Point Lobos*
 1939, 19.2 x 24.2 cm (Plate 112)

209. *Lake Tenaya Country*
 1940, 19.3 x 24.3 cm

210. *Cypress, Point Lobos*
 1940, 19.1 x 24.2 cm

211. *Cypress and Stonecrop*
 1941, 19.2 x 24.2 cm (Plate 113)

212. *Point Lobos*
 1946, 24.1 x 19.1 cm (Plate 110)

213. *Point Lobos*
 1946, 24.2 x 19.0 cm

214. *Sante Fe Engine*
 1941, 19.4 x 24.3 cm

215. *Church Door, Hornitos*
 1940, 19.2 x 24.1 cm

216. *Factory, Los Angeles*
 1925, 24.1 x 19.0 cm

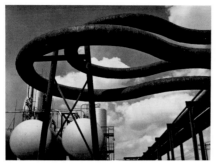
217.

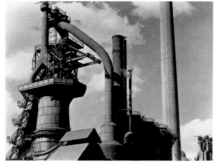
219.

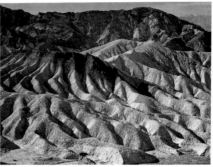
224.

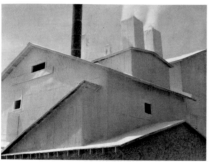
218.

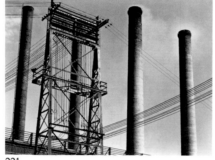
221.

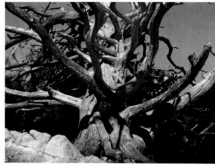
227.

217. *Gulf Oil, Port Arthur, Texas*
 1941, 19.3 x 24.3 cm

218. *Plaster Works, Los Angeles*
 1925, 19.0 x 24.2 cm

219. *Armco, Ohio*
 1941, 19.1 x 23.9 cm

220. *Telephone Lines (Armco Steel)*
 1922, platinum, 19.0 x 24.0 cm
 (Plate 10)

221. *Armco, Ohio*
 1941, 20.1 x 25.2 cm

222. *Armco Steel, Ohio*
 1922, platinum, 23.2 x 17.5 cm
 (Plate 11)

223. *Nautilus Shells*
 1947, Kodachrome transparency,
 19.3 x 24.5 cm (Plate 121)

224. *Zabriskie Point, Death Valley*
 1947, Kodachrome transparency,
 19.3 x 24.5 cm

225. *Point Lobos*
 1946, Kodachrome transparency,
 19.3 x 24.5 cm (Plate 123)

226. *Cypress, Point Lobos*
 1947, Kodachrome transparency,
 19.3 x 24.5 cm (Plate 118)

227. *Cypress, Point Lobos*
 1947, Kodachrome transparency,
 19.3 x 24.5 cm

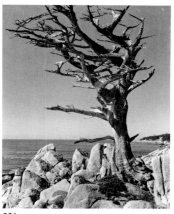
231.

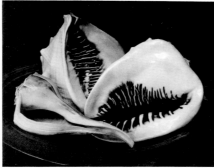
234.

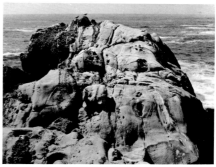
236.

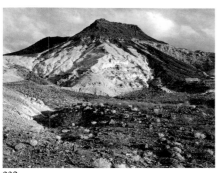
232.

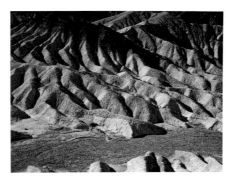
235.

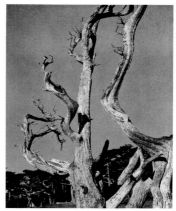
237.

228. *Nautilus Shell*
1947, Kodachrome transparency,
19.3 x 24.5 cm (Plate 120)

229. *Waterfront, Monterey*
1946, Kodachrome transparency,
19.3 x 24.5 cm (Plate 117)

230. *Death Valley, Corkscrew Canyon*
1947, Kodachrome transparency,
19.3 x 24.5 cm (Plate 122)

231. *Cypress, Point Lobos*
1947, Kodachrome transparency,
19.3 x 24.5 cm

232. *Death Valley*
1947, Kodachrome transparency,
19.3 x 24.5 cm

233. *Point Lobos*
1947, Kodachrome transparency,
19.3 x 24.5 cm (Plate 119)

234. *Shells*
1947, Ektachrome transparency,
19.3 x 24.5 cm

235. *Zabriskie Point, Death Valley*
1947, Kodachrome transparency,
19.3 x 24.5 cm

236. *Point Lobos*
1947, Ektachrome transparency,
19.3 x 24.5 cm

237. *Cypress, Point Lobos*
1947, Kodachrome transparency,
19.3 x 24.5 cm

CHRONOLOGY

1886
Born in Highland Park, Illinois.

1902
Began photography with a box camera.

1906
While visiting his sister May in California, decided on photography as a career. Began as an itinerant portraitist.

1908–1911
Attended Illinois College of Photography and worked as printer in commercial studios in Los Angeles.

1909
Married Flora Chandler. Four sons born: Chandler, 1910; Brett, 1911; Neil, 1914; Cole, 1919.

1911
Opened his own portrait studio in Tropico (now Glendale), California.

1916
Invited by the Photographer's Association of America to demonstrate his portrait techniques at their national convention.

1917
Elected a member of the prestigious London Salon of Photography in recognition of his pictorial photography.

1920
Began series of semi-abstract photographs of friends posed in attics.

1922
While visiting his sister May in Middleton, Ohio, made his first industrial photographs. Continued his trip to New York City, where he met Alfred Stieglitz and other photographers.

1923–1926
Lived in Mexico City, except for a return to California of eight months. Made out-of-door portraits, nudes, and still life close-ups of Mexican folk art.

1927
Returned to California. Began to photograph extreme close-ups of seashells and vegetables.

1929
Moved to Carmel, California, where he made his first photographs of cypress trees and rocks at Point Lobos.

1933
First "open landscapes" made in New Mexico.

1934
With son Brett, photographed immense sand dunes at Oceano, California. Began series of nude photographs of Charis Wilson.

1937–1939
Appointed fellow of the Guggenheim Foundation. With Charis, traveled 35,000 miles through California, and made 1,500 negatives.
Divorced Flora and married Charis.

1941
Crossed America to the East Coast, making illustrations for a new edition of Walt Whitman's *Leaves of Grass*.

1945
Divorced by Charis.

1946
His largest retrospective exhibition, at the Museum of Modern Art, New York. Made first color photographs for the Eastman Kodak Company.

1948
Stricken with Parkinson's disease. Made his last photographs.

1953
Supervised production by his son Brett of sets of eight prints from 838 selected negatives.

1958
Died at his home in Carmel.

SELECTED READINGS

Armitage, Merle, ed. *Edward Weston*. New York: E. Weyhe, 1932.

Bunnell, Peter. *Edward Weston on Photography*. Salt Lake City: Peregrine Smith, 1983.

Coke, Van Deren. *The Charlot Collection of Edward Weston Photographs*. Honolulu: Honolulu Academy of Arts, 1984.

Conger, Amy. *Edward Weston in Mexico, 1923–1926*. Albuquerque: University of New Mexico Press, 1983.

Davis, Keith. *Edward Weston: One Hundred Photographs from the Nelson Atkins Museum of Art and the Hallmark Photographic Collection*. Kansas City: William Rockhill Nelson Trust, 1982.

Enyeart, James L. *Edward Weston's California Landscapes*. Boston: New York Graphic Society, 1984.

Foley, Kathy Kelsey. *Edward Weston's Gifts to His Sister*. Dayton: Dayton Art Institute, 1978.

Maddow, Ben. *Edward Weston: Fifty Years*. Revised ed. Millerton, New York: Aperture, 1979.

Maddow, Ben. *Edward Weston: Seventy Photographs. Biography by Ben Maddow*. An Aperture Book. Boston: New York Graphic Society, 1978.

Newhall, Beaumont, and Conger, Amy, eds. *Edward Weston Omnibus: A Critical Anthology*. Salt Lake City: Peregrine Smith, 1984.

Newhall, Nancy, ed. *The Daybooks of Edward Weston, Volume 1: Mexico*. Millerton, New York: Aperture, 1973.

Newhall, Nancy, ed. *The Daybooks of Edward Weston, Volume 2: California*. Millerton, New York: Aperture, 1973.

Newhall, Nancy. *Edward Weston: The Flame of Recognition*. Millerton, New York: Aperture, 1975.

Newhall, Nancy. *The Photographs of Edward Weston*. New York: Museum of Modern Art, 1946.

Weston, Edward. *Fifty Photographs*. New York: Duell, Sloan & Pearce, 1947.

Weston, Edward. *My Camera on Point Lobos*. Yosemite National Park: V. Adams; Boston: Houghton Mifflin, 1950.

Whitman, Walt. *Leaves of Grass*. [With photographs by Edward Weston.] New York: Limited Editions Club, 1942.

Wilson, Charis. *Edward Weston: Nudes*. Millerton, New York: Aperture, 1977.

Wilson, Charis, and Weston, Edward. *California and the West*. New York: Duell, Sloane & Pearce, 1940; Millerton, New York: Aperture, 1978.

Wilson, Charis, and Weston, Edward. *The Cats of Wildcat Hill*. New York: Duell, Sloane & Pearce, 1947.

Designed by Katy Homans
Editorial coordination by Betty Childs
Copyedited by Peggy Freudenthal
Production coordination by Nancy Robins
Composition in Monotype Bembo by Michael & Winifred Bixler
Printed and bound by Imprimerie Jean Genoud, Lausanne

Library of Congress Cataloging-in-Publication Data

Newhall, Beaumont, 1908–
Supreme instants.

"A New York Graphic Society book."
Bibliography: p.
1. Photography, Artistic. 2. Weston, Edward,
1886–1958. I. Weston, Edward, 1886–1958. II. University
of Arizona. Center for Creative Photography. III. Title.
TR653.N49 1986 779'.092'4 85-23686
ISBN 0-8212-1621-X